HEART&SOUL

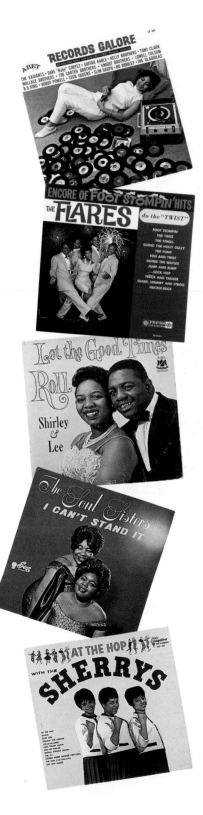
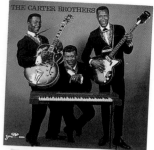
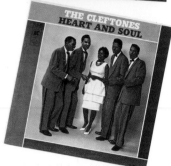

DEDICATED TO

Elsie Mae of Cragmont

IN LOVING MEMORY

ACKNOWLEDGMENTS

The authors wish to thank—Chuck Bloomingburg, Ruth Brown, Solomon Burke, Melanie Caldwell, Gregg Geller, Etta James, Lynda Keeler, David Less, Little Richard, Joe McEwen, Timothy Merlis, Tony Pipitone, Gene Sculatti, Diane Seay, Robert Vickers, Tom Vickers, Mark Wenner, Jerry Wexler… *additional thanks to*—Pat Johnson, Billy Douglas, Robin Pritzker, Ann Donahue, Eugenie Delaney, Marty Arbunich, Walter Salwitz, John Goodman, Robert Resnik… *special thanks to*—Donna Manvich at Sourcelink, Inc. for securing the rights to the images reprinted in this book.

Developed and Produced by
Heart & Soul LLC
Bill Harvey • Gary Chassman • Rico Tee

Editorial Director: Linda Sunshine
Editor: Mary Kalamaras

Book design by Bill Harvey

First published in hardcover in 1997 and distributed in the U.S. by Stewart, Tabori & Chang, a division of U.S. Media Holdings, Inc., 115 West 18th Street, New York, NY 10011

Published in 2002 by Billboard Books, an imprint of Watson-Guptill Publications, a division of BPI Communications, Inc., at 770 Broadway, New York, NY 10003

Library of Congress Card Number: 2001092976

ISBN: 0-8230-8314-4

Printed in Hong Kong

10 9 8 7 6 5 4 3 2 1

HEART&SOUL

A CELEBRATION OF BLACK MUSIC STYLE IN AMERICA 1930-1975

Concert posters, specifically those created by Globe Ticket in Baltimore, advertised local R&B package shows and became vivid visual records of the music of their respective eras. A 1965 offset job for a revue at Chattanooga's Memorial Auditorium featured a staggering lineup of predominantly Chicago-based acts, including the Impressions, Gene Chandler, Jerry Butler, Major Lance, Gladys Knight & the Pips, the Ikettes, Barbara Mason, and a host of others. The Globe format invariably included a head shot of the artists, along with the name of their latest single, resulting in an historic timeline in three colors.

CONCERT

MEMORIAL
AUDITORIUM
CHATTANOOGA
ADVANCE $2.00

TUES.
NOV. 2
8:00 P. M.
TICKETS at USUAL PLACES

SUPERSONIC ATTRACTIONS presents

ALL IN PERSON

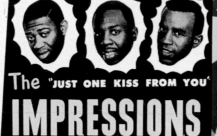
The "JUST ONE KISS FROM YOU"
IMPRESSIONS

'HERE COME' THE TEARS
GENE CHANDLER

"GOOD TIMES"
JERRY BUTLER

TOO HOT TO HOLD
MAJOR LANCE
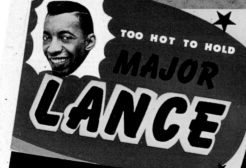

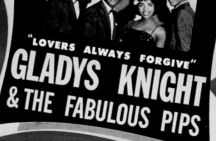
"LOVERS ALWAYS FORGIVE"
GLADYS KNIGHT & THE FABULOUS PIPS

"I'M SO" THANKFUL
The Three IKETTES
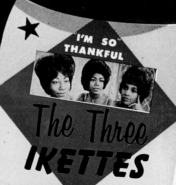

"SAD SAD GIRL"
BARBARA MASON
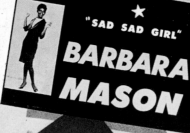

FONTELLA "Rescue Me" **BASS**

G.L. CROCKETT
"IT'S A MAN DOWN THERE"

WILLIAM BELL

THE JAMO THOMAS ORCHESTRA

GORGEOUS George M.C.

Bill Murry M.C.

POSTERS INC. 835 Cherry St., Phila., Pa. WAlnut 5-2000

FOREWORD

Looking through the pages of this book really brings back some vivid memories for me. Not only did I have the honor and pleasure of meeting some of the great artists seen here, but many of them had a real influence on my own music.

When I was little, and I do mean little—not more than five years old—I had started singing at St. Paul's Baptist Church in Los Angeles. Not only did I get to perform in front of an audience for the first time, but I also saw many of the great gospel stars of the day, including the incredible Clara Ward. She was really something special. With her hair upswept and piles of curls on top, big long earrings and lots of make-up, she gave me my first real taste of "show biz." I guess you could say she was one of my earliest role models . . . but then again, so was Sister Rosetta Tharpe. Even though I was just a child, I knew immediately that this woman was playing a different kind of music altogether. It was gospel, but the way she put it across, in her bluesy-jazzy style, was a real "revelation." And she looked like something else, too. I saw her once when she was the perfect picture of a church-going lady. But the next time she came to town, she was a lot more glamorous, with lots of lipstick and all. It was only later that I realized she played guitar kind of like T-Bone Walker, in a real "bad" groove.

When I moved up to San Francisco to live with my aunt and uncle, I discovered a whole other world of great music . . . up on the silver screen. It was at the movies that I saw and heard such great stars as Louis Jordan, Cab Calloway, and Lena Horne, who was in Stormy Weather. She was, without a doubt, the most beautiful woman I'd ever seen. As a teen-ager, I made up a story that Lena was my mother's other sister because they both had the same light skin. I had the same coloring, and I was sure flattered when people said that I might make a good Cotton Club girl one day.

Growing up in the projects in San Francisco, I remember my uncle warning me against listening to "that devil music." But I didn't pay him any mind and would go to the recreation center every chance I got to listen to those "low down" blues records with my friends.

When I was thirteen, I snuck out to see Charles Brown at the Oakland Auditorium. I got as close to the stage as I could, wearing my best blue dress and bobby socks. I loved the way he sang his songs sitting kind of sideways at the piano, especially "Black Night" and "Driftin' Blues," and he looked as good as he sang. He was gorgeous, with big white teeth like pearls and processed black hair and his all-white outfit. His skin was so smooth . . . he must have been using Max Factor #31! I was in heaven, until I saw that my aunt spotted me and pulled me right back through the crowd by my ponytail. If I'd known she was going to be at the show I wouldn't have gone up front.

After Johnny Otis gave me my big break and I started touring and recording, I had the opportunity to meet the fantastic Billie Holiday in New York. We were both on a TV show—it must have been around 1956—and Count Basie was backing everybody up. I found myself sitting next to Billie and I couldn't

help but notice how swollen her hands and feet were. It was only later that I learned that she'd been "fixing." She caught me looking at her and I'll never forget what she said to me that night: "Don't ever let this happen to you." She must have had a sixth sense, because it did.

Later, as part of the Top Ten Tour, a big musical revue, I got to work with many great R&B stars, from Little Richard to Big Joe Turner, the Moonglows and the Five Keys . . . you know, everyone that had a Top 10 hit. They were all big stars, but Little Richard was the biggest of all. And he knew it. He was so flamboyant . . . he wanted everyone to call him "King Richard," although I don't think I ever did. He had the biggest, flashiest band with all the best looking players. He also had the greatest parties in his hotel rooms. At least, that's what I was told. They wouldn't let me in, because I was still underage.

Johnny "Guitar" Watson was someone I loved so much . . . it breaks my heart that he's no longer with us. Being on the road with him—the way he moved and the way he could hit his notes—those are some of my most precious memories. I wanted to sing just like him. In fact, he was the first person whose style directly inspired my own.

Of all the people I worked with, Johnny Otis did the most for my career. He told us just how to dress and made sure we looked just right on stage. During a Johnny Otis show, all the performers had to be out on the stage at once, cheering each other on and encouraging the audience to do the same. But Johnny never tried to lord it over you. He was funny, always cracking jokes and talking that real "down home" Southern talk. We didn't know until much later that he wasn't really black. I mean, he ate chitlins and everything!

In the rock 'n' roll era, there was nobody more magnetic than Jackie Wilson. He was the most exciting person on stage that I'd ever seen and we used to call him "The Dandy Man." He would dress just so and he had that athletic boxer's body and he walked on his toes everywhere he went, holding a cigarette like Jimmy Cagney. His hair did a thing that nobody else's could: when it fell in his face, he would flick it back with a shake of his head and it would fall right back into place. When we went to Jackie's apartment in New York, he would only play his own records and if you tried to change it, he'd pop out of his bedroom in his smoking jacket and show you the door.

On stage, Jackie drove the women simply out of their minds. He would actually pick out some of the homeliest girls from the crowd . . . I mean there would be two or three on top of him and he'd kiss them all, right on the lips, for real! You just knew that it was one moment that they would remember for the rest of their lives.

Sam Cooke was another great looking guy. But I think that thoughout his whole career, he was never able to get over the guilt of leaving gospel to be a pop star. Even though he was really sophisticated, I remember seeing him hanging out with the winos in the alley behind a club and sharing their bottle.

Almost as much fun as meeting the big stars of the day was meeting entertainers who were destined to become the big names of the future. I met James Brown back in Macon, Georgia when he was still a complete unknown. I used to travel with a pet monkey at the time and I wanted to visit a famous soul food restaurant there called Mabel's. They wouldn't let me in with the monkey on my shoulder and I

was really angry about it. I stood outside and shouted, "The nerve of you! This monkey is as cool as any of you all!" Right then, this short guy came up to me on the street and said, as polite as you please, "Miss James, I'll hold your monkey while you go in there and eat." He was the sweetest kid and it was only later that I found out he was James Brown. He used to carry an old tattered napkin around with him, because Little Richard had written the words "Please, Please, Please" on it and James was determined to make a song out of it. And, of course, he did.

Otis Redding was another Georgia Peach. At one time I was asked to tour with him, but I got him confused with the blues piano player Otis Spann and refused. What a mistake! He was something to see on stage: clean cut, with a flat top, 240 pounds and 6'4", singing and stompin' like a choo-choo train.

He was on Stax and so was Rufus Thomas, who to this day lives up to his billing as the "world's oldest teen-ager." He was a fun guy, no doubt about it, and he's into the music business because he really loves it. I mean, why else would anyone wear those crazy loud hot pants and pretty gold boots that lace all the way up?

Of all my fellow female singers in those days, I think Ruth Brown had the biggest influence on me. She had those beautiful, big doe eyes and that lipstick that came up and over her lips like Carmen Miranda and those curls that hung way down. I used to say to myself "I'm going to be just like Ruth," but when I got my chance I did it a little different. I did the eyebrow thing like her, and wore those sexy fish-tail dresses that cupped my behind so tight I could hardly walk! I also added a head full of platinum blonde hair, but that wasn't my idea to begin with. When I was sixteen, these gay guys were doing my hair and they suggested I go blonde and it kind of became my trademark. I met a woman who was working in a rehab center where I was recovering who had remembered seeing me years before in Columbia, South Carolina. She told me that my hair color and look really had an effect on her back then. "You were really a pioneer," she said. "You made us feel like we could express ourselves, too."

I guess you could say that about most of the great stars you see in this book. Entertainment was one of the few ways for blacks to be themselves and to make a connection, not only to their own race, but to people of all colors. It still thrills me to death that I was a part of it all . . . and still am.

John E. Reed

ETTA JAMES
Miss Peaches)

Direction
SHAW ARTISTS CORPORATION
565 Fifth Avenue
New York 17, New York

CONTENTS

Roots of the Blues:
Muddy Waters in curlers.

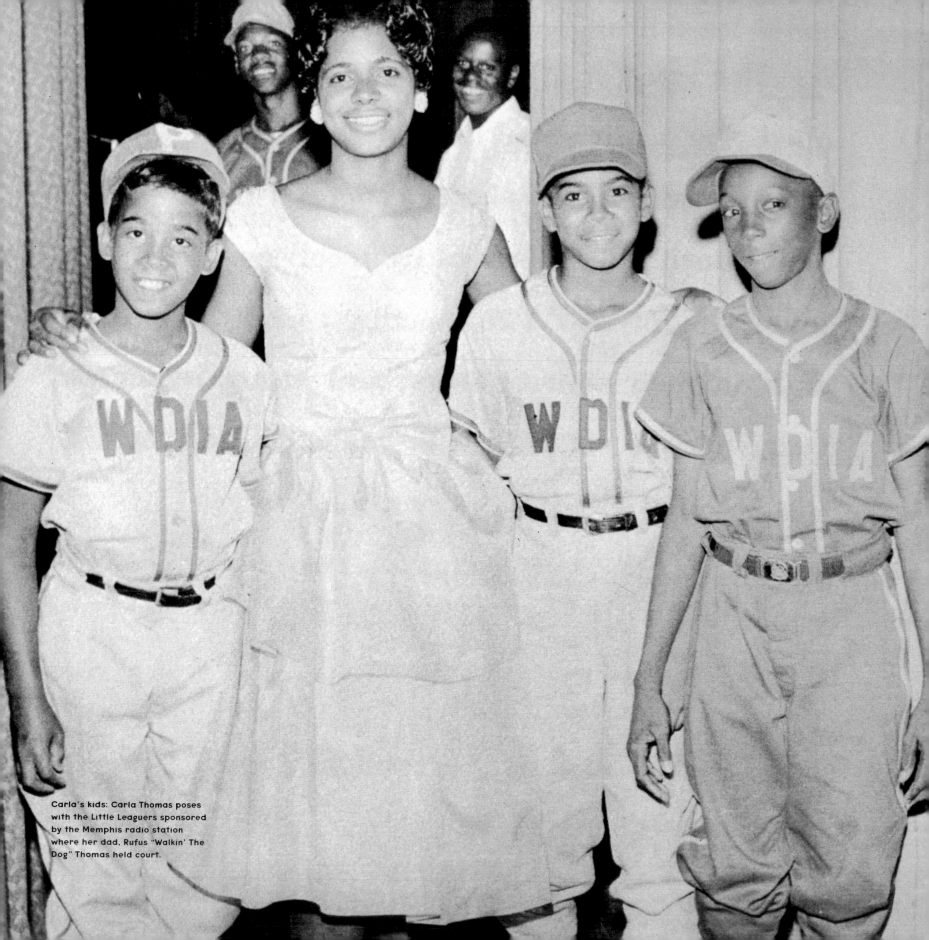

Carla's kids: Carla Thomas poses with the Little Leaguers sponsored by the Memphis radio station where her dad, Rufus "Walkin' The Dog" Thomas held court.

PREFACE

Even the most cursory survey of the American pop landscape reveals the enormous and enduring influence of black culture. One of the most significant factors in the creation of our national identity, it was also among the agents most responsible for the international appeal of all things American.

It's an influence seen in everything from music to fashion to language to the very essence of that indefinable term *cool*. It's the creation of a people whose culture was, by necessity, oversized and larger-than-life, the liberating expression of an oppressed race.

The political, social, and economic forces that shaped the black American experience have been the subject of a vast body of scholarly tomes. This book is not one of them. Through words and pictures, anecdotes and artifacts, this is a celebration of a style that shook, rattled, and rolled the whole world.

To this day, black style continues to assert its influence, in rap, hip-hop, and all their attendant attitudes. By the same token, the roots of black style can be said to extend back to slave days, to spirituals and minstrel shows, or even further to the signifying rituals of the African homeland.

Yet, there was, without question, a golden age of black style, a period of nearly half a century, from roughly the 1920s to the 1970s, of a vibrant, flamboyant, and extravagant flowering in African American culture.

It was an age of pencil mustaches and pompadours, of Zoot suits and drapes, jump suits and jive; an era of showmen, charlatans, and artists of astonishing talent and influence. It was a time when private lives were every bit as outrageous as public personae, when piano pounders and duckwalkers battered down the color barrier, and barrel-chested blues shouters made strong men weep and women weak in the knees. It's an audacious, outrageous, and contagiously exciting saga that's at the heart of soul.

It's a story told in legends, feats, and rumors every

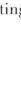

ABOVE **From Gotham to Myrtle Beach: Baby Washington, former lead singer of New York's The Hearts, found favor with the Carolina beach music devotees in her later career.**

BELOW **Graphics promoting Decca's "race music" series.**

bit as colorful and evocative as the brilliant images that illustrate these pages: a story, finally, of hot music and high style, of men and women who made history by being themselves and who made the world a richer, wilder, "cooler" place in the process.

It's been said that writing about music makes about as much sense as dancing about architecture, and while there's an undeniable wisdom to the old cliché, the stylistic and cultural context within which this remarkable revolution in music took place begs a closer look. It goes without saying that the music must speak for itself. To truly appreciate the scope and magnitude of this glorious era, one must actually hear the voices of its creators. These pages trace, in rare and revealing images, the source and context of those voices. Think of this book as a visual adjunct to the very best of soul, R&B, blues, and jazz, the music that defines us as a nation and as a people.

— Bob Merlis and Davin Seay

© Phil Spector Records, Inc.

ABOVE Phil Spector's golden girls going places in their '62 Chevy.

BELOW Atlantic Records' mid-1950s A-team together on one EP.

Chapter 1
ROOTS

Zoot suit regalia.

ROOTS

Standin' at the crossroads
tried to flag a ride
Don't nobody seem to know me, babe,
everybody pass me by . . . — Robert Johnson, *Cross Road Blues*

By the close of the nineteenth century, a professional cast of black musicians had begun to make their creative mark on mainstream American music. Their songs, in sharp contrast to the heavenly hymnody of the spirituals, celebrated a rediscovered sense of identity on the part of black America by extolling the exploits of such archetypal mythic black folk heroes as Staggerlee, John Henry, Dupree, and others. In addition, the blues quickly came to signify all the varieties of sin and suffering to which the flesh is heir. Blues singers became a different kind of priestly figure for the black community, sanctifying the secular and taking as their blessed sacraments whiskey and women, high living and hard times. Yet, for all the appeal of the blues, sacred music, especially gospel, still held a powerful place in black consciousness.

"They make one song equal 10,000 sermons": the Soul Stirrers before Sam Cooke joined.

The Sacred and the Profane

The term *gospel music* was coined in 1875 by hymn writer Ira Sankey, but its emergence in the 1930s as a lucrative form of church music is commonly attributed to one man: Thomas Dorsey, the fabled Father of Gospel Music. In Dorsey's hands, gospel was a coolly calculated commercial endeavor designed to capitalize on the enormous appeal of Negro spirituals. In the early 1930s, he founded Dorsey's House of Music in Chicago, the first publishing firm devoted to the development and dissemination of the songs of black gospel performers. By the end of the decade, his gospel empire was in full swing: he promoted *gospel battles of song* that pitted well-known groups against each other in hot and heavy sing-offs.

On a parallel track, the self-proclaimed Father of the Blues, W.C. Handy, was turning that musical form into a flourishing entrepreneurial endeavor. One of the first to use the term *blues* in a song title—

1912's *Memphis Blues*—Handy was not so much a true creative innovator as a canny marketer who had the foresight to publish a spate of quintessential blues standards including *St. Louis Blues*, *Yellow Dog Blues*, and *Beale Street Blues*. During the Roaring Twenties, he recorded with his own band in New York and formed the Handy Record Company, which went out of business before it issued a single title, apparently an endeavor far ahead of its time.

In their early commercial incarnations, blues and gospel often coexisted peaceably. Because of her jazz leanings, for example, the astonishing Sister Rosetta Tharpe was able to bring gospel music to a decidedly secular setting when she performed with Cab Calloway at the Cotton Club in Harlem in the early 1930s. Tharpe, with a voice that could convert the wicked even in that plush den of iniquity, in 1938 became the first gospel pro to record for a major pop record label—Decca. By the 1940s and the beginning World War II, gospel and blues were both booming businesses, spearheaded by savvy black musician/capitalists who parlayed their rich cultural heritage into wads of mammon.

Gospel served as a training ground for talented vocalists and musical innovators who made their marks in soul and R&B. Sam Cooke, for example, one of the greatest (if not the greatest) soul singers of all time, was born and bred in the gospel milieu and began his career in the 1940s as part of a family gospel group, the Singing Children. By age fifteen, Cooke had joined the Highway QCs, and in the 1950s came into his own as a performer. The QCs became apprenticed to R.B. Robinson, baritone singer for the legendary Texas-spawned Soul Stirrers. The Stirrers are largely credited with breaking the prevailing tradition of silky smooth harmonics that was championed by various *jubilee quartets* such as the Dixie Hummingbirds, and thus opening the way for the harder-edged *southern quartet* style popularized by the Swan Silvertones and the Sensational Nightingales. In time, the Highway QCs became a popular attraction in

Sister Rosetta — bringing gospel's good news to a cabaret congregation.

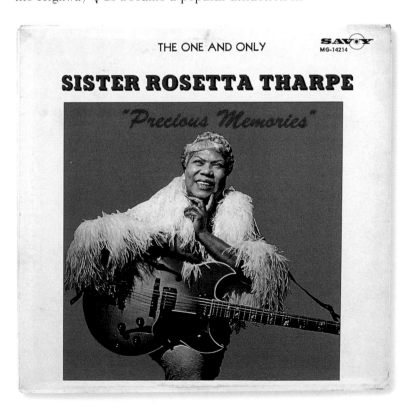

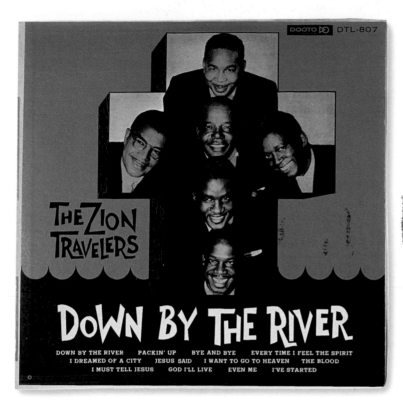

The Zion Travelers — DOWN BY THE RIVER

DOWN BY THE RIVER PACKIN' UP BYE AND BYE EVERY TIME I FEEL THE SPIRIT
I DREAMED OF A CITY JESUS SAID I WANT TO GO TO HEAVEN THE BLOOD
I MUST TELL JESUS GOD I'LL LIVE EVEN ME I'VE STARTED

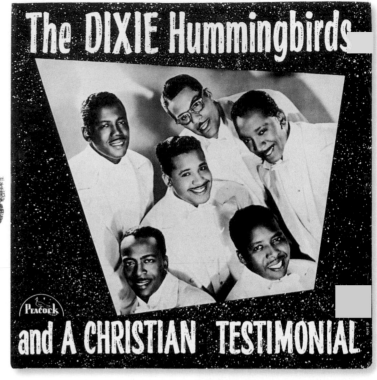

The DIXIE Hummingbirds and A CHRISTIAN TESTIMONIAL

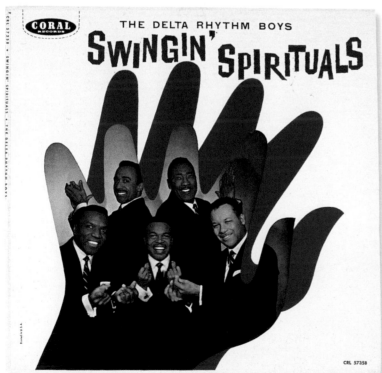

THE DELTA RHYTHM BOYS — Swingin' Spirituals

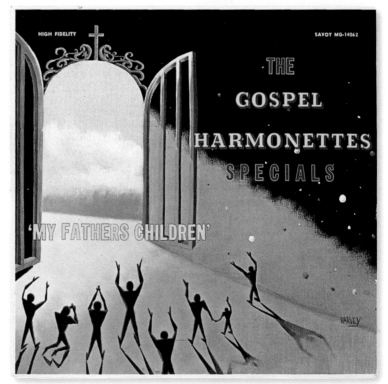

THE GOSPEL HARMONETTES SPECIALS — 'MY FATHERS CHILDREN'

their own right, touring with the Stirrers, the Blind Boys of Mississippi, the Pilgrim Travelers, and others.

The Gospel Message

As the links among gospel, R&B, and, eventually, rock 'n' roll were gradually forged, gospel groups along the lines of the Delta Rhythm Boys, Gospel Harmonettes, and Zion Travelers found their secular counterparts. Such popular mainstream acts included the Ink Spots, the Robins, the Ravens, and, perhaps, the best of them all, the Dominoes, a group boasting, at various times, the melodramatic glory of Clyde McPhatter and the keening pathos of Jackie Wilson, whose legacy has been echoed in the works of many notable talents from Smokey Robinson to Al Green to Michael Jackson. The debt owed to gospel by soul, R&B, and much of popular music, in fact, is huge. The gospel-singing Drinkard Singers alone supplied an abundance of great soul and pop talent from its ranks, including sisters Dionne and Dee Dee Warwick; their aunt, Cissy Houston (mother of Whitney); and the underrated Judy Clay, whose duets with Billy Vera made soul history as coming from the first black/white, female/male duo.

Songs of Hope

The sophisticated stylings of the Swan Silvertones or the Spirit of Memphis Quartet were unerringly reflected in the debonair warbling of the Ink Spots or the Orioles, while the house-wrecking, hard gospel sound of the Nightingales or the Five Blind Boys of Mississippi was mimicked in the vocal acrobatics of countless R&B ravers and screamers, including James Brown and Wilson Pickett. In 1952, for example, McPhatter and the Dominoes cut the blistering *Have Mercy, Baby*, a quick tempo pulse pounder based on a gospel favorite that simply substituted the word *baby* for *Lord*. This hit-making formula was repeated countless times.

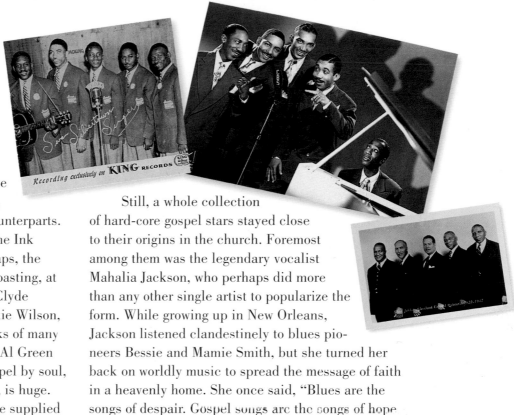

Still, a whole collection of hard-core gospel stars stayed close to their origins in the church. Foremost among them was the legendary vocalist Mahalia Jackson, who perhaps did more than any other single artist to popularize the form. While growing up in New Orleans, Jackson listened clandestinely to blues pioneers Bessie and Mamie Smith, but she turned her back on worldly music to spread the message of faith in a heavenly home. She once said, "Blues are the songs of despair. Gospel songs are the songs of hope

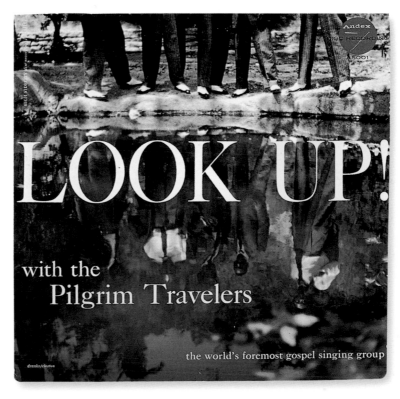

the world's foremost gospel singing group

PAGE 16 Gospel greats — God's words at 33⅓.

ABOVE Great gospel groups in early promotional shots: Swan Silvertones Singers, Deep River Boys, and Silver Jublilee Singers.

BELOW Pilgrim Travelers: building the bridge from gospel to pop.

No one better exempli-
fied the fusing of gospel,
blues, R&B, rock, and
something else
completely and
gloriously origi-
nal than Little
Richard. So
possessed was
the artist by
the torment-
ing conflict
between the
sacred and
the secular
that he
regularly
renounced his allegiance
to worldly music, once
after seeing the "flames
of hell" in the exhaust of
a prop plane over the
ocean en route to Aus-
tralia. Renouncing his
sinful but immensely
popular music, he threw a
small fortune in jewelry
into the bay off the Syd-
ney Harbor Bridge and
returned to the States to
enroll in an Alabama bible
college. *Ooh! My Soul*,
indeed! Just as often,
however, the deeply
divided Georgia Peach
succumbed to the wiles
of rock and rhythm, lured

Continued top of page 19

When you sing gospel, you have a feeling there's a
cure for what's wrong. When you're through with the
blues, you've got nothing to rest on."

Though she was born and bred a Baptist, Jack-
son's primary musical influence came from the less
stodgy Holiness movement,
which provided a
powerful musical link
between the slave ex-
perience and the music
of the church. Despite
her popular image as a
sedate and serene ma-
tron, Jackson was known
in her early days for rais-
ing the roof and, on occa-
sion, the hem of her robe,
when the spirit possessed

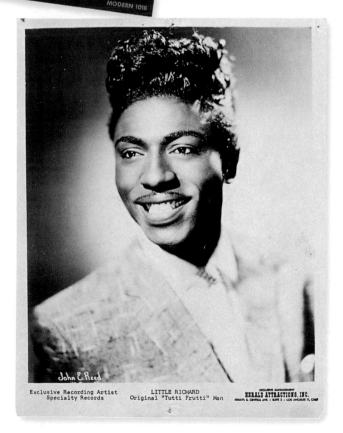

her. In fact, she
was hardly the
picture of deco-
rum when her
famous "snake hips"
got moving, and
found herself barred
from more than one
outraged Baptist
church when she toured
the South with Thomas Dorsey. In
1937, Jackson made her first recording
with Decca's Coral Records, and went
on to record for Apollo before being
signed to Columbia Records by legendary
talent scout John Hammond.

Serving Mammon

Clara Ward and the Ward Singers, who got their start
in the early 1950s, were another milestone on the
gospel road—simply, the most sensational female
act in the history of black gospel music. Clara Ward
began her career with the group at age fourteen and
created instant pandemonium with her galvanizing
gospel style; she moaned and shouted as if the Holy
Spirit had descended. Clara and the singers were
flamboyant in appearance as well, putting torrid
R&B acts to shame with their outlandish gowns and
equally phantasmagoric headgear. So successful
were Clara Ward and her group that she was able to
"clone" the act. At the height of its popularity, as
many as three or four different touring outfits, all
known as the Clara Ward Singers, were on the road
(*the* Clara Ward, however, miraculous though she
was, could only be at one venue at a time).

In the early 1960s, Clara Ward succumbed to
the ultimate show business temptation: she went
Vegas. Her lavish stage production was more a par-
ody than a genuine enactment of gospel style, but the
effect went down well with the card sharks and pit
bosses, and her contract was renewed many times

before she died in 1973. The gospel mantle of the Ward Singers, meanwhile, was held high by Marion Williams, who, after splitting with Clara and the Ward Singers, formed her own super group, the Stars of Faith.

The Meditation Singers, who came to prominence in the early 1960s, were another group whose members cleaved closely to the realms of worldly entertainment. The group at one time included in its ranks jazz/blues great

Della Reese and Chicago-born soul sister Laura Lee, as well as Laura's adoptive mother, Ernestine Rundless, wife of the highly regarded pastor, Reverend E.A. Rundless. The couple had adopted Laura Lee after her mother fell ill and was unable to care for the child. Laura broke away from her gospel upbringing in no uncertain terms with her first recording as a solo artist, the lascivious

Continued from page 18

into the spotlight until, inevitably, the heavenly glare of God's divine judgment sent him fleeing back to the fold. Richard has settled somewhere betwixt and between, a full-fledged minister of the gospel who is not above "screaming like a white lady" when joy of the profane or holy variety overcomes him, as it seems to do with great regularity.

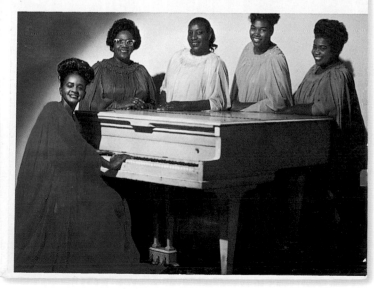

Dirty Man. Thereafter, she became known for her feminist raps, including *Wedlock Is a Padlock*, *Women's Love Rights*, *Rip Off*, and *I Need It Just as Bad as You*. And nobody needed it worse than the Reverend Al Green. The "Green Giant" dallied with Ms. Lee in the 1970s before they both returned to the Lord's fold, à la Little Richard.

Chicago's Staple Singers struck a chord with Mississippi Delta transplants by fusing blues licks with gospel material and creating a sound that ultimately made the leap into popular music. Their breakthrough came in 1956, with the enormous gospel hit *Uncloudy Day* on VeeJay Records. The group was truly a family undertaking, anchored by the tremolo-laden guitar of Roebuck "Pop" Staples and the low-register wailings of daughter Mavis, and, variously, her sisters Cleotha and Yvonne and brother Purvis. When the group took its act into the mainstream, the members maintained a strong link to their sunny gospel message. Their upbeat input is clearly heard in *Respect Yourself* and *I'll Take You There*, even though the former was penned by Sir Mack Rice of funky *Mustang Sally* renown.

Blues and Jazz Variations

While gospel was evolving, blues and jazz were developing along parallel lines, with a roster of early pioneers that set some very high musical standards. Clara Ward may have made gospel history, but the blues also had its fair share of female pioneers, the original of whom was Mamie Smith. In 1920, her voice became the first ever to be heard singing a blues song on a recording. The song, cut for Okeh Records, was *Crazy Blues*, the flip side of which was *It's Right Here for You*. It sold over a million copies—a virtually unprecedented achievement for the time—and it simultaneously launched the singing career of this former vaudeville dancer and signaled blues viability as a marketable aspect of the music business. No fewer than nine other record companies

recorded black female blues singers in the three years that followed *Crazy Blues*, thus opening the door for Negro performers to demonstrate definitively that blacks could move product with the best of their white counterparts.

Among those early blues pioneers was Clara Smith, known in the 1920s as "the World's Champion Moaner" for her lugubrious take on blues themes. Renowned for such maudlin exercises as *Awful Moaning Blues*, she cast herself as a long-suffering and put-upon heroine. An early piece of Columbia Records

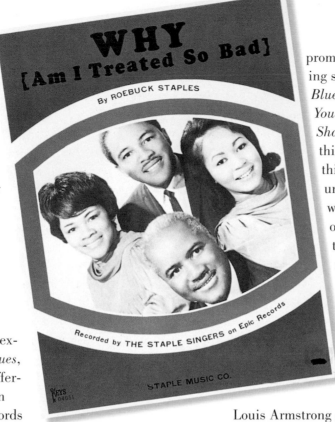

promotional literature, touting such titles as *Percolatin' Blues*, *Cheatin' Daddy*, and *You Don't Know Who's Shakin' Your Tree* put it this way: "Every blues thinks it's full of misery until Clara Smith goes to work on it. Blues, that no ordinary mortal dare tackle, subside into a melodious melody of moans and groans when Clara gets warmed up to her work." Before her untimely death at age forty, Smith had been backed by some of the best, including Louis Armstrong and Coleman Hawkins.

ABOVE & BELOW RIGHT **Gospel staples, the Staple Singers: the family that prays together . . .**

BELOW LEFT **The Drinkard Singers: gospel training ground for the Warwick sisters, Dionne and Dee Dee.**

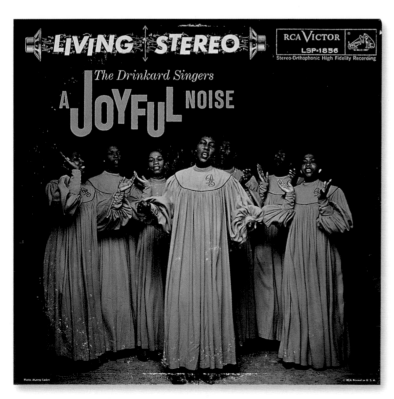

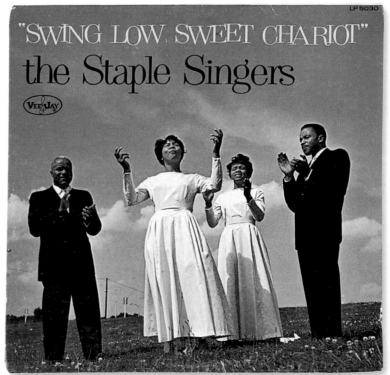

"Ain't Misbehavin'"
Comfortably ensconced on the top rung of early innovators was generous-of-girth Fats Waller, the barrelhouse pianist and gifted composer born in New York City shortly after the turn of the century. The son of a minister, Waller's early churchly upbringing meant he was one of the earliest jazz organists. A technically masterful keyboard virtuoso, he emerged from the *stride school* of piano and was, by any reckoning, a superstar of his day. Waller hosted his own radio show, appeared in numerous films and short subjects, and even produced his own piano rolls.

His instrumental ability was eclipsed by his rollicking persona on and off the stage. Sporting his trademark derby, Waller wrote and sang such immortal jazz classics as *Ain't Misbehavin'*, *Honeysuckle Rose*, *Jitterbug Waltz*, and *Squeeze Me*. So popular was his music during the Roaring Twenties that he was once shanghaied from a Chicago hotel at gunpoint and whisked to Al Capone's East Cicero hideaway where, for three days, he played requests for Scarface at a hundred dollars apiece.

Barons of Rhythm
Waller was a tremendous influence on another jazz icon, William "Count" Basie, who stands at the

ABOVE With her opulent stage outfits and backing by her band, the Jazz Hounds, Smith became the model for countless blues vamps in years to come.

BELOW The Smiths — Mamie and Clara — blues recording groundbreakers.

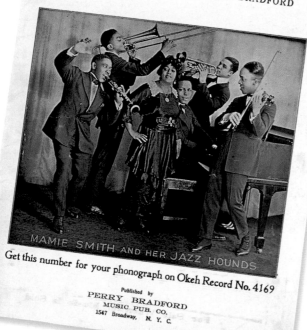

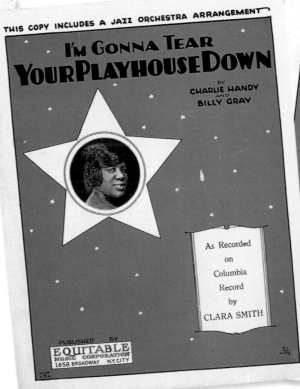

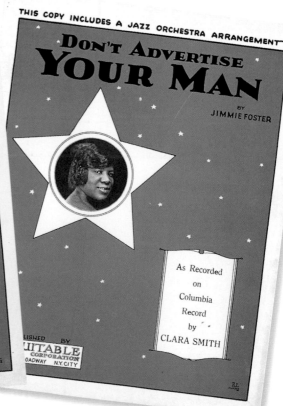

pinnacle of achievement in big band jazz with almost a half century of definitive recordings and performances to his credit. He was born in New Jersey and taught to play piano by his mother. Later, Basie learned to play the organ literally at the feet of Fats Waller, who accompanied silent films at Harlem's Lincoln Theater. Waller invited the young Basie to sit on the floor and work the organ pedals with his hands, eventually giving his apprentice a shot at the keyboard by feigning a pressing appointment and allowing Basie to accompany that day's program. Waller's training stood Basie in good stead when he was stranded in Kansas City, where Basie kept body and soul together by playing organ in silent-film houses.

It was also in Kansas City that Basie formed the Barons of Rhythm, a nine-piece band discovered at the Reno Club by none other than talent scout extraordinaire John Hammond. He heard them on the shortwave radio in his car, parked hundreds of miles away outside the Congress Hotel in Chicago, where his brother-in-law Benny Goodman was in between sets.

Over many years on the international jazz circuit, Basie's bands boasted some of the greatest names in music—Billie Holiday, Clark Terry, Harry "Sweets" Edison, Jo Jones, Lester Young, Buddys DeFranco and Rich, Eddie "Lockjaw" Davis, Thad Jones, Joe Williams . . . the list goes on.

Fats Waller was notorious for his appetites. A prodigious imbiber, he was prone to rewarding his band members for exceptional improvisation with a tumbler full of gin. Naturally, the boss joined in each and every toast. On one occasion, he bought an entire twenty-pound ham for himself at a church fundraiser, along with the "drippings" pan in which it had been cooked, a carving knife, and a gallon of mustard. He once ate twenty-five hamburgers in his bus on the way to Atlantic City. When he arrived, he continued his feeding frenzy with three chickens, three steaks, rolls, potatoes, and, of course, salad for a well-rounded meal.

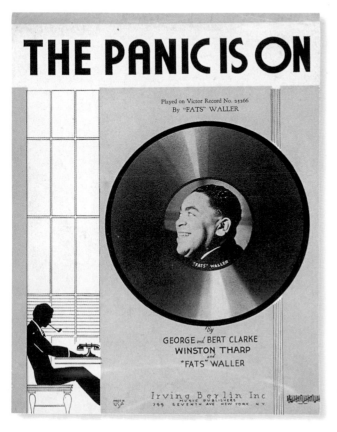

Fats Waller: larger than life.

Sportin' Life

If the Count, the Duke, and others were aristocrats in jazz's court, Cab Calloway was undoubtedly its jester. One of the most colorful entertainers in the annals of American music, Calloway was born in Rochester, New York in 1907, and raised in Baltimore and Chicago. For a time he considered a career as a lawyer before realizing his true vocation as an eye-rolling, zoot-suited, icon-cum-jive cat of everything cool and crazy in black America. His sister Blanche initially made the possibility of a musical career real for brother Cabell when she hired him to play in her band. His catch phrase, "hi-de-ho," was a national sensation, a precursor of later jive jargon ranging from "McVooty" to "word up."

Calloway put a unique spin on everything to which he put his hand and voice. He was the toast of New York's upper crust as the Cab company spent the better part of 1931–32 at the famed Cotton Club after Duke Ellington's outfit moved on. Among his most popular recordings were *Minnie the Moocher*, *Blues in the Night*, and the dope ditties *Kickin' the Gong Around* and *Reefer Man*. With both his big band, the Cab Calloway Orchestra, and his smaller ensemble, the Cab Jivers, he was nothing if not a nimbly adept and thrilling performer.

Calloway further defined a crazed version of pure black style on stage and screen with many theatrical and film roles throughout his career. He served as the model for no less a character than Sportin' Life in George and Ira Gershwin's *Porgy and Bess*, and art imitated life when Calloway himself played the role in a 1950s Broadway production of the enduring opera.

When Calloway was not looming larger than life in the limelight, he was dashing around the country on a bus with the most popular and best-paid touring band in the country. He took the *sport* in Sportin' Life literally, organizing a baseball team composed of his musicians and pitting them against other bands' teams when they crossed paths between dates. At one time, Calloway appointed band member Tyree Glenn as team manager, whereupon Glenn promptly benched the bandleader, because Cab had been

ABOVE Fats' cats: Fats Waller and band.

BELOW Down for the Count: Basie and Co. bringing Kansas City to the world.

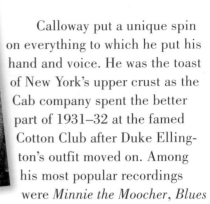

having trouble connecting with the ball. Calloway was outraged, but to no avail. Glenn held firm and the hi-de-ho guy gave the team the heave-ho, selling it, uniforms, bats, balls, and all to the head-strong manager for one cent.

If he wasn't playing baseball, Cab was working off his excess energy in other ways, not all of them benign. Calloway and trumpet player Dizzy Gillespie once got into a fight over a spit-ball that he thought Diz had lobbed at tenor-sax man Chu Berry. Push literally came to shove, and before the band's heftier members could pull them apart, Diz pulled a knife on Cab. Quite a while later, the two patched things up when Cab discovered that the real spitball hurler had, in fact, been Jonah Jones.

In sharp contrast to Cab Calloway was pianist and bandleader Claude Hopkins, another Cotton Club attraction who lacked Calloway's panache and antic energy. Still, Hopkins, who once backed the great Josephine Baker, must be afforded recognition for his smooth melodies and tasty dance music, despite the frenetic title of one of his hits, *I Can't Dance I Got Ants in My Pants*. He once studied

COUNT BASIE
COLUMBIA RECORDS exclusively

medicine, but as far as audiences were concerned, his bedside manner paled next to Calloway's. He did have at least one thing in common with his competitor, however. His mellow moves were documented in a number of films, including *Dance Team*, *Barbershop Blues*, and *Broadway Highlights*.

Group Efforts

If Cab Calloway's name was synonymous with a unique time and place, the music of the Mills Brothers found receptive audiences across an extraordinary span of American musical history. In fact, the quartet recorded more hit material over more years than any other vocal group in history, starting with *Tiger Rag* in 1931 and running through to 1968, when they cracked the Top 40 with *Cab Driver*. But it was only during the first decade of their extraordinary career that the term *brothers* really applied. After the death of founding member John Mills Jr. in 1936, the surviving brothers—Herbert, Harry, and Donald—were joined by their dad, John Sr., making the lineup more appropriately titled the Mills Father & Sons.

Whatever the familial ties, the group crossed

The origin of Basie's nickname has long been disputed. The artist himself claims that he adopted it to match the titles of other jazz greats, including King Oliver, Earl Hines, and, of course, Duke Ellington. John Hammond insisted it was a radio announcer on station WBH in Kansas City who dubbed Basie "Count." But perhaps the most colorful tale comes from band member Eddie Durham, who claims that Basie's first Kansas City boss, Benny Moten, ridiculed his employee as a "no 'count." Durham turned the insult around and made it an ironic in-joke, and the name became permanently associated with the greatest of jazz nobility. Some, including Lester "Prez" Young, considered Basie to be semi-divine. Young often referred to Basie as "the Holy Main," as in *main man*, later shortening this to the reverent "Holy."

paths in the studio with the likes of Bing Crosby, the Boswell Sisters, Ella Fitzgerald, and Louis Armstrong, all of whom were drawn to their patented ability to fashion smooth and supple harmonies, usually accompanied only by a guitar. Their style found receptive ears on both sides of the color line, and the brothers had the unique distinction at that time of drawing as many white fans as black, thanks to the soft and soothing sounds of such perennial Mills Brothers favorites as *Tiger Rag*, *Dinah*, *You Always Hurt the One You Love*, *Glow-Worm*, and *Till Then*; the latter covered successfully twenty years later by the Classics. In 1943, they sold over six million copies of the hit *Paper Doll*, a staggering number for the time and impressive even by today's multiplatinum standards.

Another seminal vocal group that featured a strong distinctive style was the Ink Spots, whose technique has been echoed in virtually every singing ensemble since. Founded in Indianapolis in 1934, the group pioneered the soaring-tenor lead, as perfected by Bill Kenny, and the talking-bass part of Hoppy Jones, subsequently heard in countless

doo-wop hits from the Orioles to the Teenagers to the Stylistics to Boyz II Men and beyond. In 1939, they recorded *If I Didn't Care*, a song that reverberated in pop music history with a melodramatic power completely its own. It was followed by a virtually uninterrupted string of hits until 1951. Among them was *My Prayer*, which was later covered by the Platters, a group that drew directly from the Ink Spots' mellifluous style. At their charting peak in the mid-1940s, the quartet racked up back-to-back number one hits with *I'm Making Believe* and *Into Each Life Some Rain Must Fall*, which topped the chart within a week of each other. They went on to record with Ella Fitzgerald and, even after the demise of all the original members, the group lived on, proliferating into some forty different versions by the 1990s.

Over the next half century, the legacy of the Mills Brothers and the Ink Spots was carried on by a wide assortment of vocal

ABOVE **Hail Cab! The Hi-De-Ho Man in all his glory.**

BELOW **Claude Hopkins, the Doctor of Dance.**

HEART & SOUL

groups that borrowed and refined many of their forefathers' innovations and, in the process, created the foundations of doo-wop, soul, and modern pop genres. Among these groups were the Five Red Caps. Originally from Los Angeles, the group moved to New York and emerged in the mid-1940s with an act that had an instrumental component, although their vocal performance assured their legacy. Among their pre-R&B era hits was *I've Learned a Lesson I'll Never Forget*.

Along with the Five Red Caps, the Orioles are widely considered to be among the originators of the R&B vocal sound. Their approach to four-part harmony resonated for many decades to come. Formed in Baltimore by Erlington Tilghman, who adopted the stage name Sonny Til, the group broke through in a major way in 1948 with *It's Too Soon to Know*, the first of their three number one hits. Ironically, the song that put them on the pop map was one of their last: *Crying in the Chapel*, an ethereal, emotionally resonant piece that was curiously inspiring in its tragic grandeur. Elvis Presley's version was a fitting tribute to the pioneering work of the Orioles.

In a different vein, Billy Ward's Dominoes broke new vocal ground with the hilarious *Sixty*

Minute Man, a musical exercise in sexual braggadocio. In addition to such classics as the *Bells* and *Have Mercy Baby*, the group launched the careers of Clyde McPhatter and Jackie Wilson, thus earning the eternal gratitude of music fans of every description.

R&B's early trajectory was further traversed by Washington, DC's Clovers, who had chart successes on Atlantic Records in the early-to-mid-1950s. They were out of the gate quickly with two number one smashes in 1951, *Don't You Know I Love You* and *Fool, Fool, Fool*, both written by Atlantic founder Ahmet Ertegun, who also penned *Ting-a-Ling*, their chart-topping hit the following year. The Clovers were a vital link between R&B and rock 'n' roll and enjoyed more chart records than any other R&B vocal combo of the 1950s. Their success set the

Sheet music from the Mills Brothers.

stage for the Coasters, the Drifters, and other pop R&B groups that attracted a broad-based following in both the black and teen markets, and helped to usher in the golden age of the a cappella sound of doo-wop.

During a mid-1950s doo-wop bonanza, the East Coast was home to many street-corner groups that included the Nutmegs and the Five Satins, both from Connecticut. Although the success of both groups in terms of overall hits was minimal, their impact is still felt, thanks to the reverential appreciation accorded the Satin's *In the Still of the Night* and the Nutmegs' *Story Untold*.

Blues-prints for Rock 'n' Roll

In the 1920s, the blues were split between the down-and-dirty country-crossroads style of the Deep South, practiced by Lightnin' Hopkins, Muddy Waters, Howlin' Wolf, Little Walter, et al., and the more urbane and sophisticated midwestern variety, championed by Jimmy Rushing, Big Joe Turner, and others. Still, the intensity of the music reveals they were all variations on the same musical and lyrical themes.

Short, round, and fully packed, Jimmy "Mr. 5X5" Rushing was first among equals in the blues-shouter all-star lineup. Although born in Oklahoma, he came to be associated with

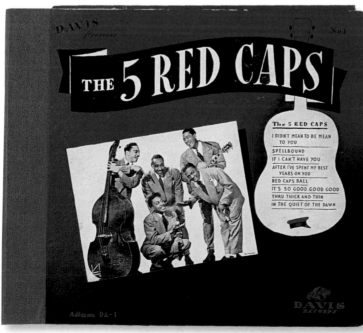

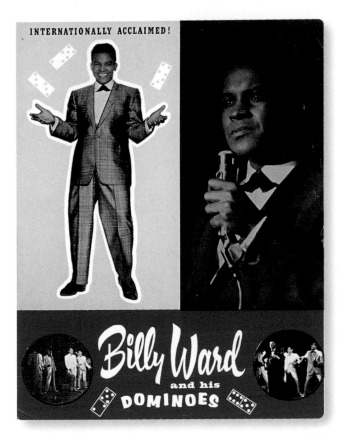

INTERNATIONALLY ACCLAIMED!

Billy Ward
and his
DOMINOES

stage as to his incomparable vocal chops—Rushing could quite literally overpower a whole orchestra by the sheer force of his lung power. A shouter to be sure, Rushing never sacrificed nuance and technique for raw volume, even though he could deliver a song all the way back to the cheap seats. Rushing was known for fronting big bands, including Benny Goodman's and Count Basie's, and it was with Basie's group that he introduced his signature tune, *Sent for You Yesterday and Here You Come Today*.

Rushing was matched in girth and glorious vocal dexterity by another Kansas City blues titan, Big Joe Turner, a singer who was equally comfortable with blues, R&B, and rock 'n' roll. With pianist Pete Johnson, Turner initially made his formidable mark by popularizing the rolling, boogie-woogie sound kicked off by Turner's vocal on *Roll 'Em Pete*. The duo was spirited from Kansas City to New York City by John Hammond for 1937's landmark Carnegie Hall concert, *Spirituals to Swing*, a panoramic overview of black music through the ages.

the late 1920s Kansas City movement spearheaded by Walter "Hot Lips" Page, Benny Moten, and, most important, Count Basie. A legend in his own time— thanks as much to the distinctive figure he cut on

Big Joe stayed in New York, becoming a fixture on the emerging boogie-woogie scene. Having worked with Basie

the ORIOLES
sing
Oh Holy Night
The Lord's Prayer

Jubilee #5045
Jay-Gee Record Corporation
315 West 47th Street
New York 19, N.Y.

the Orioles sing
What Are You Doing
New Year's Eve?
Lonely Christmas

Jubilee #5017
Jay-Gee Record Corporation
315 West 47th Street
New York 19, N.Y.

ABOVE **Ward Healer: Billy Ward and the Dominoes.**

BELOW **The Orioles in a holiday mood.**

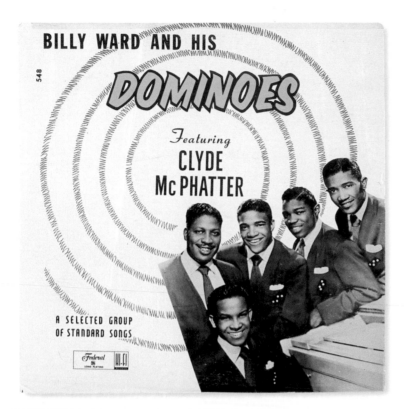

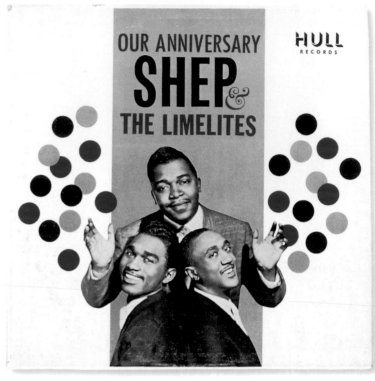

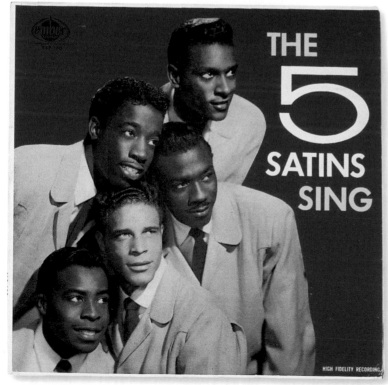

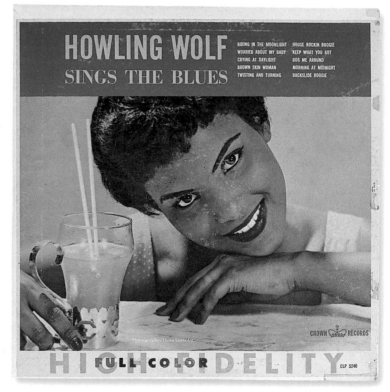

in Kansas City, he linked up for a time with Duke Ellington's Jump for Joy Revue. For Turner, boogie-woogie gave way to R&B, which resulted in a string of substantial hits that included *Honey Hush*, *Chains of Love*, *Flip, Flop & Fly*, *TV Mama (I Got a TV Mama, She's Got a Big Wide Screen)* with Elmore James, as well as 1954's *Shake, Rattle & Roll*, a template for the rock 'n' roll revolution to come. Turner's version was decidedly more earthy than the white-market cover rendition by Bill Haley & His Comets. Compare Big Joe's, *". . . way you wear those dresses, the sun comes shining through. I can't believe my eyes all that mess belongs to you . . ."* to Little Bill's, *"The way you wear those dresses, your hair done up so nice. You look so warm, but your heart is cold as ice."*

If Big Joe's *Shake, Rattle & Roll* was one of the blueprints for rock 'n' roll, then the foundation on which the musical edifice was constructed was laid by Roy Brown. Perhaps more than any other song in the pre–rock era, his 1948 composition *Good Rockin' Tonight*, covered simultaneously by Wynonie Harris, demonstrated the utter abandon and liberating power of the new musical hybrid. It was one of the first R&B records that employed the euphemism for sex play, *rockin'*, as a metaphor for good times in general.

Like many R&B artists, Brown preceded a career in music with one in the boxing ring. A native of New Orleans, he moved to Los Angeles in 1942 while still a teen and gained notoriety as a vocalist rather than a boxer. He hit his peak over the course of three amazing years from 1949 through 1951, during which he dominated the field with thirteen Top Ten singles, including *Rockin' at Midnight*, *Boogie at Midnight*, and *Long About Sundown*. In 1950, he also scored with *Cadillac Baby*, a case, perhaps, of

art imitating life, since the high-rolling Brown was given to touring the country in a fleet of Caddys.

If Roy Brown used *rockin'* to describe all manner of letting the good times roll, there was never any doubt as to what Wynonie Harris was implying. Few artists of any caliber could compete with the pure pandemonium generated by this Omaha native. From his arrival in Kansas City, where he first heard Big Joe Turner, it was clear that Harris was wholly original. No one was more convinced of his genius than Wynonie himself, and his arrogance rubbed many of his contemporaries the wrong way. But that wasn't all he was rubbing: at his libidinous best, Harris could turn any song into an excuse for double entendre. Among his down-and-dirty hit ditties were *Lolly Pop Mama*, *Lovin' Machine*, *Sittin' on It All the Time*, *All She Wants to Do Is Rock*, and *I Like My Baby's Pudding*.

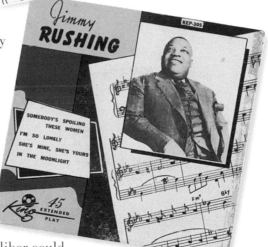

LEFT The Nutmegs telling the story.

CENTER Atlantic's Clovers: champion charters.

BELOW Jimmy Rushing: Kansas City's Mr. 5 x 5.

CLOCKWISE PAGE 30 ABOVE LEFT The Domino Effect: Billy Ward's Crew and their imitators. ABOVE RIGHT The influence of New York's Shep & the Limelights, whose leader, James Sheppard, founded the Heartbeats, is still felt. The Limelights' epochal 1961 hit, "Daddy's Home," in fact, was a very long-distance answer song to the Heartbeats' "Thousand Miles Away," a hit six years earlier. BELOW RIGHT Howlin' Wolf, packaged for the pop market. BELOW LEFT The Five Satins, led by Freddie Paris, recorded New York's all-time favorite oldie, "In The Still of The Night."

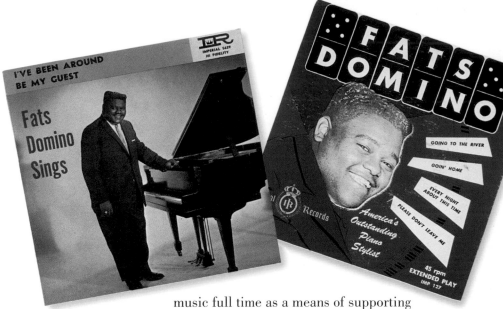

country music after he moved to the West Coast in the early 1940s. In Oakland, Hunter recorded his first hit, *Blues at Sunrise*, backed by Johnny Moore's Three Blazers. In terms of instrumentation, Moore's lineup was a mirror-image of Nat King Cole's legendary trio. At one time it included Moore's brother, Oscar, a guitarist who had earlier served a stint in the Cole ensemble, and keyboardist Charles Brown, who formed his own trio before going solo and scoring with the number one hits *Trouble Blues* and *Black Night* on Aladdin. Despite his finesse on the black and whites, Hunter did not play piano on the *Blues at Sunrise* sessions, deferring to Charles Brown, who was himself something of Hunter's disciple back in their native Texas. The song was released on Hunter's own Ivory label, one of the first artist-owned companies in black music. Another company was Pacific, where Hunter also occupied the executive suite and scored his first number one hit, *Pretty*

music full time as a means of supporting fourteen brothers and sisters. Hunter was initially recorded by folklorist Alan Lomax for the Library of Congress while still a teenager, but Ivory Joe's career was anything but limited to satisfying anthropological interest.

He immersed himself in jazz, blues, and

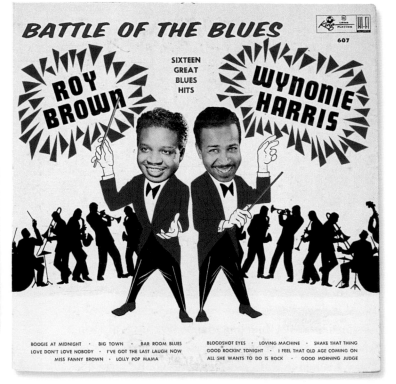

ABOVE The syncopated soul of Fats Domino.

BELOW LEFT Boozie boogie baron Amos Milburn.

BELOW RIGHT R&B's Rhythmic Diversity: jump blues masters Wynonie Harris and Roy Brown.

PAGE 35 The country flavors of Ivory Joe Hunter.

Mama Blues. A year later, he returned with what would become his signature song, *Guess Who?*

Ivory Joe Hunter eventually folded his own recording concerns to concentrate on what he did best: cutting appealing, easy-going pop renditions that carried him through to the next decade on such labels as King, MGM, 4 Star, and Atlantic. His hits included *I Almost Lost My Mind*, *I Need You So*, and his biggest-selling pop record, *Since I Met You, Baby*, which was later covered by a plethora of pop and country artists that included Bobby Vee, Sonny James, Freddie Fender, and Dean Martin.

Hunter again broke ground as one of the first black artists to record country material. One of his biggest hits in this vein was 1949's *Jealous Heart*, which featured Eddie "Cleanhead" Vinson. The saxophonist, who had served a stint in the Milt Larkin Orchestra, dubbed "the Greatest Band of All Time," got his nickname after an ill-conceived hair-straightening attempt took a disastrous turn. Vinson was also a band mate of electric guitar pioneer T-Bone Walker, up from Texas and a favorite on Chicago's South Side. In 1939, Walker, along with the Les Hite Cotton Club Orchestra, added his unique vocalizing and guitar work to *T-Bone's Blues*, one of the most enduring blues standards of the era.

Bandleader John Veliotes, aka Johnny Otis, shared several creative links to Ivory Joe and other West Coast jazz and blues practitioners, including the group, Three Blazers, which featured Otis in the drummer's seat on its 1946 breakthrough *Drifting Blues*. In turn, Otis would spotlight the piano of Ivory Joe Hunter and the sax and shiny pate of Eddie "Cleanhead" Vinson on a dazzling 1970 hit album, recorded live at the Monterey Jazz Festival.

Among Otis's discoveries was Little Esther

Phillips, who lived up to her diminutive billing. Little Esther was thirteen years old when she recorded *Double Crossing Blues* in 1950, backed by Otis's band. The youngest female artist ever to reach the top spot on Billboard's R&B charts, Esther was a Texas native transplanted to Los Angeles. Her real name was Jones, but she adopted her stage handle from a Phillips gas-station sign after she had outgrown the

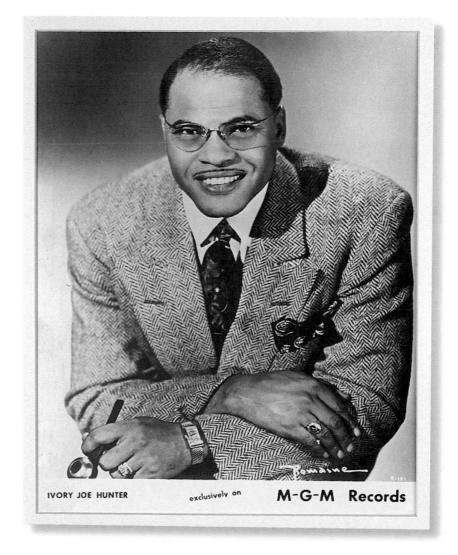

IVORY JOE HUNTER exclusively on **M-G-M Records**

A renaissance
man in the truest
sense, Johnny Otis
was at one time or
another, and often
simultaneously, a
talent scout, singer,
songwriter, record
producer, bandleader,
multi-instrumentalist,
politician, ordained
minister, disc jockey,
painter, sculptor,
cartoonist, farmer,
author, TV host, and label
owner. Greek by birth,
Otis always considered
himself culturally black
and it's easy to under-
stand why. In addition to
writing quintessential
R&B evergreens such as
his own hit *Willie and the
Hand Jive*, he penned
Gladys Knight & the Pips'
first charter *Every Beat
of My Heart*, the Fiesta's
So Fine, and the *Wall-
flower* by his protégé,
Etta James. As a talent
scout and ring leader of
the Johnny Otis Show, he
introduced the world to a
wide spectrum of elemen-
tal R&B talent, including
Sugarpie DeSanto, the
Robins (later to become

Continued top of page 37

Senders in the late 1940s. Also active at the time
was Earl Bostic, a reed man (sax, clarinet, flute) from
Tulsa whose *Flamingo* topped the charts in 1951;
and Tiny Bradshaw, a multi-instrumentalist and
vocalist who made his mark soon thereafter with his
string of King Records hits, among them, *Train Kept
A'Rollin'*, *Walking the Chalk Line*, and *I'm Going to
Have Myself a Ball*. Somewhat later but no less influ-
ential was Bill Doggett, an alumnus of dates with the
Ink Spots, Illinois Jacquet, Louis Jordan, Louis Arm-
strong, and others. His distinctive organ/sax workout
Honky Tonk, also on King, became a kind of smoky
nightclub national anthem.

Before World War II, there was a mighty out-
pouring of not only big band blues but of smaller
combo and solo performers. Most who recorded
were guitarists and vocalist in the country-blues
mode of Robert

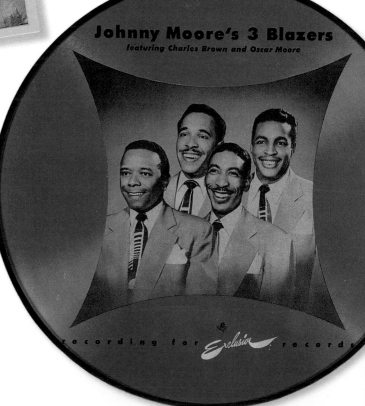

"Little" designation. Her
career and life were truncated by chronic
drug abuse, but before her tragic death in 1984,
she received a unique tribute from Queen of Soul
Aretha Franklin, who passed along her 1972
Grammy Award to Esther for her work on the
album *From a Whisper to a Scream*.

Among bandleaders who had variously
influenced the origins and development of pre–rock
'n' roll black musical forms was Roy
Milton, a drummer who scored hits with *R.M. Blues*,
Hop Skip and Jump, and *Hucklebuck* with the Solid

Johnson, but in the late 1920s, Leroy Carr emerged as a pianist par excellence. With guitarist Scrapper Blackwell, he gave the blues a more refined voice both vocally and instrumentally. He died young and was mourned by his vast following, but there was someone in particular who felt the passing acutely. Bill Gaither literally renamed himself "Leroy's Buddy" and recorded a tribute to his idol entitled *The Life of Leroy Carr*. Ironically, Buddy was not a pianist, but a guitarist. To do justice to his mentor's style, he recruited various keyboardists to try and fill Carr's bench seat.

———■———

The postwar period of American musical development saw the large ensemble orchestras and their flamboyant leaders fade as the torch of the blues was picked up by small groups. Their emphasis was on the Delta-rooted country sound, now electrically amplified for urban audiences. In fact, vocal and instrumental amplification gave new life to this raw variant in an urban setting: four dedicated bluesmen could now make as much joyful/mournful noise as a whole tuxedoed orchestra. In the process, after nearly thirty years of variations on the blues theme, music once again returned to its country point of origin.

Continued from page 36

the Coasters), the Midnighters, Etta James, Little Esther, and Linda Hopkins. He produced *Hound Dog* by Big Mama Willie May Thornton and *Pledging My Love* by the martyred Johnny Ace.

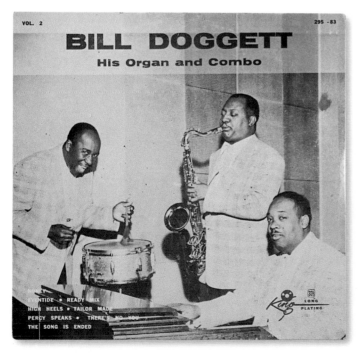

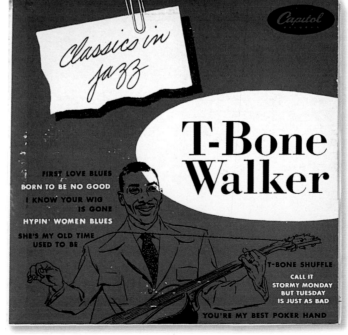

PAGE 36 Three Degrees of Separation: the Blazers and Eddie "Cleanhead" Vinson, all backed Ivory Joe Hunter.

ABOVE & BELOW RIGHT Prime Cuts: T-Bone Walker and Les Hite.

BELOW LEFT The honky tonkin' Bill Doggett.

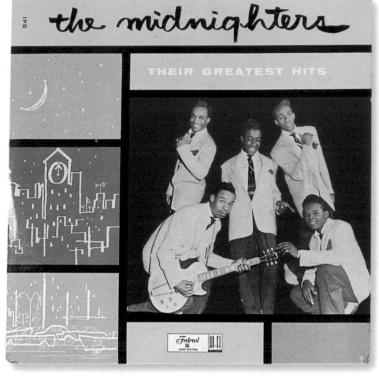

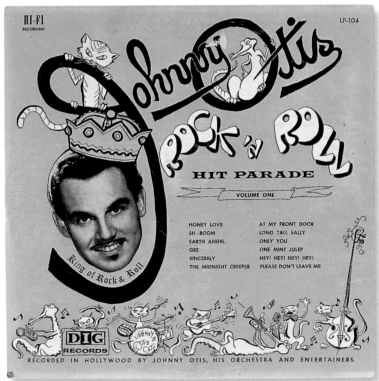

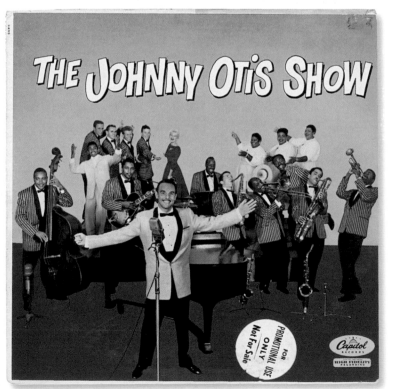

Muddy Waters

Standing squarely at this musical crossroads was McKinley Morganfield, aka Muddy Waters, a guitarist and songwriter who deserves a place on music's Mount Rushmore for his contribution to America's music culture. After leaving Mississippi for Chicago in 1943, he plugged in and updated the Delta sound of his mentors, Robert Johnson and Son House, in a monumental body of work, most of which was cut for Chess. Blues greats who at one time or another played in a Muddy Waters band include Jimmy Rogers, Earl Hooker, James Cotton, Junior Wells, Little Walter, Willie Dixon, Memphis Slim, and Otis Spann. Muddy Waters's recordings of such enduring classics as *I Got My Mojo Working*,

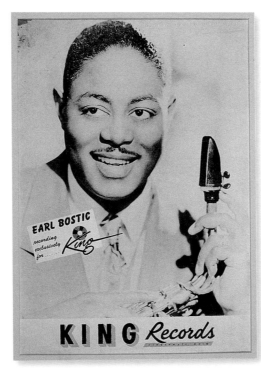

Mannish Boy, Honey Bee, Long Distance Call, and *I'm Your Hootche Cootche Man* inspired thousands of renditions by bar bands and supergroups alike, white and black, from London to Clarksdale. Where, for example, would the repertoires of Eric Clapton, the Rolling Stones, Stevie Ray Vaughan, and Jimi Hendrix be were it not for the commanding presence and unadulterated primal urgency of Waters's weighty vocals and guitar?

Lightnin'

Coming from a somewhat different tradition, Lightnin' Hopkins named Texas bluesman Blind Lemon Jefferson as his earliest influence. He met and

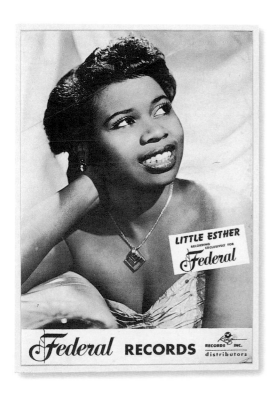

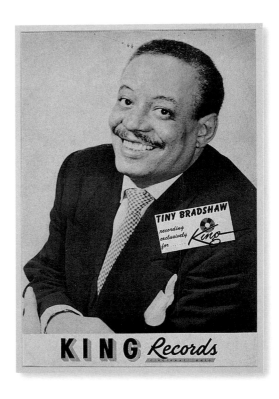

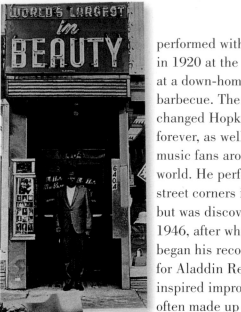

performed with Jefferson in 1920 at the age of eight at a down-home Texas barbecue. The experience changed Hopkins's life forever, as well as those of music fans around the world. He performed on street corners in Houston, but was discovered in 1946, after which he began his recording career for Aladdin Records. An inspired improviser, he often made up lyrics as he went along, even in the recording studio. During the course of his more than sixty-year career, until his death in 1982, Hopkins eschewed royalties and insisted on recording each song for a flat fee. This policy accounted for the plethora of labels that claimed him on their respective rosters.

Because his sense of timing and rhythm was unique and specific to him, most of Hopkins's recordings were solo performances. Bands simply found it nearly impossible to follow him. For example, Dusty Hill and Frank Beard, who later comprised ZZ Top's rhythm section, were employed early in their professional careers to back Hopkins. Wanting to be

Blues lights, Muddy Waters and
Lightnin' Hopkins.

accommodating, they inquired of the elder statesman as to where the changes would fall in the songs. Hopkins's response? "Lightnin' change when Lightnin' want to change."

The same could well be said for the blues itself. 🎵

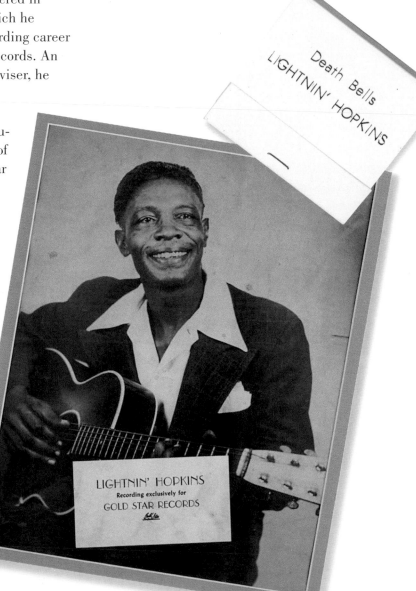

Chapter 2
TEEN TYPES

Litte Stevie Wonder: the key was 'C'.

TEEN TYPES

I see the lights, I see the party lights.
They're red and blue and green.
Everybody in the crowd is there,
but you won't let me make the scene . . . —Claudine Clark,

Party Lights

Mama listen: Claudine Clark's teen lament.

When Claudine Clark sang her plaintive teen lament in 1962, taking the song into the national Top 10, the song's message reached restless teenagers of every race. The response of America's youth to music by the black R&B artists who were a major presence on the pop charts throughout the 1950s was in some ways unprecedented, and it is tempting to view it as echoing, or at least resonanting, the civil rights movement that was gaining momentum in the 1950s. Whether or not such a connection can be made, the scale of black music's entry into the pop charts was certainly new.

After World War II, American popular music had been strictly segregated, as was nearly every other segment of American society. Major record labels, interested in exploiting the black music market, created labels specifically for black performers, among them RCA's Bluebird, Capitol's Black & White, and Columbia's Okeh. So great was the response of African Americans to black performers that Atlantic was able to build its reputation on a roster comprised almost entirely of black artists.

At this time, the mainstream music favored by white Americans was a holdover from the Big Band era. Artists such as Frank Sinatra, Doris Day, Eddie Fisher, Patti Page, and Vaughan Monroe emerged as solo performers, capitalizing on their fame as swing-time front men and women. Bland, and terminally mellow, this music retained its popularity across

generations until the 1950s, when the response to popular music, formerly split primarily along racial lines, began to reflect differences between parents and their children as well.

By the mid-1950s, the term *teenager* had entered the national lexicon, and this age group had become an important economic force that record companies were eager to capitalize on. Teen idols such as Pat Boone, Georgia Gibbs, and the Crew Cuts, who often mimicked black musical stylings, were packaged to appeal to the teenage market. At the same time, however, teenagers were also irresistibly drawn to the *backbeat*, responding, even if unconsciously, to rock 'n' roll's ability to break the color barrier in popular music. As this music gained its first foothold on the stale pop charts of the time, parents panicked and ministers and politicians decried the degenerate influence of the "jungle beat." In the decade of Cold War paranoia and

McCarthyism, rock 'n' roll's resistance to traditional musical categories and its blurring of racial divisions were viewed as anarchic and subversive. To make matters worse, the nation's white children were flocking to the music's clarion call!

Towering Pompadours

Supported by their passionate young followers, genuine rock 'n' roll pioneers were achieving celebrity status. Fats Domino, an overweight, middle-aged black man evoking the "thrill" to be found "on Blueberry Hill," elicited shrieks of delight from white teens.

There is no more compelling evidence of rock 'n' roll's barrier-breaching power than the Del-Vikings, the first racially mixed group to enjoy significant commercial success. Formed while its members were serving stints in the Air Force, the Del-Vikings' enduring musical contribution, *Come Go with Me*, was a Top 5 single in 1957, with a chart run of thirty-one weeks and over a million in sales. The follow-up, *Whispering Bells*, helped secure their place as doo-wop icons.

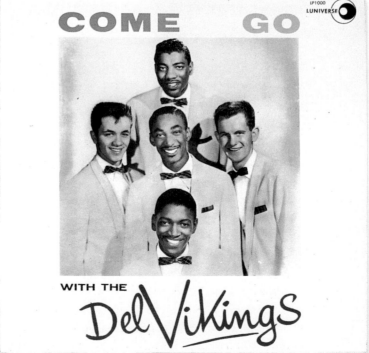

ABOVE & BELOW RIGHT the Del-Vikings: R&B's first integrated group.

BELOW LEFT Richard and Pat: battling for the soul of rock 'n' roll.

Little Richard, an eye-popping black man with pancake makeup, a towering pompadour, and a trembling falsetto, got the sons and daughters of the middle class all hot and bothered by suggesting that Miss Molly "sure likes to ball." And, perhaps most threatening to the white majority, R&B wailers and shouters like Big Joe Turner, Screamin' Jay Hawkins, and Jackie Wilson were viewed as teenage sex symbols. Wilson especially was able to arouse instant hysteria on both sides of the color line on the strength of just two "lonely teardrops."

Hot Dogs for Songs

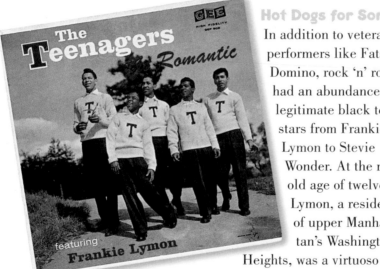

featuring **Frankie Lymon**

In addition to veteran performers like Fats Domino, rock 'n' roll had an abundance of legitimate black teen stars from Frankie Lymon to Stevie Wonder. At the ripe old age of twelve, Lymon, a resident of upper Manhattan's Washington Heights, was a virtuoso soprano fronting a vocal group named the Premiers. By 1955, when they landed their recording contract with George Goldner's Gee Records, the group had become the Teenagers, further evidence of the term's value as a marketing tool.

At age ten, Lymon began working as a pimp in Harlem, but his street savvy was of little help to him in negotiating the dark byways of the mob-dominated music business. Legend has it that Gee Records rewarded Lymon's efforts on the group's first Top Ten hit, *Why Do Fools Fall In Love?*, with a hot dog purchased from a street vendor. Whether or not this tale is true, its widespread circulation underscores the reality of the often-ruthless exploitation of black artists in the early days of rock 'n' roll.

New York's fabulous Frankie Lymon.

Stevie Wonder was a Michigan native whose stage name, "the Twelve-Year-Old Genius," was a direct reference to Ray Charles, another blind multi-instrumentalist and R&B icon. Born Steveland Morris, he began playing harmonica, piano, and drums almost in the cradle and was drawn into the Motown orbit at age ten by the Miracles' Ronnie White. Dubbed "Wonder" for his miraculous musical intuition, his effect on teenagers can be heard in the cries of pure delight audible on the live recording of his breakthrough 1963 hit, *Fingertips Part 2*, which was number one on both R&B *and* pop charts. *Fingertips* was the first live recording ever to top the charts, and a careful listen to the track recorded at Chicago's Regal Theater as part of the Motortown Revue also reveals the perplexed bass player, Larry Moses, frantically inquiring, "What key, Little Stevie, what key?" (For the record, it was C.)

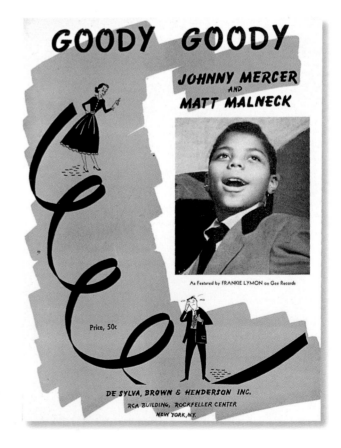

GOODY GOODY

JOHNNY MERCER AND MATT MALNECK

As Featured by FRANKIE LYMON on Gee Records

Price, 50¢

DE SYLVA, BROWN & HENDERSON INC.
RCA BUILDING, ROCKFELLER CENTER
NEW YORK, N.Y.

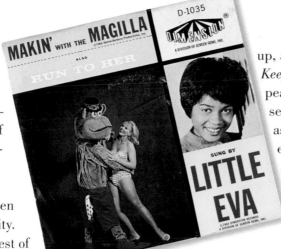

While Wonder's longevity as a hit music maker is a matter of record—quite literally, many records—most black teen stars had brief careers. Like their white counterparts, most of these novas shone brightly long enough to produce one or two hits and then faded into their former obscurity. Among the brightest and briefest of those lights was Eva Narcissus Boyd, aka Little Eva.

Discovered by songwriters Gerry Goffin and Carole King, Eva was initially hired to baby-sit for the couple's daughter, Louise. However, when the two discovered Eva's musical talent, they tapped her to sing *The Loco-Motion*, a Goffin/King dance tune. The song rocketed up the charts when the aptly named Little Eva was sixteen years old. Her follow-

up, another Goffin/King original, *Keep Your Hands off My Baby*, peaked before Eva reached her seventeenth birthday. And that, as they say, was that. With the exception of the misbegotten *Let's Turkey Trot*, Little Eva's entire career, soup to nuts, was over in a little more than six months.

Will You Still Love Me Tomorrow?

In contrast to Little Eva, the Shirelles—Shirley Owens, Beverly Lee, Doris Kenner, and Micki Harris—were among the more enduring of Goffin/King's clients. A teacher found the girls singing together at the high school gym in their hometown, Passaic, New Jersey, and encouraged them to enter a local talent contest. Subsequently, Mary Jane Greenberg discovered the quartet and brought them to her mother,

ABOVE & BELOW RIGHT **Brill Building babysitter.**

BELOW LEFT **Little Stevie Wonder: The Twelve-Year-Old Genius.**

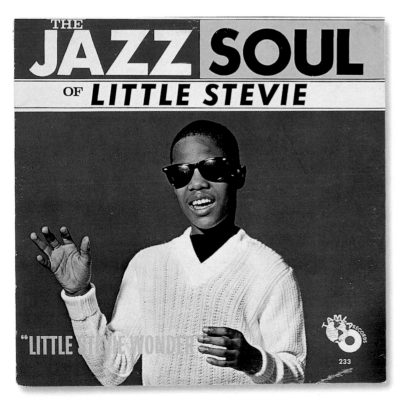

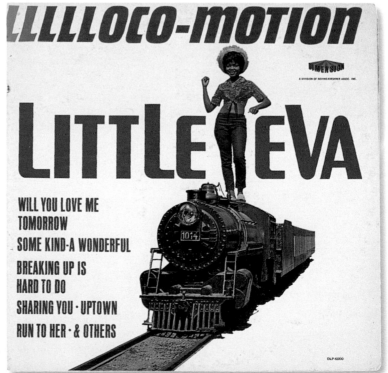

music entrepreneur Florence Greenberg. Greenberg signed them in 1957 and sent them on the road on the "chitlin' circuit," a tour routing that included nightclubs, dance halls, and theaters in the Deep South and inner cities of the North. The girls were so young that their parents insisted on chaperones; the older and considerably more worldly Etta James and Ruth Brown were given the job—dubious choices at best.

The Shirelles recorded many of the era's most memorable paeans to teenage angst—

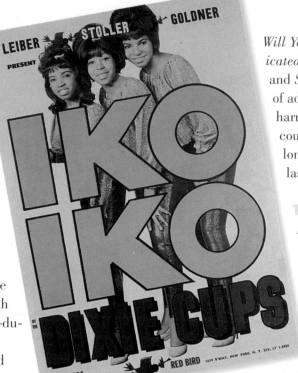

Will You Still Love Me Tomorrow, *Dedicated to the One I Love*, *Mama Said*, and *Soldier Boy*—a veritable catalog of adolescent yearning in four-part harmony. Unlike most of their teen counterparts, the quartet had a long and successful career that lasted well into the 1970s.

The Dixie Cups

A group every bit as delightful as the Shirelles, although they had a much shorter career, was the Dixie Cups, discovered by Joe Jones, a former valet for B.B. King and hit artist in his own right (*You Talk Too Much*). New Orleans-born and bred, the Dixie Cups—sisters Barbara Ann and Rosalie Hawkins and cousin Joan Marie Johnson—were enrolled at Booker T. Washington High when they were persuaded to sign with Red Bird Records in New York. Their brief and brilliant career lasted all of twelve months, but included such girl-group perennials as *Chapel of Love*, *People Say*, and the New Orleans "national anthem" *Iko, Iko*.

Gregorian Chants at the Apollo

The pristine, clean-living Chantels served as role models for countless girl groups that followed them. The girls were, in fact, preteens when their singing careers got under way in the locker room of St. Anthony of Padua, a parochial school in the Bronx. The time was the early 1950s and the five Catholic girls—Lois Harris, Sonia Goring, Jackie Ladry, Rene Minus, and the legendary Arlene Smith—made their debut at nearby P.S. 60, sharing the stage with the Crows and the Sequins. Having learned their licks singing Gregorian chants, the Chantels created harmonies having an ethereal quality, which became their trademark. They made their professional debut

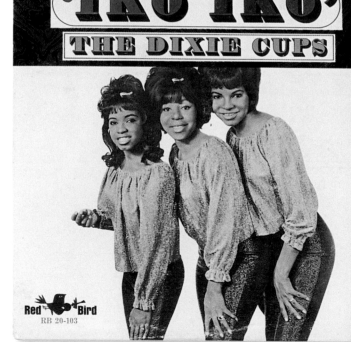

Dixie Cups: pouring on the charm. American Can, which then owned the Dixie Cup Company, at first refused to yield their trademark to the girls but ultimately relented.

PAGE 47 The Chantels: the pride of St. Anthony of Padua.

46

HEART & SOUL

WE ARE THE CHANTELS

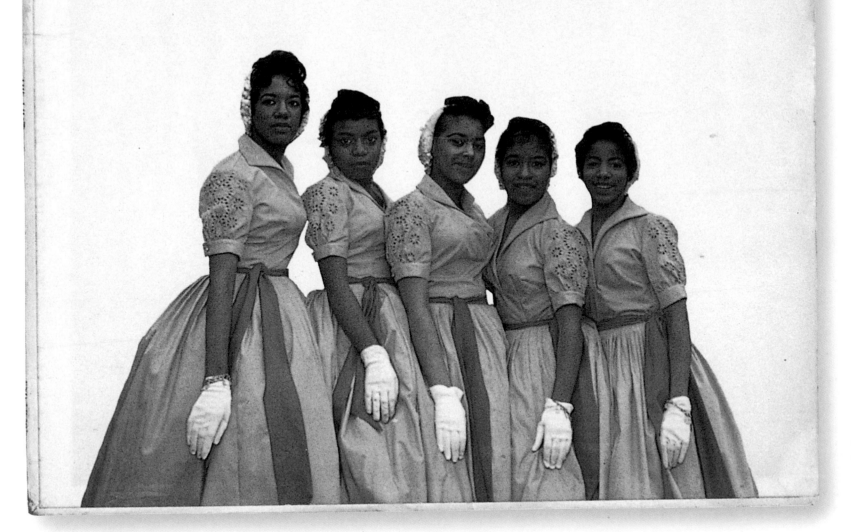

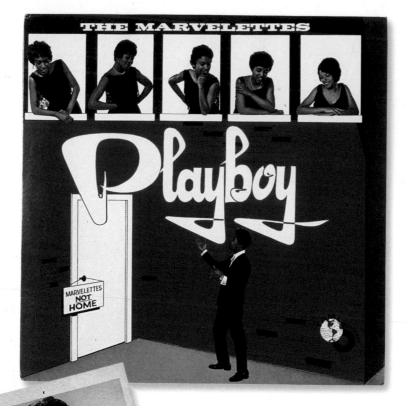

THE MARVELETTES

Playboy

MARVELETTES NOT HOME

Tamla label, and fronted by room-rumbling lead singer Gladys Horton, they scored their first chart topper with *Please Mr. Postman*, which was Motown's first number one record. The Marvelettes predictably followed the success of their debut hit with *Twistin' Postman*, which neatly combined the appeal of a sequel with a nod to the prevailing dance craze of 1962.

While the message of the music dealt with universal teenage concerns—boys, girls, dating, parental and peer approval—the fact that it was being delivered by artists on both sides of the racial divide set a tone for the civil rights struggle and battle over integration that was to come. Ironically, the "jungle music" disparaged by the self-proclaimed guardians of propriety and the old order was, in fact, bringing kids together through a common bond—the trials and triumphs of post–adolescence. 🎵

at the Apollo for legendary New York rhyming deejay, Jocko Henderson. Jocko and Richard Barrett (leader of the Valentines) conspired to shoehorn the unbilled group between acts, thus introducing an unsuspecting world to one of the most heavenly female vocal groups of all time. And it was Barrett who got the girls out of the vestry for good and onto the radio to sing *Maybe*, one of the era's definitive R&B ballads.

Considerably *less* heavenly were Inkster, Michigan's own Marvelettes, a group that racked up over twenty hits on both R&B and pop charts with a style that was as raw and unpolished as the Chantels' was sweet and pure. The Marvelettes were signed to Motown's Tamla subsidiary after a strong showing in a talent contest at their Inkster alma mater. Under the

THE MARVELETTES

The Marvelettes: "postman" rang twice.

HEART & SOUL

Chapter 3
Soul Men

James Brown.

SOUL MEN

I'm a soul man, I'm a soul man,
I'm a soul man, I'm a soul man . . . — Sam & Dave, *Soul Man*

Sam & Dave, shouting the refrain of their Isaac Hayes and David Porter-penned 1967 hit, *Soul Man*, were sending a gritty and glorious message of self-affirmation that was as timely a statement of emerging black consciousness as any sit-in or freedom march. And what better medium for their message than *soul music*, a blend of blues, gospel, and R&B, comprising in equal parts the stirring call-and-response of slave-era field hollers, the testifying fervor of the black Baptist church, and the down-and-dirty blues lament of the southern roadhouse.

But can the origin of the term that so aptly describes this remarkable music ever really be identified? It has been suggested that it sprang from sources such as Sam Cooke's early gospel group, the Soul Stirrers, or a vintage 1950s jazz outing from Ray Charles and Milt Jackson titled *Soul Brothers*. The etymology is ultimately less important than those who gave it voice, but here again, creationist myths abound. Was it Solomon Burke, an erstwhile preacher and mortician who first raised the roof? Or Brother Ray, who posited yet another of his formulas on the album, *Genius + Soul = Jazz*? Whoever the father of soul music might have been, by the mid-1960s, the brotherhood had grown to include some of black music's greatest performers—soul men, one and all.

The explosive Sam & Dave: Stax's powder-keg.

Mr. Dynamite

First among equals must be the self-proclaimed and, to date, undisputed number one soul brother, James Brown. Like many other soul practitioners, Brown's roots reach down into the fertile soil of the church . . . and the cathouse. Raised in his aunt's brothel in Augusta, Georgia, the young Brown's first professional duties included spirited sidewalk dancing intended to lure GIs from a local army base into becoming "underwriters" for his aunt's enterprise. From there, he served time in a reform school before setting out on a much narrower path by joining the Gospel Starlighters. The group, which also boasted future Brown major-domo Bobby Byrd, subsequently morphed into the Flames, transforming their petitions to the Almighty into a prayer for an "all-nightie" in *Please, Please, Please*. This James Brown original was first cut in 1956, and reached the Top 5 on R&B charts thanks to his trademark emotion-and-sweat-drenched delivery. It was also the origin of Brown's oft-parodied *cape routine*. In a drama that would play itself out many times during the course of a single concert, Brown, supposedly overcome by torturous emotional and physical cravings, would drop prayerfully to his knees unable to continue. Only when his seconds, the Famous Flames, draped a velvet cape across his shoulders and led the shambling singer from the stage would he again find the strength to continue. Whatever the stuff James Brown strutted, it spelled histrionic and historic success, including over

The "hardest workin' man in show business" on the job.

51

Soul Master James Brown.

114 appearances on the Billboard chart (more than any other black artist). No wonder Brown called himself "Mr. Dynamite." He was adept at applying his gritty soul style to virtually any topic, as when he waxed political during Nixon's downfall with *Funky Watergate, People It's Bad*. The superstar's hairstyles have also been a reflection of the social and cultural changes of his epoch. From processed pompadour to natural, from bouffant to afro, from Beatle bowl-cut to his characteristic cascade, his coiffure has been as inventive and entertaining as his music.

Brown's interest in style extended to a fondness for certain revealing fashion trends, immortalized in the leering *Hot Pants (She Got to Use What She Got, to Get What She Wants) (Part One)*, which also features another common characteristic of Brown's compositions. Brown's relentless riffing necessitated a record number of two-part singles, among them, *I Got Ants in My Pants (and I Want to Dance) (Part One)*, *Get Up (I Feel Like Being Like a) Sex Machine (Part One)*, and *Papa Don't Take No Mess (Part One)*.

As inspirational a dancer as he was a vocalist, Brown often created dance songs and the steps that went along with them. Case in point, the Popcorn, one of many dances Brown invented and promoted. In fact, he had four separate Popcorn-themed chart hits, although few besides the artist himself knew the specific moves. *The Popcorn* was followed by perhaps the mother of all Popcorn songs, *Mother Popcorn (You Got to Have a Mother for Me) (Part One)*, which, in turn, yielded to *Low-down Popcorn, Popcorn Road*, and, lest we forget, *Let a Man Come In and Do the Popcorn (Part One)*, which resulted, inevitably, in *Let a Man Come In and Do the Popcorn (Part Two)*.

Incredibly, all of James Brown's Popcorn cycle was completed in six short months in 1969, with each selection charting on both R&B and pop (!) charts.

Brown's incredible charisma often took his fans over the edge of decorum, not to mention sanity. On one occasion, hankering for a taste of real Oakland barbecue, Brown sauntered into an East Bay pit stop, only to be held hostage by the enamored proprietress, who locked him in the eatery until she could roust her daughter to come and bear witness to the divine visitation.

With such compelling, if disturbing, displays of adoration from fans, it is small wonder that the James Brown who once proclaimed, "Jump back, I wanna kiss myself," could never be content with a single acclamation of his super-funky magnitude. At one time or another, he proclaimed himself "Soul Brother Number One," "Mr. Dynamite," "the

James Brown proving there is no generation gap in soul.

Godfather of Soul," "the New New [not a typo] Minister of Super Heavy Funk," and, of course, "the Hardest Working Man In Show Business."

Mr. Libido

One who challenged James Brown's soul status was the sometimes-risqué Joe Tex, the man who extolled *Skinny Legs and All*, counseled the *Love You Save May Be Your Own*, and commanded *Show Me*. In fact, Tex originated the microphone stunt made famous by Brown and later used by the Rolling Stones' Mick Jagger, where the stand is purposely kicked over, then caught one-handed at the last moment as the singer dropped to his knees. A sharp rivalry between Mr. Dynamite and Mr. Libido inevitably developed, which perhaps accounts for Brown's choice of Tex's *Baby, You're Right* as one of his rare covers.

Born Joseph Arrington Jr., Tex took on the abbreviation of his native state as a stage name, but his name changes didn't end there. Following the suc-

cess of *I Got 'Cha* in 1971, Tex became a Black Muslim and adopted the name Joseph Hazziez, although it has been suggested that a more fitting Islamic name would have been *Joe X*. However, after the death of Nation of Islam founder Elijah Muhammed in 1975, he lustily reverted back to Joe Tex and scored mightily with the hit, *Ain't Gonna Bump No More (with No Big Fat Woman)*, a fitting coda to his *Skinny Legs and All*, albeit ten years in the making.

Mr. Excitement, Mr. Delightment

While the number one spot in the soul pantheon will be forever occupied by James Brown, the assignment of subsequent slots is subject to opinion and partisan fervor. Among the prime contenders is Jackie Wilson, whose larger-than-life persona and astonishing stage presence in many ways made him a precursor of Brown and a true protosoul pioneer. His earliest influences included Al Jolson and Mario Lanza, telling indications of the melodramatic bent of his

LEFT **Joe Tex taught James Brown a new trick.**

RIGHT & PAGE 55 **Jackie Wilson delighted Dominoes fans.**

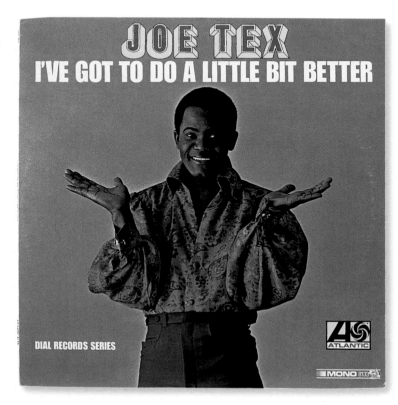

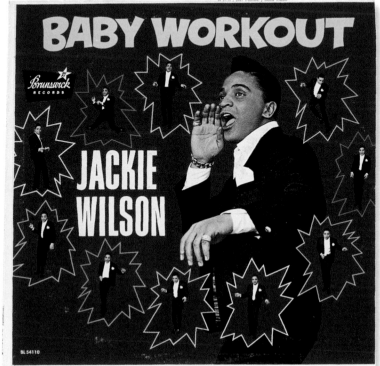

BILLY WARD AND HIS
DOMINOES

Featuring —

Clyde McPhatter and Jackie Wilson

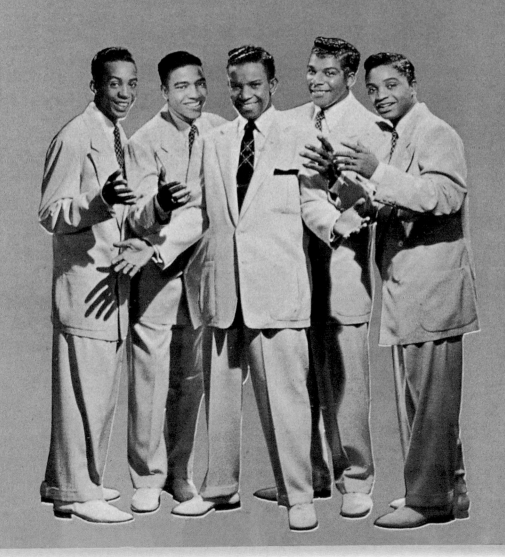

A SELECTED GROUP
OF STANDARD SONGS

TENDERLY

OVER THE RAINBOW

LEARNIN' THE BLUES

WHEN THE SWALLOWS COME BACK
TO CAPISTRANO

HARBOR LIGHTS

THESE FOOLISH THINGS

THREE COINS IN THE FOUNTAIN

LITTLE THINGS MEAN A LOT

RAGS TO RICHES

MAY I NEVER LOVE AGAIN

LONESOME ROAD

UNTIL THE REAL THING COMES ALONG

own developing style, which was punctuated by yelps, whines, and choking sobs. In 1953, this Detroit native with the obligatory gospel credentials heard a rumor that Clyde McPhatter was about to quit Billy Ward's Dominoes. At age nineteen, Wilson, claiming he could sing rings around the departing McPhatter (who did, in fact, leave shortly thereafter to form the Drifters), was hired on the spot. Three years and a number of hits later, he left the group to pursue a solo career; it was then that Wilson's soul juices really began to simmer.

He joined forces with fellow Detroiter Berry Gordy, who, like Wilson, had been a boxer. Gordy composed a number of Wilson's better-known hits, the first of which, *Reet Petite*, found Wilson doing a fairly convincing vocal impression of Elvis Presley. The admiration apparently was mutual as Elvis later identified Wilson as one of his favorites.

The Gordy-Wilson cornucopia spilled forth with the fruit of early soul, including *Lonely*

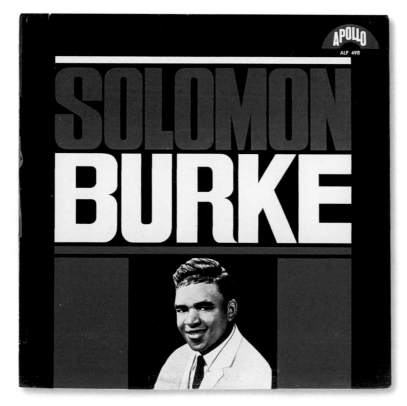

Solomon Burke: soul pioneer and concessionaire.

Teardrops (produced by Gordy), *That's Why (I Love You So)*, and *I'll Be Satisfied*. However, when Gordy struck out on his own to lay the foundation of his Motown empire, Wilson was unable to follow, hampered by an onerous lifetime contract with the shady Brunswick label.

At the height of his appeal Wilson had an extraordinary effect on women. Known as Mr. Excitement, Mr. Delightment, he more than lived up to his billing, favoring skintight mohair and silk stage garb, and eliciting ecstatic screams from his adoring fans. Caught up in the libidinous undertow during one late-1950s appearance at Philadelphia's Uptown Theater, Wilson followed the trademark removal of his jacket by stripping off his shirt and pants and finishing the concert in shorts and socks.

Despite his lust for life and the joyous musical expression this enthusiasm resulted in, Wilson ended his days in tragedy. In 1975, while on stage at Cherry Hill, New Jersey's Latin Casino, Wilson collapsed from a heart attack, hitting his head and falling into a coma from which he never emerged. Sharing the stage that night was another oldies act, Dion (and the Belmonts) Demucci, whose efforts to revive Wilson saved his life, for what it was worth. Wilson died nine years later, never having had the chance to perform or record again. But Wilson's spirit lived on through his music. Reissued in the U.K. almost three years after his death, *Reet Petite* became a number one hit and sold almost a million copies.

King Solomon's Temple

Another contender for the Soul Hall of Fame would have to be Solomon Burke. A singer and songwriter who certainly owed more to the church than to the blues for his soul stylings, Burke's first experience before an audience was at age nine as the 'Boy Wonder" preacher. He headed his own freelance denomination, Solomon's Temple, the House of God for all People, which he claimed was founded by his

grandmother over twenty years before in anticipation of the advent of his birth.

Burke was arguably the first artist to earn the title "soul singer." By the early 1960s, when he was signed to Atlantic Records by visionary artist and repertoire (A & R) man Jerry Wexler, soul had become part of the musical lexicon. Burke certainly personified the newly minted genre with such hits as *Just Out of Reach (of My Open Arm)* (previously a country charter) and *Everybody Needs Somebody to Love*, a song written by Wexler, Burke, and producer Bert Burns, and later covered by Wilson Pickett and the Rolling Stones. The Stones also covered two other Burke perennials, *Cry to Me* and *If You Need Me.*

As with his music, Burke's private life was of

legendary proportions. A man of astounding girth and seemingly ever-expanding appetites, Burke is the acknowledged father of twenty-one offspring, a significant number of whom to this day find gainful employment backing him on stage. In addition to his careers as a performer and preacher, Burke has managed to maintain several non-show-business concerns, including a chain of mortuaries and a snow-removal service in his native Philadelphia. At one time, he even commandeered the popcorn concession at the Apollo from a flummoxed theater manager who had given him the right to sell merchandise carrying his likeness and name, never suspecting Burke would test-market Solomon Burke Popcorn within the confines of the fabled Harlem showplace.

ABOVE **The Falcons: a flock of great soul stars.**

BELOW LEFT **The perennial "Isley Guys."**

BELOW RIGHT **O.V. Wright: beauty's only skin deep.**

Wicked Pickett

Despite his reputation as the wicked Pickett, Wilson Pickett had a thriving gospel career before his soul sojourn. From picking cotton at age four, he went on to sing in a number of gospel ensembles, including the Sons of Zion, the Violinaires, and the Spiritual Five. After moving to Detroit from his native Alabama, Pickett was drawn to worldly music and joined the Falcons, a group that included Eddie "Knock on Wood" Floyd and Sir Mack Rice. As the Falcons' lead, Pickett can be heard on the 1962 single *I Found A Love*.

Mustang Sally, however, has been Pickett's enduring signature tune. Composed and recorded by Rice in 1965, the song helped boost sales of Ford's famous pony car, as well as Pickett's reputation as a certified soul great. *Midnight Hour*, likewise, is a song that will be forever connected to Pickett and the Memphis musical style made famous at Stax Records. In fact, it is the Stax house band, Booker T. & the MGs, that can be heard backing Pickett on this 1965 hit that was co-written by the MGs' guitarist Steve Cropper.

Bright Lights

Clustered within the constellation of mighty soul stars—everyone from the immortal Otis Redding and

ABOVE **The Wicked Pickett and the Lachrymose Garnet Mimms.**

BELOW LEFT **Chuck Jackson scored with Bacharach's "Any Day Now."**

BELOW RIGHT **J.J. Jackson: from the Bronx to Blighty.**

Percy Sledge to Marvin Gaye and Rufus Thomas—are a host of other bright lights. Of them, the fabulous Isley Brothers can claim the singular distinction of having songs on the charts in five different decades—from their 1959 exuberant calling (and response) card, *Shout*, to *This Old Heart of Mine*, performed as a duet with Rod Stewart in the 1990s. After the death of brother O'Kelly and the departure of brother Rudolph to preach the gospel, the remaining Isley, Ronald, still recorded as the Isley Brothers with the help of younger brothers Ernie and Marvin, who had not been part of the original lineup.

Then there are those short-lived but bright-shining artists who forever will be associated with the specific hit that launched them into soul's glittering galaxy. Who else could have delivered *Cry Baby* with the utter conviction of Garnet Mimms? Who could have blended the sophistication of Ian Fleming's James Bond with the regalia of a true rhythm & boulevardier better than Edwin Starr with his *Agent Double-0-Soul*? Then there's O.V. Wright, whose intensity on such hits as *Eight Men and Four Women* fit well with his scarifying reputation as "the man too ugly to tour." And Chuck Jackson, whose haunting *Any Day Now* was paid the ultimate homage of an Elvis remake. But Presley was not the Carolinian's only famous fan; no less a light than wailin' Welshman Tom Jones credits Jackson as his greatest vocal influence.

The gap-toothed Percy Sledge will always be associated with his majestic 1966 hit *When a Man Loves a Woman*, whose soaring sentiment triumphs over the woefully out-of-tune vocals and horn section of the track. The song was written and recorded while Sledge worked as an Alabama hospital orderly. To this day, it remains an evocative soul classic.

For Major Lance of *Monkey Time*, singing was a sidelight to his primary interest in boxing. Neverthe-

less, it is fitting that *Monkey Time*, which described a new dance step, should have been cut by a man who also appeared as a dancer on a local Chicago knockoff of *American Bandstand*. *But It's Alright* by rotund Bronx native J.J. Jackson was the first U.S. soul chart hit ever recorded in Great Britain, underscoring soul's international reach. Florida's James &

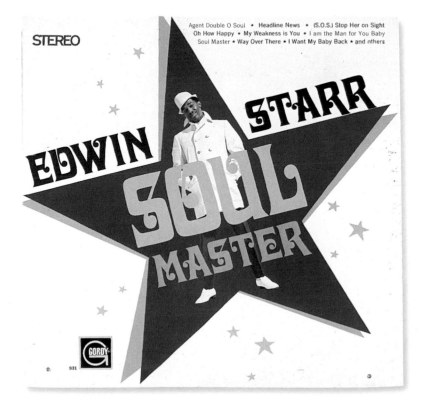

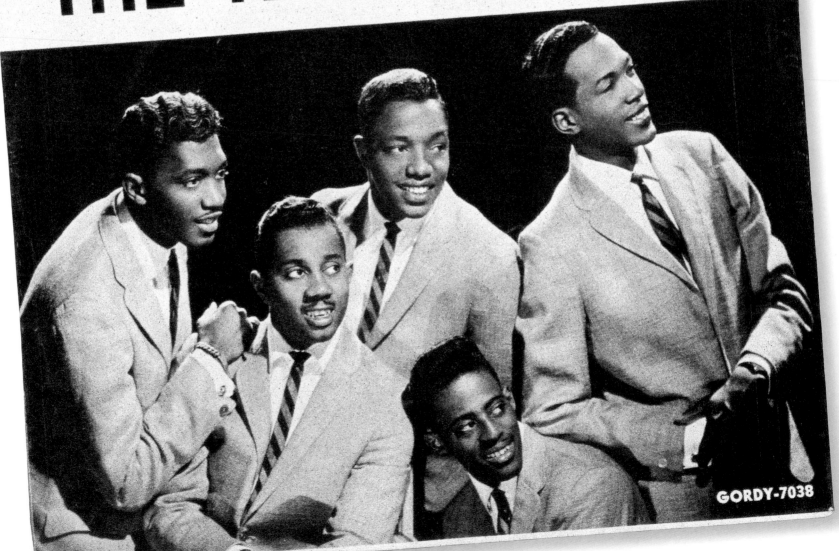

MY GIRL

"TALKING, BOUT" NOBODY BUT MY BABY

THE TEMPTATIONS

GORDY-7038

Bobby Purify were not brothers, but cousins. Bobby, aka Robert Lee Dickey, teamed with James Purify in 1966 to record the unadulterated soul standard, *I'm Your Puppet*. The duo endured despite the fact that Bobby retired in 1970 and was replaced by a singer who was neither a Bobby nor a Purify—Ben Moore.

With its message of honesty and directness, *Tell It Like It Is* brought Aaron Neville to a worldwide audience in 1967, but he was unable to come back with a significant follow-up and soon found himself back working as a stevedore on the docks of his native New Orleans. It wasn't until he joined forces with his brothers more than a decade later that Neville traded his grappling hook for a microphone.

Motown Variations

While Berry Gordy's Midas-touched Motown Records could be said to have a sound so distinctive that its artists transcended every other musical category, the

LET LOVE COME BETWEEN US

Words and Music by JOE SOBOTKA and JOHNNY WYKOR III

AL GALLICO MUSIC CORP. 75¢

label was still well-represented in soul's arena. Among the most noteworthy practitioners of soul at Motown, Inc. were the twin male super-groups, the Four Tops and the Temptations. These two ensembles represented varied approaches to the idiom: although Four Tops' membership has not changed since the group's inception in 1954, the Temptations' lineup has varied a great deal over the years. The Four Tops, despite their uptown jazz origins, were anchored to a more immediate and visceral sound, differing from the high harmonies and smoother, sophisticated stylings of the Temptations.

Originally dubbed the Aims, the Four Tops changed their name to avoid confusion with the Ames Brothers. The Temptations arrived at Motown as the Primes, along with their female backup trio, the Primettes, who later forged their own career as the Supremes. The two groups reunited near the end of Diana Ross's tenure with the Supremes in 1968 and shared vocals on a number of hits, including *I'm Gonna Make You Love Me*. The Temptations continued to perform well into the 1980s with hits written and produced by Norman Whitfield that updated the spirit of vintage Motown soul.

The Four Tops' hit-making tenure also continued until recently. At one point they left Motown, but ultimately returned, always remaining true to the seamless and sincere vocal approach that defined their work at the label. It's a musical legacy that can be heard on such quintessential Vietnam-era classics as *I Can't Help Myself*, *Reach Out, I'll Be There*, and *It's the Same Old Song*.

One of the keys to Motown's musical hegemony

REACH OUT I'LL BE THERE
UNTIL YOU LOVE SOMEONE

FOUR TOPS

PAGE 60 **The Temptations.**

THIS PAGE ABOVE **Motown titans the Four Tops.**

BELOW **James & Bobby Purify: 99 ⁴⁴/₁₀₀% soulful.**

was the writing and producing team of Holland/Dozier/Holland. Of the brothers, Brian and Eddie Holland, the latter also enjoyed success as a recording artist, most notably with his hit *Jamie*, honing his vocal chops singing Gordy-penned demos for Jackie Wilson in the pre-Motown days. As part of the H/D/H dynasty, Eddie helped produce and write hits for the Four Tops, Marvin Gaye, the Isley Brothers, Martha & the Vandellas, the Miracles, the Supremes, and Mary Wells, among others. Later, Lamont Dozier also enjoyed chart success as an artist, although on ABC Records rather than at Motown.

Junior Walker, on the other hand, was a Motown anomaly. He fronted one of the company's only self-contained bands, the All Stars, and scored instrumental hits at a time when the Motown music machine was, by in large, fueled by its vocalists. Junior and company arrived on Motown's

doorstep when the omnipotent Berry Gordy bought out Harvey Records, which was owned by his brother-in-law, Harvey (of the Moonglows) Fuqua. In sharp contrast to the team-composing formula that then prevailed at the label, Walker distinguished himself by writing his own first hit. His credentials as a soul stalwart were buttressed by classics issued on the subsidiary soul label such as *Shot Gun* and *Road Runner*.

It was Arthur Conley, an Otis Redding protégé, who summed up soul music's essential appeal on his 1967 hit, *Sweet Soul Music*, with its compendium of essential soul references. An adaptation of Sam Cooke's *Yeah, Man* produced by Otis Redding, the song pays tribute to some of the era's best know soulsters, including Conley's mentor Otis, whose distinctive "fa-fa-fa-fa" refrain is lovingly replicated by Conley. Conley subsequently dropped out of the music scene, emerging years later as a transsexual living in Belgium, which only goes to prove there's room for everybody under soul's big tent.

When all is said and done, soul music speaks most eloquently for itself in celebration of its sassy, strutting style that fearlessly claims bragging rights to a sound that set the whole world dancing. 🎧

ABOVE **Junior Walker & the All Stars: the raw side of Motown.**

BELOW **Otis protégé Arthur Conley.**

Chapter 4
RED HOT MAMAS

The sassy Sarah Vaughan.

RED-HOT MAMAS

The Woman's Got Soul . . . —The Impressions, *Woman's Got Soul*

In spite of her enormous talent, Billie Holiday had to struggle to make ends meet. Early in her career as a vocalist with the Count Basie Band, she made fourteen dollars a day—a good wage at the time, had

Billie not been required to under- write all her own road ex- penses, including makeup, grooming,

Continued top of page 65

B lack female performers have blasted through the glass ceiling of gender, shattering it in a glorious burst of pure artistic expression. Clearly, black music is one of the few creative arenas where sexual bias has been all but obliterated. In their influence on musical form, popularity with audiences, and genius as performing artists, black women have been and are the equal of men. Certainly, the ratio of black female music stars is equivalent to that of males.

Her Own Voice

Billie Holiday without a doubt reached the apex of musical artistry in terms of technique and sheer musical ability. Blended in a paradox of the earthy and ethereal, her vocal majesty remains un- matched. When Holiday's career first got underway in the early 1930s, it was cus- tomary for black singers to try and imitate their

64

SEPIA

DECEMBER, 1959 35¢

HOW INTEGRATION
HAS WORKED
IN THE
ARMED FORCES

"ME AND
MY SIX HUSBANDS"
By Dinah Washington

IS
OLLIE
MATSON
WORTH
NINE
STARS?

1939 for its anti-lynching theme. By the time of her tragic death in 1959 at age forty-four from the effects of drug abuse, Holiday had created a musical legacy that would influence countless blues and jazz divas.

Dinah Washington was initially perceived as a jazz singer in the Billie Holiday mold, but with her elastic vocal range and consummately dramatic readings she developed a distinctive style that was completely her own over a career that spanned three decades. According to musicians on hand in the studios, most of Washington's hits, including *What a Difference a Day Makes*, *Harbor Lights*, and the 1953 charter, *TV Is the Thing This Year*, were recorded in a single, electrifying take. Before her untimely death in 1963 following years of drug abuse, Washington had earned an enduring place in the pop, blues, and jazz realms.

The Queen of Soul

Born in Memphis—the soul music capital—but raised in Detroit, Aretha Franklin occupies a place at the fulcrum of black style and has the track record to prove it: eighty-nine Top 40 R&B hits in thirty-two years, with seventeen of them number one. Having grown up as the daughter of one of America's most famous preachers, the Reverend C.L. Franklin, she was exposed to and fully developed the raw power accessible to her from her gospel roots. Like Billie Holiday, for whom she has great admiration, Franklin was signed

white counterparts. Not Billie. She perfected an evocative phrasing that drew directly from black jazz and blues instrumental idioms.

Billie was signed in 1933 by talent scout and producer John Hammond to record with Benny Goodman, and went on to have a ten-year string of recorded hits that ranged from *Twenty-Four Hours a Day*, *Summertime*, and the *Way You Look Tonight* to *Carelessly* (a 1937 smash), *Nice Work If You Can Get It*, and the controversial *Strange Fruit*, banned on radio in

As Recorded by ARETHA FRANKLIN on Atlantic Records

Chain Of Fools

Words and Music by DON COVAY

$1.50

PRONTO MUSIC & 14th HOUR MUSIC, INC.
1841 Broadway • New York, N.Y. 10023

Continued from page 64

costumes, and room and board. This didn't leave much to send home to Mama, but the ever-resourceful Holiday, who grew up on the wrong side of the tracks in Baltimore and once worked as a prostitute, managed to augment her earnings by playing craps with the boys in the band. According to one revealing though unsubstantiated story, she once parlayed four dollars into sixteen hundred during an all-night bus trip from West Virginia to New York. On arrival, she triumphantly presented her Mama Sadie with the proceeds.

PAGE 64 Lady Day. She sang it like they played it. On her epochal recording of "Strange Fruit" she "defied the noose" in song and was banned for her efforts.

THIS PAGE ABOVE Dinah Washington. Like Billie, a heavenly voice and a hellish life.

BELOW The young Aretha: Muscle Shoals made the difference.

Records in 1949, Brown was recommended for the label by none other than Duke Ellington. Her seminal R&B hits included *So Long, 5-10-15 Hours, (Mama) He Treats Your Daughter Mean*, and *This Little Girl's Gone Rockin'*. As a result of these and other successes, Atlantic came to be known as "the House that Ruth Built."

by John Hammond to a contract with Columbia Records.

Her first albums were in the jazz idiom, but these were followed by records in a tepid pop vein. After nine albums and disappointing record sales, she left Columbia and landed at Atlantic Records, where she cut at the legendary Muscle Shoals Studios in Alabama under the supervision of Jerry Wexler. There she rediscovered the primal, gospel-fueled power of her heritage, evident in a string of definitive soul hits—*Chain of Fools*, *Respect*, *I Never Loved a Man (the Way I Loved You)*, *Baby, I Love You, Think*—the list goes on and so, too, does Aretha's remarkable impact on the musical land-scape. Possessed of a multifaceted musical genius that has spanned gospel, R&B, jazz, pop, blues, and rock, she is truly the Queen of Soul.

The House that Ruth Built

Ruth Brown, another female R&B pioneer, has often been compared to Aretha Franklin. In fact, on hearing the teenage Franklin sing for the first time, Ruth, aka "Miss Rhythm," exclaimed, "If I had to follow her, I'd break both her legs, young as she is!" Yet Ruth Brown was in many ways the measure of Franklin, or any other soul singer. The first major artist to be launched by the nascent Atlantic

Catwoman

What Ruth Brown was to bottom-heavy R&B, Eartha Kitt was to the slinky, sophisticated cabaret style. With her minx-like looks and purring delivery, Eartha dished up a simmering sexuality, which is perhaps best recognized on her come-hither holiday classic, *Santa Baby*. Its catalog of Christmas goodies contains a yacht, a Rolls, and a passel of diamonds, and Kitt plays the musical personification of a gold digger to perfection. Madonna, for whom Kitt served as a role model, recorded a note-for-note copy of *Santa Baby* a quarter of a century after the original. Kitt also tapped an international audience with *C'est Si Bon*, and her feline grace was put to good use when she appeared on TV's campy *Batman* as the prowling, purring Catwoman.

Sweethearts of Rhythm

Big Maybelle was a lusty, larger-than-life blues belter. This Tennessee native got her start in the early 1940s in the all-girl orchestra, Sweethearts of Rhythm, and went on to record with the Christine Chatman, Leroy Kirkland, and Kelly Owens Orchestras. Between these stints, she recorded as a solo performer. Among her definitive R&B chart hits

LEFT **Miss Rhythm put Atlantic Records on the map.**

RIGHT **The purr-fect holiday gift.**

were *Gabbin' Blues*, *Way Back Home*, and *My Country Man*, all cut for the Okeh label.

LaVern Baker was another R&B great who segued neatly into the rock era. A Chicago native, Baker was the niece of Merline Johnson, "the Yaz Yaz Girl" who recorded during the 1930s, and was also related to the legendary blues singer Memphis Minnie. In 1947, Baker joined Fletcher Henderson's band as "Little Miss Sharecropper,"dressed for the part in a tattered country costume. However, she was one novelty act who had real vocal chops, apparent in her recordings of hits like *I Want a Lavender Cadillac*. Her riveting singing style was displayed in smash singles

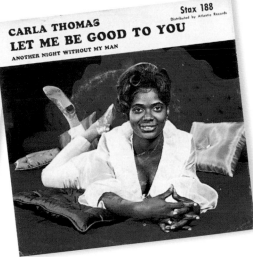

recorded for Atlantic during the mid-1950s—*Soul on Fire*, *Bop-Ting-A-Ling*, *Tweedlee Dee*, and *Jimmy Dandy*—and her rural persona was left in the dust for good when she became known as "the High Priestess of Rock 'n' Roll."

Baker's nemesis was white vocalist Georgia Gibbs, who was prone to copying Baker's songs and

ABOVE LEFT & BOTTOM RIGHT **LaVern Baker: Lil' Miss Sharecropper all grown up.**

ABOVE RIGHT **Stax stalwart Carla Thomas.**

BELOW LEFT **Big talent in a big package.**

charts *exactly* and scoring pop hits in the process. LaVern, incensed by Gibbs' piracy, finally took her case to Congress, but her attempt to acquire copyright protection for her arrangements was unsuccessful.

Carla Thomas, whose father, Rufus, was among those who put the Memphis Sound on the map, began her career at age ten when she performed with the Teentown Singers. Her first recording was *I Love You*, a duet with her father that featured a teenage Booker T. Jones. This was followed by her first chart hit, *Gee Whiz (Look at His Eyes)*, which was penned by Thomas herself and became the premier hit for Stax when it was released through its Satellite label. The New York doo-wop feel of the song was inspired by Baby Washington, a Gotham artist who was a major influence on the younger Carla.

In addition to her solo hits that included the seductive *B-A-B-Y* and the irresistible *Let Me Be Good to You*, Carla recorded duets with another Stax stalwart, Otis Redding. Together they scored with the singles *Tramp*, *Lovey Dovey*, and a version of the Eddie Floyd stomper *Knock on Wood*, as well as with the classic album *King & Queen*. Among the first of Stax's great stars, Carla was also one of the last, remaining with the label until it went bankrupt in 1976.

Carla Thomas and Mary Wells: you go girls!

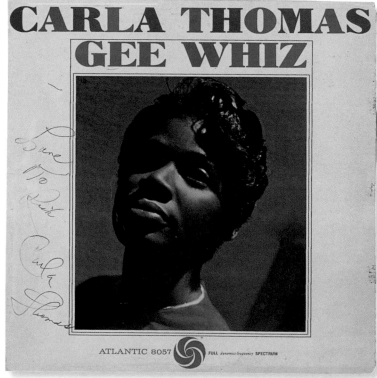

"That Mary Wells Girl"

While the Motown music empire boasted of many enduring women on its all-star roster, the first and still one of the best was "that Mary Wells girl." She was only a girl when she signed with the label at seventeen after auditioning her original song *Bye, Bye, Baby* for Motown founder—and Jackie Wilson collaborator—Berry Gordy. Wells hoped that Gordy would pass the track on to Wilson, but because he was signed to rival label Brunswick, Gordy instead signed Mary Wells and produced her song. The result was an uncharacteristically rough-hewn performance compared with Wells's later and better-known hits like the *One Who Really Loves You*, *You Beat Me to the Punch*, *Two Lovers*, and *My Guy*, most of which were produced and written by Smokey Robinson. Smokey was apparently less demanding than the perfectionist Gordy, who had Wells run through twenty-two takes of *Bye, Bye, Baby,* accounting for its sandpaper vocal quality.

Unlike Carla Thomas, who remained loyal to Stax until the bitter end, Wells left Motown as soon as she came of age, when a court declared her contract void. However, she never again came close to the success she enjoyed during her four years at the Detroit label. In 1992, she succumbed to throat cancer, leaving behind an enduring legacy of great music.

Tell Mama

Etta James's career has proven to be one of the longest-lasting and most varied of any female soul artist. R&B, blues, rock 'n' roll, even jazz and a touch of cabaret—she's done them all.

Etta was only fifteen when she approached bandleader Johnny Otis with her own version *(Roll with Me Harry)* of Hank Ballard & the Midnighter's ribald *Work with Me Annie*. Otis was so impressed that he offered to cut the song the next day, provided Etta could obtain parental permission. Etta assured him that this would not be a problem but neglected to mention that her wayward mother was incarcerated at the time. Unwilling to let circumstances interfere with opportunity, the resourceful teen forged her mother's signature and her career was off and running.

Etta later hooked up with the Moonglows' Harvey Fuqua, who got her onto the Chess Records roster, where she cut such classics as *At Last*, *Pushover*, *Something's Got a Hold on Me*, and the tune that became her signature, *Tell Mama*.

Etta has flirted with oblivion on more than one occasion only to rise, phoenix-like, from the ashes of heroin addiction. For a time, she was a ward of the state in a long-term, lockdown drug rehab house in Los Angeles, but nothing has been able to subdue the exuberant spirit of this true original for long. She

Etta: Betta than Eva.

has continued to record numerous singles and albums up to the present day, and one, *Etta James Rocks the House*, recorded live in 1965 at the New Era Lounge on Charlotte Street in Nashville, Tennessee, testifies to her indomitable nature. Etta appears on the cover of this album with her left arm bandaged. The story given at the time was that she had injured her arm in a fall from the stage prior to the performance, but the gauze actually served to cover needle tracks. While the art director certainly could have pulled out a stock photo of an uncamouflaged Etta in action, he must have felt that nothing less than an actual picture from the event would

ABOVE & BELOW RIGHT **The ephemeral Maxine Brown.**

BELOW LEFT **Marva Whitney: in James Brown's orbit.**

PAGE 71 ABOVE **Dee Dee Warwick: Dionne's little sister.** BELOW LEFT **Coming-of-age with Barbara Mason.** BELOW RIGHT **Barbara Lynn: the Left Hand of Sin.**

serve. For those who know the truth, the image today provides a forceful reminder of this remarkable woman's resiliency in adversity and courage and determination in overcoming addiction. A dynamic presence on stage, Etta, unconstrained by the time and space limits of the record studio, can be counted on to give her all—and that's quite a bit—at every performance.

Brown's Revue

Not all soul singers have had the lasting impact of the great Etta James, even those who benefited from having James Brown as a mentor. Brown was given to featuring assorted hopefuls in his multifaceted revue, among them Marva Whitney and Anna King. When he strayed from King Records to Mercury's Smash label for a short interlude in 1964, he saw to

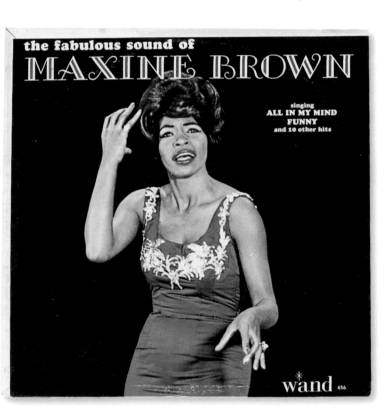

it that Anna King was signed to a recording deal as well. At Smash, Brown recorded Carolyn Franklin's *Baby, Baby, Baby* as a duet with Bobby Byrd, a member of Brown's backing band, the Famous Flames. The superstar continued to keep it all in the family when he returned to King Records by getting Marva Whitney signed, and by producing tracks for her that included *I Made a Mistake, Because It's Only You (Part Two).*

Soul Sisterhood

Sisterhood is powerful, especially if your older sibling happens to be the number one-selling artist of the day. Though clearly a genuine talent in her own right, Dee Dee Warwick stood in the shadow of her older sister Dionne, who achieved prominence with numerous Bacharach/David hits. While Dionne had the benefit of the Bacharach songbook, Dee Dee's repertoire was more catch-as-catch-can. Her most successful outing was the Jerry "Swamp Dogg"

Williams/Gary "U.S." Bonds original, *She Didn't Know (She Kept on Talking).*

Maxine Brown was another artist who benefited from a strong stable of songwriters when she recorded for Wand, a subsidiary of the Scepter label. Born in South Carolina, Brown was a perennial New York area favorite, despite her rare appearances on the national hit parade. Goffin/King and Ashford/Simpson were among the teams that lent

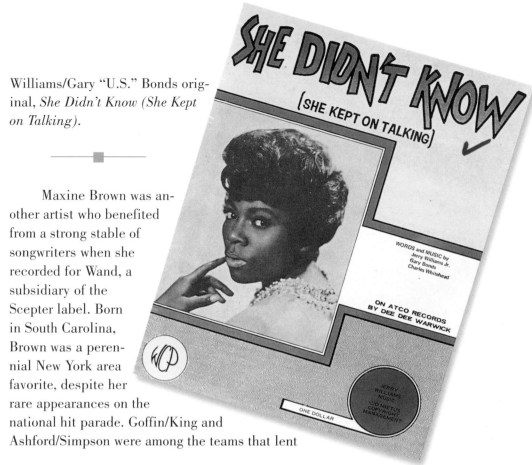

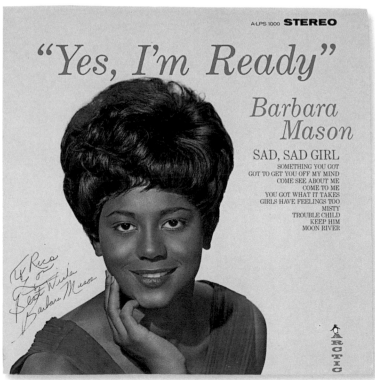

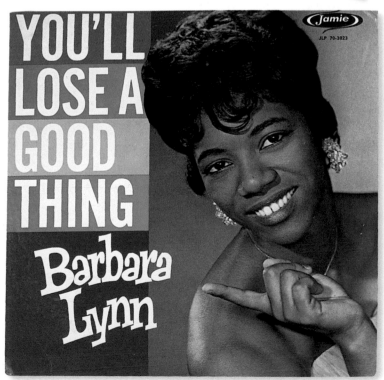

Barbara Mason: Philly filly.

their talents to the singer, although to little avail. She had some success with her first record, 1961's *All in My Mind*, and recorded the stirring *Oh No, Not My Baby* in 1964, on which can be heard the remarkable vocal influence of the song's co-author, Carole

King, but these are the only real highlights of an otherwise unremarkable career.

Barbara Lynn was known as "the Left Hand of Sin," because of her atmospheric left-handed guitar style. Hailing from Beaumont, Texas, she was recorded in New Orleans by legendary Cajun talent scout, Huey P. Meaux, who captured her Gulf Coast essence on her first hit, 1962's *You'll Lose a Good Thing*. She later scored with the masterful *(Until Then) I'll Suffer*.

Barbara Mason, on the other hand, traded on a fetching innocence in 1965, with the coming-of-age hit, *Yes I'm Ready*. The Philadelphia native fit the teen bill well, writing and cutting the track when she was eighteen with some of the same studio players who would go on to become the bulwark of the Sound of Philadelphia, backing the O'Jays, Harold Melvin & the Bluenotes, and the Spinners, among others.

In pop music, talented black women have found a potent and remarkably unfettered form of expression often denied them in other artistic arenas. That freedom—to celebrate the full range of human experience and rich spectrum of emotions, ideals, and hard-won wisdom—has resulted in some of the most resonant and revealing music of any era or idiom.

Chapter 5
WiLD STYLE

Muddy Waters gets his "do."

WILD STYLE

You know you make me wanna shout!

— The Isley Brothers, *Shout*

I t's undeniable that one of the most arresting aspects of the black music experience is the *visual* appeal of the artist, evident in everything from stage attire and body language to stage presence and personal charisma.

Black performers have long put a premium on flamboyant showmanship, with an emphasis on the outrageous. Contrast the safe, sanitized presentation of most white entertainers with the gyrations, gymnastics, and gesticulations of their black counterparts, and the astonishing originality of the latter becomes gloriously evident.

It was not simply Elvis's appropriation of black music that attracted teen audiences but his libidinous approximation of black stage antics, which extended even to his choice of clothing, purchased at Lansky's on Beale Street, the South's

premier haberdashery for musicians, entertainers, and sportsmen of color.

No question about it. Black artists have always set the pace with their wild style in terms of dance and dress, whether they adopt a down-home demeanor or uptown sophistication. Even their posturing and posing are a wonder to behold. In vintage publicity 8 x 10s, these geniuses at capitalizing on a photo opportunity create excitement simply by standing still in glorious black and white. Imagine the thrill they conveyed in person and in living color.

A survey of some of the primary practitioners of this wild style reveals a cast of characters who changed the way music *looked* for all time. Whether the genre is jazz, swing, soul, or rock 'n' roll, it is the exuberance and infectious energy of these true originals that tie it all together.

Suitable for the Stage

Any overview of wild style must begin by paying homage to the man who helped develop the look that was key to the concept of crazy and cool stage wear. Hal Fox, inventor of the Zoot suit, was himself a musician of sorts who led Chicago's Jimmy Dale Orchestra. He acquired some of the day's best big band arrangements from the likes of Count Basie, Duke Ellington, and Louis Armstrong by trading his original clothing designs for them.

A Fox Zoot not only looked sharp but *sounded* sharp, as Fox was given to rhyming descriptions of his creation's unique features—to whit, the reet pleat, reave sleeve, ripe stripe, and drape shape. The word Zoot, itself, was the fruit of Fox's transcendent imagination. He conceived the notion that the hippest handle for any human expression was "the end to end all things." Since the hippest suit would start with the letter that ends the alphabet . . . viola! *le Zoot*. With its padded shoulders, high waist, long jacket, and narrow cuffs, the Zoot suit was perfectly tailored for cutting the rug and earned Fox—as much an innovator with a needle and thread as any musician he ever outfitted—a place of honor in musical and fashion history.

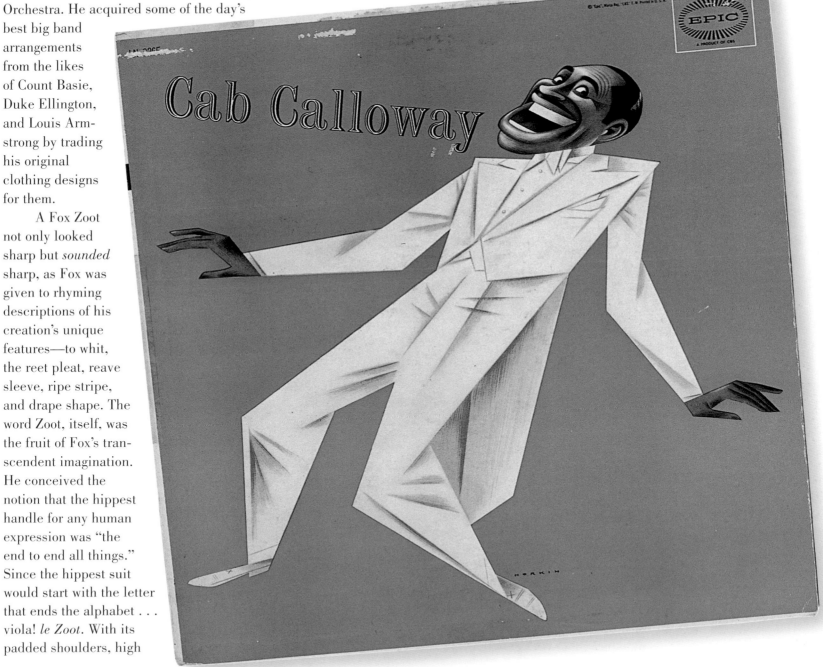

The Incredible Cab Calloway.

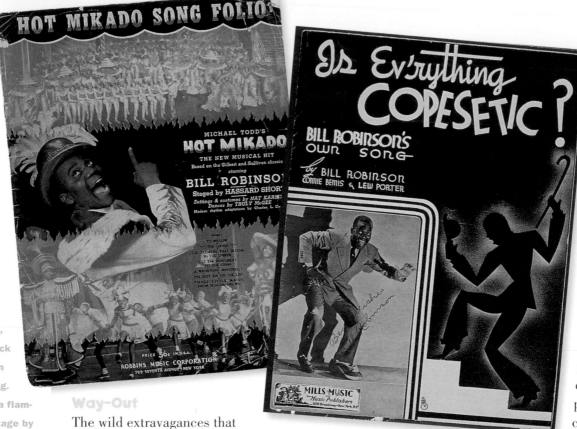

Cab Calloway
and Bill Robinson
showed that serv-
ing a stint in
vaudeville could
be good prepara-
tion for the type
of outrageous
stage presence
fans often associ-
ate with rock idols
of the 1960s and
later. Some older
performers, in fact,
found a niche in rock
'n' roll by calling on
their earlier training.
Rufus Thomas cut a flam-
boyant figure on stage by
wearing hot pink pants,
cape, and white boots, all
at the ripe old age of
fifty-five and beyond.
With decades of vaude-
ville experience behind
him, and short-lived
recording careers at both
Chess and Sun, this
Mississippi native and
long-time Memphis resi-
dent had a string of
definitive dance-based
hits in the mid-1960s,
many predicated on the
animal kingdom. Aside
from the *Funky Chicken*
and the *Funky Penguin*,

Continued top of page 77

Way-Out

The wild extravagances that
defined the stage style of some of black music's ear-
liest pioneers were legendary. Cab Calloway and Bill
"Bojangles" Robinson were first among equals.
Calloway, "the hi-de-ho man," moved on stage like a
sailor on the deck of a rolling steamer. Arms flailing
and spinning dervishly, he seemed to be listening to
an entirely different song in his head, even as he ran
through his own inimitable repertoire. Some of those
songs, often delivered in a call-and-response style,
dealt with the gloriously giddy effects of recreational
substances, with the emphasis on reefer and the
"happy dust" of the era.

At times, however, the on-stage antics of the
backup performers overshadowed even a showman
like Cab Calloway. For example, Dizzy Gillespie
served for a time in Calloway's big band, where the
drummer-in-residence was one Cozy Cole, perhaps
best known for his rock-era percussion and laconic
spoken-word version of Topsy. While Calloway was
balladeering front and center, Diz and the guys
would make faces behind their boss's back, even

throwing "passes"
to each other with
an imaginary foot-
ball. When one of
these passes found
its intended receiver,
Cole would punctu-
ate the moment with
his bass pedal, elicit-
ing laughter from the
audience and bewil-
derment from the
hi-de-hoing Cab.
Although not particu-
larly good with names,
Cole was nonetheless a
personable sort. When
confronted by a familiar
person whose name es-
caped him, he would
simply address him as
"Face." With his fellow musicians, he combined this
nickname with the individual's instrument: thus,
players in bands ranging from Louis Armstrong's to
Benny Goodman's became known as everything from
"Sax Face" to "Bass Face."

Calloway's own histrionics were not restricted
to the stage. He actually appeared with squeaky-
voiced cartoon vixen Betty Boop in a surreal
animated fantasy built around his music and replete
with much sly innuendo. But Calloway's film career
extended beyond sharing screen time with big-eyed,
pen-and-ink *femmes fatales*. In 1943, he costarred in
a major studio production of the all-black musical
Stormy Weather that featured many great black stars
of the day.

One of these stars was Bill Robinson, a vocalist
and dancer who initially achieved fame doing the
New Low Down on the Great White Way in *Lou
Leslie's Blackbirds of 1928*, a pre–Stock Market
Crash, all-star black revue. Robinson's distinctive

men, guitarists, and others who liberated their instruments from the confines of the bandstand. Aside from the fact that Aaron "T-Bone" Walker developed a style of guitar-playing emulated by everyone from B.B. King to Chuck Berry to generations of British wannabes, the Texas-born string man also pioneered several anatomically implausible forms of playing. He could pick and strum behind his head as well as any correctly positioned virtuoso, and several decades before Jimi Hendrix tongued a chord, Walker worked the frets frantically with his teeth.

For Johnny Watson, "guitar" was literally his middle name. Like many, he was a disciple of Walker and also hailed from Texas. However, he did the master one better by playing with his teeth while doing a handstand. Always decked out in the finest of pimp attire, the self-styled "Gangster of Love" enjoyed a career that spanned five decades. Watson was not only an instrumental virtuoso of the first order, but an outstanding vocalist who was acknowledged by the great Etta James as a direct influence.

Honorable mention in the guitar-robics class must go to San Francisco's own Rodger Collins, who was also known to use the "guitar" handle as a middle name. Collins included in his repertoire credible imitations of Elvis and

loose-limbed tap and heel-and-toe style took center stage in numerous Hollywood productions, including charming sequences with Shirley Temple in the *Little Colonel*, the *Littlest Rebel*, *Just around the Corner*, and *Rebecca of Sunnybrook Farm*. Despite efforts to characterize him as a shuffling, grinning Uncle Tom—the norm in Hollywood's race portrayals—Robinson exuded a distinctive, sparkling dignity that subverted the subservient nature of the roles to which he was relegated in those benighted times.

Guitar-robics

There was no craziness more instrumental than that of the honking sax

T-BONE WALKER

Direction
SHAW ARTISTS CORPORATION
565 Fifth Avenue
New York 17, New York

Continued from page 76

Rufus, father of teen queen Carla, quite literally put on the *Dog* in 1963, and followed up with other canine-themed funk workouts: *Walking the Dog, Can Your Monkey Do the Dog?* and *Somebody Stole My Dog.* His first release, in fact, was *Bear Cat,* the answer song to Big Mama Thornton's *Hound Dog.* Rufus also celebrated our feathered friends with *Do the Funky Chicken, Do the Funky Penguin,* and the generic *Funky Bird,* all of which illustrated why he was dubbed the "Clown Prince of Soul."

PAGE 76 The legendary Bill Robinson: the original Mr. Bojangles.

THIS PAGE Cozy Cole and T-Bone Walker: instrumental icons.

RODGERS "Guitar" COLLINS
CLAUD & His HIGHTONES
Appearing Every Tuesday Night
SHELTON'S BLUE MIRROR
935 FILLMORE ST., SAN FRANCISCO, CALIF.

RODGER COLLINS

"Prez" for his executive role in the history of jazz. A native of Mississippi, Young found fame as a member of Count Basie's Orchestra, but left the ensemble after refusing to play a recording session that happened to fall on the unlucky thirteenth of the month. Prez, too, had the uncanny ability to play the sax in gravity-defying modes, but his wild style on stage extended past the tenor's virtuosity. During his stint with Basie, the band played behind vocalist Earle Warren on a number called *I Struck a Match*. To underscore the point of the ditty, each band member was instructed to provide the appropriate dramatic illumination by striking a match at the moment the lights were turned off. Leave it to the iconoclastic other well-known artists, black and white. Like many others, he was wickedly covered by Wilson Pickett on Pickett's 1967 hit, *She's Lookin' Good*, a Collins composition that the composer had released earlier but with less commercial success.

Sax Men

As with the guitar, the saxophone was also an instrument that seemed to bring out the exhibitionist in many a player. Among the most innovative was Lester Young, known as

JOHNNY "GUITAR" WATSON

KING 857

POSIN'
CUTTIN' IN
EMBRACEABLE YOU
GANGSTER OF LOVE
BROKE AND LONELY
YOU CAN'T TAKE IT WITH YOU
THAT'S THE CHANCE YOU'VE GOT TO TAKE
THOSE LONELY, LONELY FEELINGS
I JUST WANTS ME SOME LOVE
WHAT YOU DO TO ME
SWEET LOVIN' MAMA
HIGHWAY 60

ViViD SOUND

West Coast fretmen Rodger Collins and Johnny "Guitar" Watson.

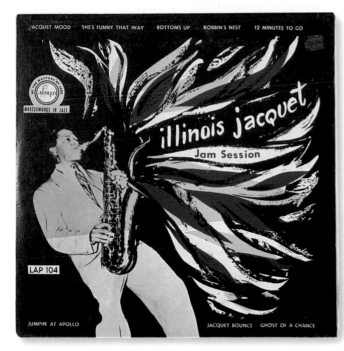

The story of Diz's bent horn is the stuff of jazz folklore. The year was 1953 and Gillespie was at a party with other jazz notables. When he left for a spell, two other revelers, the dance team of Stump 'n' Stumpy, got into a tussle and Diz's horn came tumbling down, causing its bell to bend upward at a sharp angle. Gillespie returned to find his precious trumpet hideously mangled. Initially distressed, he eventually found inspiration in the sound that the twisted bell yielded. In fact, he instructed the Martin Company to custom build all his horns with that signature 45-degree bend.

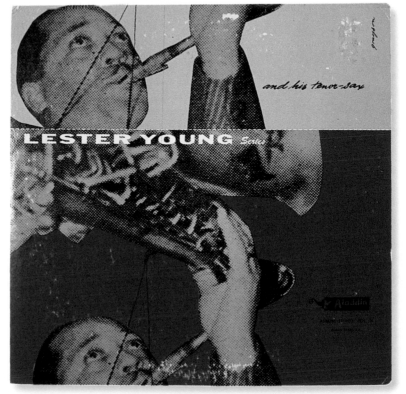

Prez not only to strike a match, but to set fire to the band's sheet music!

Despite his given name, Illinois Battiste Jacquet was actually born in Louisiana and came to be known in swing circles for his squealing high "freak" notes on the sax, which were heard later in the rockin' soul of Junior Walker and others. A legendary show-off, Jacquet's live performances were pitched to the cheap seats, especially in his use of the high-note harmonics he achieved by putting his teeth to the reed. A key player in jazz history, Jacquet served a stint with Lionel Hampton, providing the incendiary solo on the acclaimed 1942 hit *Flying Home*.

Man with a Horn

What Jacquet was to the saxophone, Dizzy Gillespie was to the trumpet . . . and then some. This be-bop pioneer's dedication to his art was manifest in cheeks that were stretched literally beyond human proportions, but his real wild-style trademark was his heaven-pointing trumpet, which made for a memorable visual in keeping with his groundbreaking music.

Illinois Jacquet and Lester "Prez" Young: saxsational.

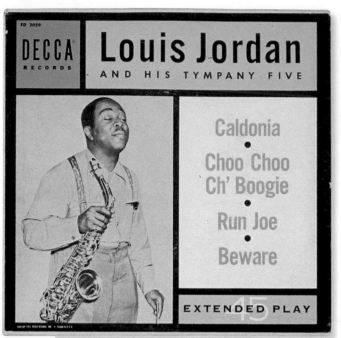

Saxophonist and singer Louis Jordan is one of the undisputed fathers of R&B and rock 'n' roll. A graduate of the Rabbit Foot Minstrels Tent Show of the 1920s, the Arkansas native went on to found the fabled Tympany Five, a group that paradoxically often exceeded five members. Aside from dominating the R&B charts and often crossing into pop realms, Jordan's rollicking comedy-laced act made it onto the silver screen in what stands as the first example of a protomusic video—a "soundie" promoting his 1945 hit *Caledonia*. The twenty-minute clip featured Jordan and his band mugging shamelessly to the delight of audiences. It was followed by a one-hour film with a theme to complement his hit, *Beware*, that also spotlighted Jordan's elastic countenance.

In Synch

Instrumentalists weren't the only ones exemplifying wild style in black music. In fact, vocals groups who chose to depart from the staid approach were free to cut loose completely, unencumbered by instrumental baggage. Perhaps none were looser than the Holy Roller–inspired former gospel singers, the Isley Brothers. The group's eye-catching act included the synchronized twirling of their suit jackets on a single finger raised above their heads.

Stock in trade for Hank Ballad & the Midnighters was a charismatic stage presence that served as a model for James Brown and the Famous Flames. Ballard was known among black audiences in the early 1950s for his prurient *Annie* trilogy: *Work with Me Annie*, *Sexy Ways*, and *Annie Had a Baby*. In 1959, he invented a dance, the Twist, that changed the world, only to have his thunder stolen by Chubby Checker. Doggedly determined to reclaim his place in the Dance-Craze Hall of Fame, Ballard made several more attempts, including the Coffee Grind, the Hoochi Coochi Coo, the Continental Walk, the Float, and the Switch-a-Roo.

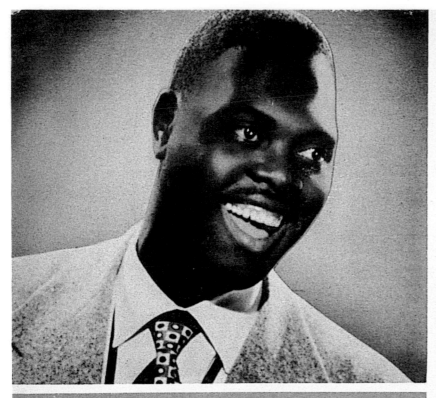

BIG JAY SHUFFLE

NERVOUS MAN NERVOUS

THE GOOF

3-D

GO! GO! GO!
with
Big Jay McNeely

Federal
45
EXTENDED PLAY

EP 246

PAGE 78 ABOVE RIGHT The be-bop bent of Diz. ABOVE LEFT & BELOW Love that Louie: The multi-talented Louis Jordan.

THIS PAGE Big Jay McNeely was a honkin' tenor-sax man who served as a vital link between jump blues and rock 'n' roll. He was known for his incendiary live shows when he would leave the stage to roam the audience, all the while honking and squealing away on his sax.

Cinematic Tales and immortal Segues

The unrestrained aspects of many classic R&B, soul, and blues perennials were often best represented in the music itself. For example, the Cadets' 1956 hit, *Stranded in the Jungle*, is among the most cinematic songs ever recorded in the black musical idiom. The song painted a lurid scenario replete with whale rides, the stereotypical cannibal stew pot, and a bird-dogging Lothario. The ditty also featured jump cuts between scenes on two continents with the immortal segues ". . . meanwhile back in the jungle" and ". . . meanwhile back in the States." The Cadets, however, were not the originators of this geographically packed tale. They were, in fact, covering another L.A. group, the Jayhawks, who were not as successful with their original version of *Stranded*.

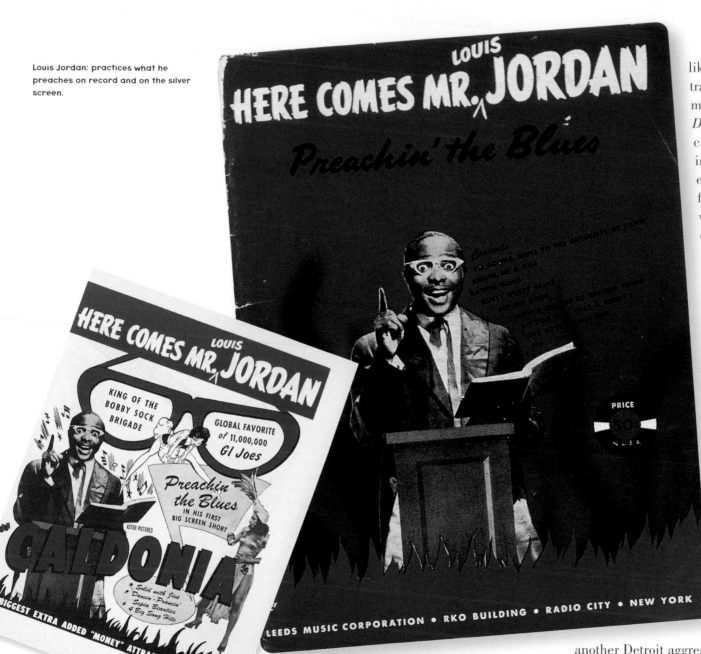

Louis Jordan: practices what he preaches on record and on the silver screen.

like splits and flips were well translated into lyrics and melody with their 1962 hit, *Do You Love Me?* The song captured the group's amazingly energetic stage presence and was notable for its false ending, which gave way to a short but frantic coda just when you thought it was safe to leave the dance floor. The Contours were formed in Detroit in 1958 and, although signed to Motown's Gordy label, ran directly counter to the label's smooth and modulated mandate. While the Four Tops, the Supremes, and others were trained to deport themselves with grace and charm, the Contours took it to the max with a sound and act that recalled the most liberating of authentic R&B.

Four years later the dance might well have been the *Cool Jerk*, as performed by another Detroit aggregate, the Capitols. It was a song that elicited its fair share of frenzy among cool jerkers of every persuasion. A similar response was evoked by Bobby Freeman with his bongo-infused anthem *Do You Wanna Dance?*, which also featured a false ending and an irresistible invitation to cut loose. Freeman, a native of San Francisco, followed this hit years later with *Come On and Swim*, produced by no less than Sylvester "Sly Stone" Stewart. The song was certainly a staple of his frenetic live

The Cadets found additional fame in another incarnation as the Jacks. Essentially the same group with a different lead, the Cadets handled the upbeat numbers while the Jacks were assigned the dreamy side of the repertoire, including 1955's *Why Don't You Write Me?* The Jayhawks for their part became the Vibrations, known for such hits as *Watusi*.

For the Contours, acrobatic excesses on stage

show at the infamous Condor Club in San Francisco's North Beach, where he was part of a house band that performed behind topless dancers.

Not for Prime Time

Wild style and a certain deliberate blurring of familial ties were at the center of Charlie and Inez Foxx's heart-stopping live show. At the climax of their performances, one-time basketball player Charlie would carry the swooning but still singing Inez from the stage in his arms. A potent romantic image—except that the two were brother and sister. Together the pair recorded an enduring R&B standard with the oft-covered *Mockingbird.*

Another torrid R&B pairing, Ike and Tina Turner, yielded to no other couple in terms of blatant eroticism. As an artist and repertoire (A&R) man in the 1950s, Ike is credited with recording what is often acknowledged to be the first rock 'n' roll record: *Rocket 88* by Jackie Brensen, released on Chess. With Tina, he looked and played the part of the pimp, lording over his wife and the Ikettes, who were all resplendent in the shortest of miniskirts that left little to the imagination. For his part, Ike looked on impassively, a svelte, sinister Svengali playing a savage guitar.

It was against all odds that 1970s cafe society wholeheartedly embraced what amounted to a lewd R&B sideshow and elevated the pair to superstar status. They even toured with the Rolling Stones before their acrimonious divorce, after which Tina went on to carve out an impressive solo career that

ABOVE **The Midnighters,** (BELOW RIGHT) **the Cadets, and** (BELOW LEFT) **the Isley Brothers: real gone groups.**

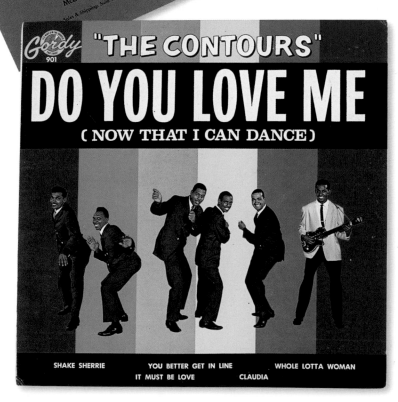

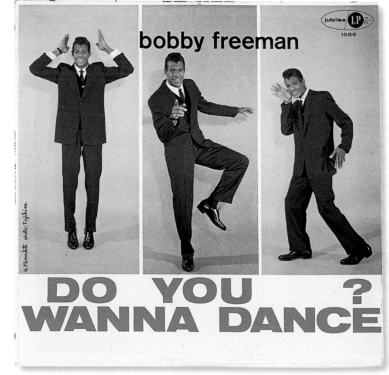

COOL JERK

Recorded by THE CAPITOLS on Karen Records

Words and Music by DONALD STORBALL

McLAUGHLIN MUSIC PUBLISHING Co., Inc.
1300 Arbor View, Ann Arbor, Michigan
Sales & Shipping: Suite 611 1841 Broadway New York, N. Y. 10023

.75

included her own hit records and the best-selling autobiography, *I, Tina*, later made into the acclaimed film *What's Love Got to Do with It?* Meanwhile, Ike has suffered several run-ins with the law, resulting in a stint in stir.

Outrageous and Unfettered

Perhaps no one better exemplifies the outrageous and unfettered spirit of real wild style than Little Richard. The self-styled Georgia Peach and Bronze Liberace, Richard Penniman personified the liberation that rock 'n' roll afforded 1950s teens. From the top of his processed hairdo to the tips of his two-tone shoes, Little Richard was untouchable in terms of sheer style. His early stage shows with his band, the Upsetters, were wild affairs with piano pounding and shrieking the likes of which

INEZ & CHARLIE FOXX

MY MOMMA TOLD ME—I FANCY YOU—HURT BY LOVE—DON'T DO IT NO MORE—LA DE DA I LOVE YOU—ASK ME—IF I NEED ANYONE—MULBERRY BUSH—I WANNA SEE MY BABY—DOWN BY THE SEASHORE—JAYBIRD—MOCKINGBIRD

"THE CONTOURS"

Gordy 901

DO YOU LOVE ME

(NOW THAT I CAN DANCE)

SHAKE SHERRIE YOU BETTER GET IN LINE WHOLE LOTTA WOMAN
IT MUST BE LOVE CLAUDIA

bobby freeman

jubilee LP 1086

DO YOU WANNA DANCE?

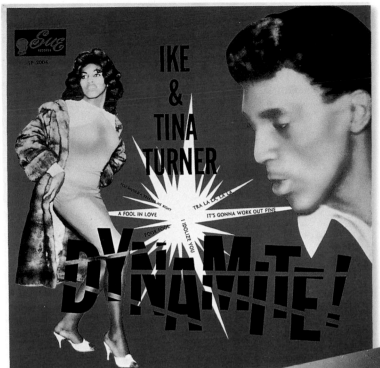

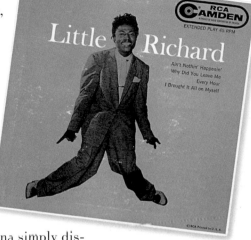

PAGE 84 The Capitols, the Contours, Inex & Charlie Foxx, and Bobby Freeman: on-stage pandemonium at its wildest.

THIS PAGE Ike & Tina and Little Richard: pushing the envelope.

down color, age, gender, and societal barriers in one fell "a womp bop a lula a womp bam boom," Little Richard casts a giant pompadoured shadow to this day. Slathered with pounds of pancake makeup and mascara, projectile perspiration popping from his pores, and his eyes rolling heavenward as if seeking divine guidance, it's incredible to imagine this androgynous black apparition as something of a role model for the white teens of postwar middle America. But he was. The ferocity of his music combined with the flamboyance of his persona simply dissolved all inhibitions, turning his appearances into unbridled rock 'n' roll parties. There can be but one originator, one king (Elvis notwithstanding) of rock 'n' roll, and that role is played to the hilt by Little Richard.

galvanized both his audiences and his peers. Richard forever changed the way music is presented, both on record and in person. Breaking

As it continues to this day, the black music experience is underscored by a celebration of eccentricity as well as talent. The appeal of these true originals is as simple as it is sublime. As they embody their own utterly unique musical and personal points of view, they also serve to liberate their audiences by demonstrating that possibility of freedom inherent in us all.

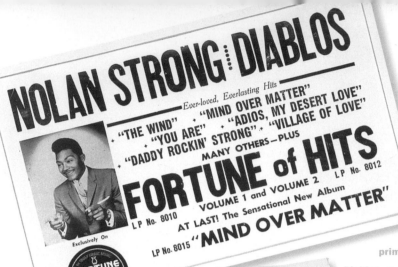

Nolan Strong and Nathaniel Mayer: the Fortune-ate few.

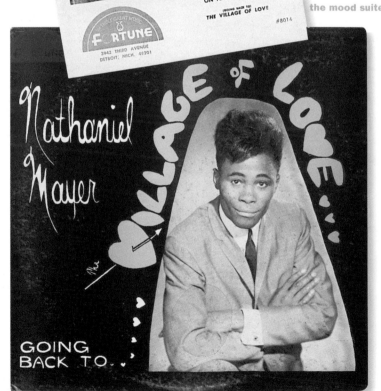

Preceding the formation of Motown in Detroit by more than a decade was Fortune Records. Literally a mom and pop operation that included a warehouse, retail store, and recording facility, it was founded by husband and wife Jack and Devora Brown in the late 1940s. Initially, the company recorded hillbilly and western-swing artists, capitalizing on the influx of Southerners pursuing automobile factory jobs in Detroit. In 1954, however, their business took on a different sound with the addition of several primal R&B hopefuls to the roster. The most successful of the lot, Nolan Strong & the Diablos, recorded such raw and potent tracks as the *Wind, Mind over Matter*, and the doo-wop-infused *Dolores*. Strong cited Clyde McPhatter as his primary influence, while no less a vocal light than Detroit neighbor Smokey Robinson testified to idolizing Strong.

Other Fortune recording artists included Andre Williams, a singer and writer who was obsessed with penology, evidenced in his string of prison-related laments that included *Jail House Blues, Pulling Time*, and the courtroom drama *Jail Bait*, a cautionary tale of statutory indiscretion that features the voice of the judge played by a mocking trumpet. Williams took time out from his study of penitentiary life to extol the virtues of *Bacon Fat* on a 1957 hit with Fortune label mates, the Five Dollars, whom he also managed, capriciously changing their name from the Dollars to the Don Juans and back again as the mood suited him.

Fortune prefigured the "garage sound" of many of today's earnest alternative grunge artists by actually recording some of its hits in a garage, alternately located in carports at 12th Street, Linwood Avenue, and finally on 3rd Avenue, where the entire complex was grandly named the Fortune Building. After the death of Jack Brown (some say caused by a crazed member of a hillbilly group in a hit and run "accident"), Devora, his wife, continued at the Fortune helm, writing, arranging, and engineering many sides.

In 1962, one of Fortune's most explosive attractions, Nathaniel Mayer, scored with the Fabulous Twilights on the primordial R&B mesmerizer, *Village of Love*; it was followed by, what else? *Return to the Village of Love*, an even more aboriginal ode. 🎵

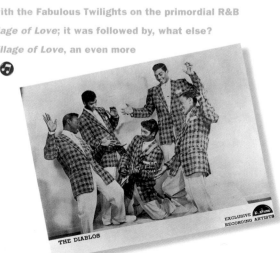

THE DIABLOS

Chapter 6
ART & SOUL

Chuck Willis: the Sultan of Soul.

ART & SOUL

Gee I miss you so, I wish your picture was you . . .

— Lloyd Price, *I Wish Your Picture Was You*

THIS PAGE R&B nobility: Chess precursor Aristocrat and the royal sound of Duke.

PAGE 89 ABOVE LEFT Chart burners: Fire and Sun Records. BELOW LEFT Fire's Buster Brown: burnin' soul. RIGHT Parrot, Bluebird, and Peacock records: the Bird is the word.

In marketing and merchandising music, record labels, from their inception, have labored to establish an identity among consumers, not only for their respective artists, but for their entire corporate image. Companies used the sleeve of the lowly single to make a statement about who they were, or, more often, how they wanted the public to see them. If the artist's message was in the music, the record company's calling card was the art on the label and sleeve. Since no one would buy a favorite radio tune because of the way the sleeve looked, record companies could use these tempting canvases to sell an image.

Of course, image was also crucial to the performers, and as colorful, corny, and even elegant as record art could be, it didn't hold a candle to the sartorial splendor and eye-catching power of the clothing sported by the stars themselves. Black artists by and large had an unerring aesthetic sensibility that they used to express who they were, or wanted to be, to their audiences. These marvels of self-creation surpassed the record companies' efforts at corporate image-making, but sometimes, when they were lucky, fans got both.

"The Medium is the Message"

It's hard to think of anything more tellingly named than the *labels* with which record company founders inundated the public. Ranging from the crudely personal to the grandiose, they permitted companies to indulge in all manner of fanciful reverie and wishful thinking. Called your company Duke? Well, then paste a crest on your product and throw in the slogan "Royal Fidelity" to hammer home the point. Putting on noble airs, in fact, was part and parcel of the blues scene. Leonard and Phil Chess, immigrant brothers from Poland, renounced their humble origins by naming their first label Aristocrat. After some hits with Muddy Waters, they felt secure enough to use their own name, but retained their pretensions to nobility by depicting a knight's piece on the label.

The label of the Houston-based vinyl home of Bobby "Blue" Bland appropriated the Cadillac "V" directly off the nose of a Coupe DeVille, while its parent label, Peacock, went the literal route by sketching its namesake on the label. For obvious reasons, bird motifs were popular with record companies, particularly with RCA, which perched its pioneering race subsidiary, Bluebird, as well as Parrot Records and, much later, Red Bird, on that conceptual limb.

Sun Records, portraying itself as the center of the musical solar system, clapped a bright yellow sun on its label that served as a beacon for fans of Junior Parker, Howlin' Wolf, Rufus Thomas, and, of course, Elvis, Jerry Lee Lewis, and others who recorded for that seminal Memphis label. A similarly obvious design advertised Bobby Robinson's Fire Records, the Harlem home of such notable and intense blues artists as Elmore James, Arthur "Big Boy" Cruddup, and Lightnin' Hopkins. The label, of course, looked as if it had just burst into flames.

Some connections between name and image were less clear. The symbolic power of Sun and

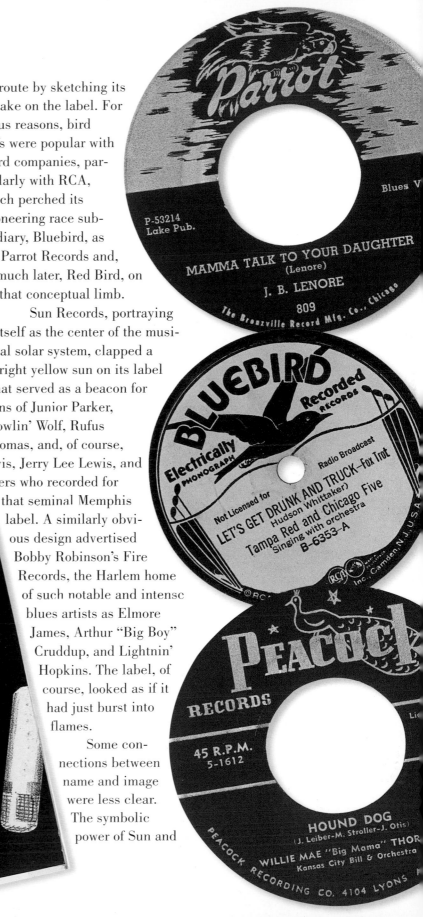

Fire Records's "brilliant" image-making contrasts with the somewhat puzzling illustration adopted by New York doo-wop pioneer George Goldner. Goldner had a penchant for the ponies, but alas, most of the nags he bet on failed to win, place, *or* show, which perhaps accounts for the uninspiring name of his company, End Records. What remains a mystery is why a tail-chasing dachshund adorns the company's sleeves and labels. Only slightly less obscure was the rationale behind the crude depiction of a Victorian-era bicycle on the label of Tamla, Motown's subsidiary. The link between the picture and the message? The company's half-baked slogan, "Another one . . . going places."

Nashville's Excello exuded pure class, as did its roster of stars. Other companies, like Hollywood's Aladdin, whose trademark was a magic lamp, adopted the practical expedient of using the record sleeve to advertise its artists. Atlantic's generic sleeve for 78-RPM singles featured illustrations of some of the most renowned artists of the 1950s, including Big Joe Turner, Ruth Brown, LaVern Baker, and Ivory Joe Hunter, backed with the label's stick-figure band.

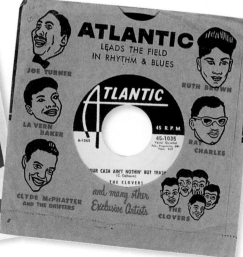

HEART & SOUL

Wax Impressions

Before the advent of the long-playing-album cover, graphic space on record labels and packaging was at a premium. Blues star Roy Milton addressed the issue in an innovative way in the 1940s by including cartoons of the song's often suggestive themes on releases for his own Miltone label. They were a blur at 78 RPM, but risqué fun when the turntable slowed down enough to allow an unblurred glimpse of the artwork.

The next logical step in record decoration was the famed Vogue picture discs. Both sides featured a full ten inches of brilliantly colored and evocative graphics actually pressed into the wax. This innovation was picked up by R&B singer and keyboardist, Cecil Gant, who emphasized his reputation as the "GI Sing-sation" by having his own likeness, replete in Army uniform, laminated into the grooves of his Gilt-Edged Records releases. Using the albums themselves as canvases had a new, if brief, life in the 1970s, when all manner of posturing rock stars were given their own twelve-inch picture discs.

But Is It Art?

By the 1940s, 78-RPM records were offered to the public in collections. These folios came to be known as *albums* and, along with posters, programs, and sheet-music covers, represented some of the earliest examples of visual expression designed to sell and symbolize music. Early graphic approaches heavily favored illustration and borrowed liberally from a variety of influences and schools, from art deco to

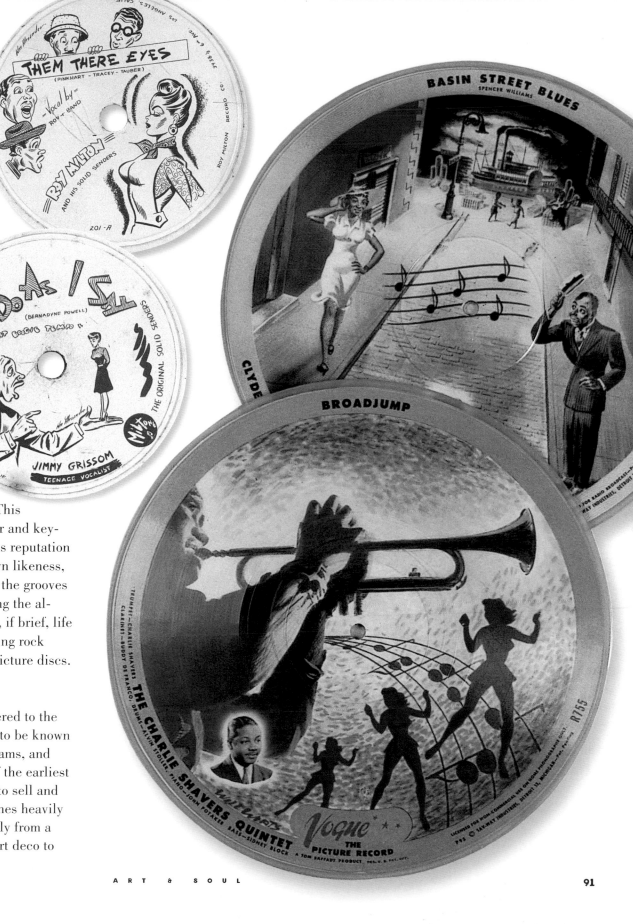

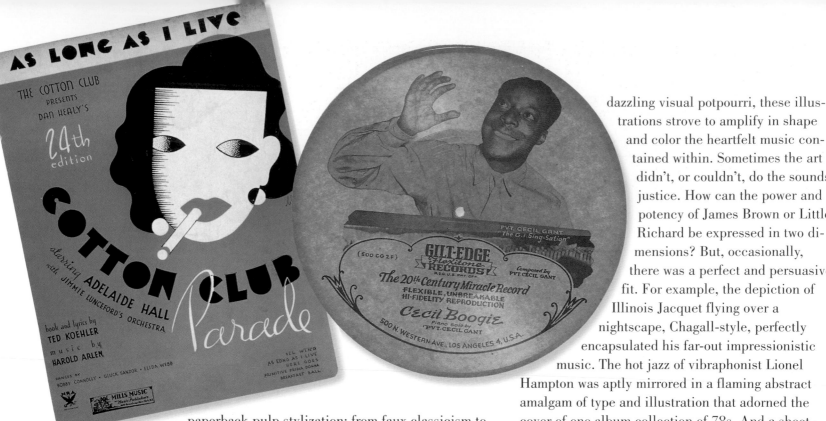

paperback pulp stylization; from faux classicism to every variation of cubist, pointillist, abstract expressionist, art naïf, surrealist, primitive, and beyond. A dazzling visual potpourri, these illustrations strove to amplify in shape and color the heartfelt music contained within. Sometimes the art didn't, or couldn't, do the sounds justice. How can the power and potency of James Brown or Little Richard be expressed in two dimensions? But, occasionally, there was a perfect and persuasive fit. For example, the depiction of Illinois Jacquet flying over a nightscape, Chagall-style, perfectly encapsulated his far-out impressionistic music. The hot jazz of vibraphonist Lionel Hampton was aptly mirrored in a flaming abstract amalgam of type and illustration that adorned the cover of one album collection of 78s. And a sheet-music cover for *As Long As I Live* from the Cotton Club Parade revue, showing a bob-haired, cigarette-smoking portrait of sophisticated chanteuse Adelaide Hall, summed up in cool sepias the cosmopolitan allure of that legendary venue.

The program cover of *Born Happy*, a Bill Robinson vehicle, pulled out all the visual stops with a derby-hatted, dice-tossing caricature in a blatant racist stereotype. Hadda Brooks, who in the 1950s became the first black woman ever to host her own TV show, appeared on the cover of her *Queen of the Boogie* album on Modern Music wearing a deco moderne crown and placed in a decidedly futuristic motif.

The arrival of the ten-inch, and later twelve-inch, long-playing 33⅓-RPM album forever codified the squared-off perimeters of record art. But, while the canvas might have been *square*, the artwork was anything but. Whereas labels like jazz bulwark Blue Note created a cool, restrained style completely its own, many other companies searched far and wide for the appropriate graphic to illustrate the music of their stars. For instance, what better representation

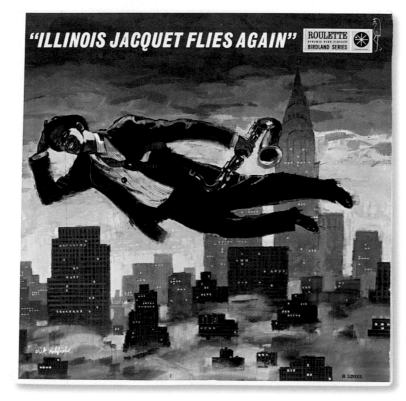

ABOVE LEFT **The Cotton Club: Harlem's legendary hotspot.**

ABOVE RIGHT **Cecil Gant: rhythm in uniform.**

BELOW **Illinois Jacquet's "freak" thing.**

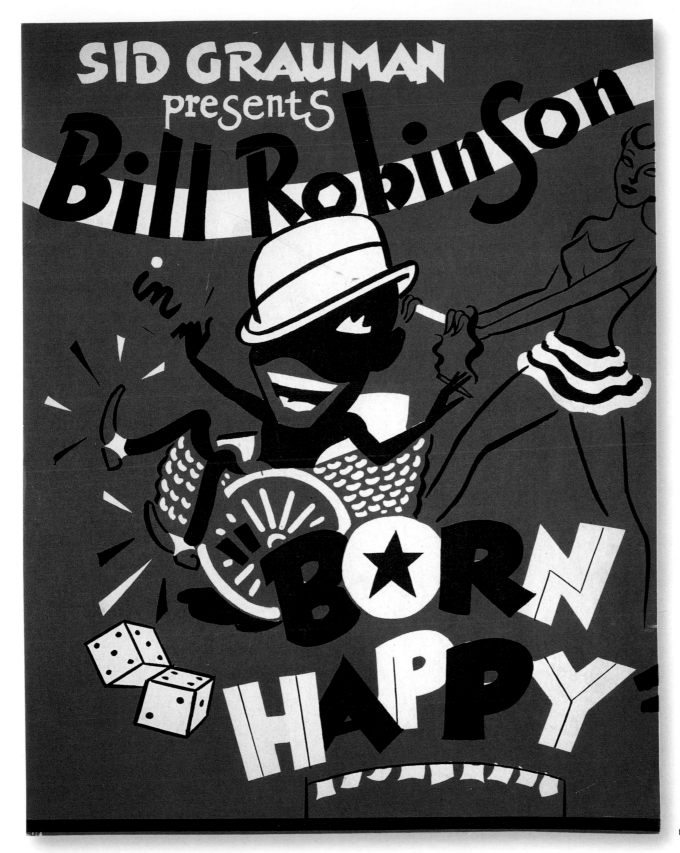

Bill Robinson: The early years.

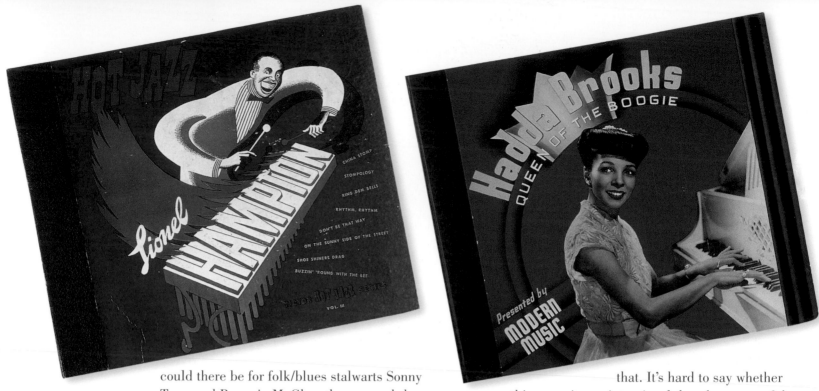

From drop shadows to wood cuts: visual artistry mirrored the music.

could there be for folk/blues stalwarts Sonny Terry and Brownie McGhee than a rough-hewn woodcut? Sax giant Lester "Prez" Young, who cast a giant shadow across the jazz world, was portrayed on the cover of his *Tenor Sax Solos* album doing just

that. It's hard to say whether this conceit was intentional, but the power of the visual impact was undeniable.

Often, cover art far from reflected the artist's gestalt. The career of the ancient and mellow blues-

man Lonnie Johnson was revived on a King Records collector's edition with absolutely no regard for the pioneer's smooth sound. Instead, pyrotechnics exploded across the type and the cover illustration of a bemused-looking Johnson. On the same label, the artwork on James Brown's second album, *Try Me*, was similarly out of synch, casting the singer's tender plea for a lover's favors as a gun-toting gal's pulp-style challenge.

Song Stylings

There was no way an inventive art director could go wrong if hc or she simply took the name of the group or the title of the featured song and rendered it in the simplest, most literal visual terms on the album cover. When smoldering soul god Al Green began his

PRESTON LOVE'S
OMAHA BAR-B-Q
FEATURING SHUGGIE OTIS ON GUITAR

STEREO
KST 540

KENT

Promotional Copy
NOT FOR SALE

EVERYBODY'S GOTTA PAY SOME DUES

TM-223

COOKIN'
WITH
the
MIRACLES

TAMLA RECORDS

THE SOUL CLINIC
HANK CRAWFORD

ATLANTIC 1372

FULL *dynamics-frequency* SPECTRUM

1 2
3 4 5

the best
of
the five
Keys

ALADDIN RECORDS HIGH FIDELITY LP 806

grayson

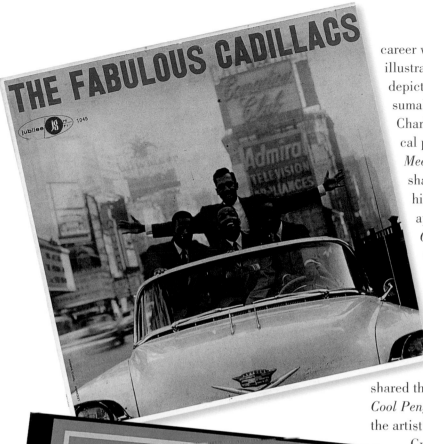

THE FABULOUS CADILLACS

career with the R&B workout *Backup Train*, the illustration for the follow-up album release depicted Al at the controls of a locomotive, presumably charging full steam in reverse. Ray Charles displayed at least two of his many musical personae on the album *Country and Western Meets Rhythm & Blues*, where he is shown shaking hands with costumed versions of himself. The irrepressible Dizzy Gillespie appeared on his Verve release *Dizzy in Greece* in full Hellenistic regalia, complete with pom-pom shoes and traditional skirt called a *foustinella*.

Such groups as the Coasters, the Emeralds, Honey and the Bees, and the Five Keys all got the literal treatment on albums that made art out of the obvious. The Penguins of *Earth Angel* fame shared the very frosty cover of their album *The Cool, Cool Penguins* with an actual penguin. Sometimes the artistic tie-ins seemed forced, as when Hank Crawford's *Soul Clinic* release featured the saxophonist with what looked like a chemistry set. Preston Love, another sax man and a graduate of the Johnny Otis school of R&B, donned an apron and chef's hat to illustrate the theme of his *Preston Love's Omaha Bar-B-Q* release. This followed an earlier "culinary" effort by the Miracles, who wore toques and wielded mixing bowls for their *Cookin' with the Miracles* album on Tamla Records.

For Otis Redding's *Dictionary of Soul* collection, a kitchen-sink ethos prevailed. Not only on the cover did the Big O sport a

COMPLETE & UNBELIEVABLE THE OTIS REDDING DICTIONARY OF SOUL

As the film *American Graffiti* entertainingly showed, the 1950s and 1960s were in some ways characterized by America's romance with the car, and musical groups and their album covers reflected this. Cadillacs figured large as the status symbols of choice for many artists, including, of course, the marque's namesakes, who on one album were pictured cruising Times Square. The automobile's power as a mark of prosperity is also evident on the cover of Little Junior Parker's *Driving Wheel* album. The cover pays tribute to the success of this potent blues singer by featuring a picture of a long, white 1960 Fleetwood Sixty Series, six-window, hardtop sedan parked outside Parker's palatial digs.

DRIVING WHEEL

Little Junior Parker

DLP-76

PAGES 96, 97 & 98
Taking it literally:
album art makes an
obvious point.

THIS PAGE ABOVE LEFT &
BELOW RIGHT Driving
home the point with
The Cadillacs and Little
Junior Parker.

BELOW LEFT Otis Redding:
Ph.D. of Soul.

scholarly mortarboard in Harvard crimson while leaning against volume O–R of a dictionary, but the back of the album took the concept to extremes with a "glossary of soul" defining such Otis utterances as "fa-fa-fa," "na-na-na," "gotta, gotta," and "my-my-my," a term independently highlighted on the cover for no discernible reason.

it's All in How You Wear it

On the cover of his album, *The Maharaja of the Saxophone*, tenor-sax man Lynn Hope wore an orange turban, an obvious visual nod to the album's title. Its appearance might also have had something to do with Hope's being a follower of Islam. Hope, whose adopted name was Hajji Ahmad, was the exception in explaining an artist's choice of this headpiece. What *was*

it about turbans that attracted so many black artists of the 1950s? Did their connection to the exotic, offbeat, daring, or simply strange account for its frequent presence atop the heads of artists who had no apparent connection to the Middle East? Whatever the case, turbans appeared with regularly on the heads of certain R&B, blues, and pop stars of the period.

Chuck Willis, who was fretting over the onset of pattern baldness, took to wearing a turban at the suggestion of his Okeh Records label mate, Screamin' Jay Hawkins. He eventually collected a reported total of fifty-four over the course of his career. The erstwhile *Sheik of the Blues* and *Sultan of the Stroll* was best known for his 1957 hit *CC Rider*, with its perfect stroll tempo. Although Willis came across as an exotic, *CC Rider* and its follow-up, *Betty and Dupree*, drew heavily on indigenous African American folkloric tradition.

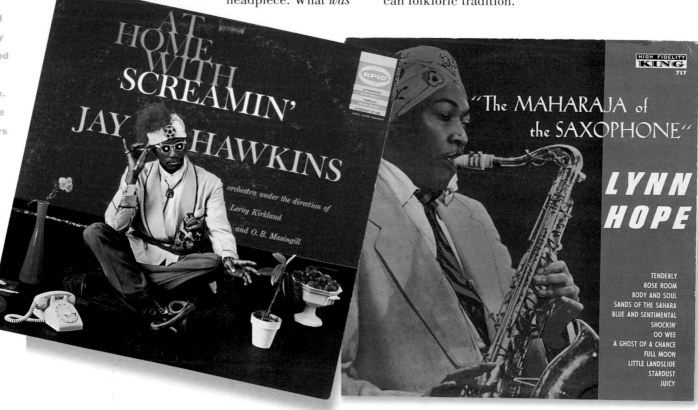

Crowns played an important role in the literal representation of the names of a number of rhythm and blues greats. The Imperials and the Five Royales both presented themselves in regal robes and glittering diadems on, respectively, *We Are the Imperials* for End Records and *The Five Royales*, appropriately released on King Records. The Five Royales, in fact, can claim to be blue bloods in the religious, if not the secular, sense; during their beginnings in gospel, they sang the Lord's music as the Royal Sons Quintet. And, for their part, Anthony Gourdine and the Imperials certainly belong in music's noblest ranks, with classic hits that included *Shimmy Shimmy Koko Bop* and *Tears on My Pillow*. The group eschewed their imperial trappings on an End

extended-play release, trading the purple for loud plaid dinner jackets (to achieve that all-important common touch, no doubt).

Sending himself into orbit, fashionwise, was New York disc jockey Jocko Henderson, who in the early 1950s had one of the first black-hosted teen-dance TV shows in the nation. Before moving to television, Henderson was known for his rhyming record intros and took teens of all races for a nightly ride over the radio airwaves on his *Rocket Ship Show*. A collection of hit songs culled from his radio program made their way onto vinyl as *Jocko's Choice R&B Oldies*, featuring the "Ace from Outer Space" in full astronaut regalia; this about a dozen years before Neil Armstrong took his "one small step."

PAGE 100 Chuck, Jay and Lynn: turban renewal. BELOW RIGHT Whether he went by Lynn Hope or Hajji Ahmad, the Alabama native will always be best remembered for 1950's "Tenderly," a hit on both R&B and pop charts.

THIS PAGE The Imperials and The 5 Royales: noblesse oblige.

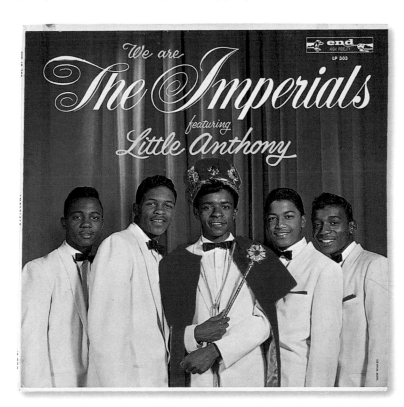

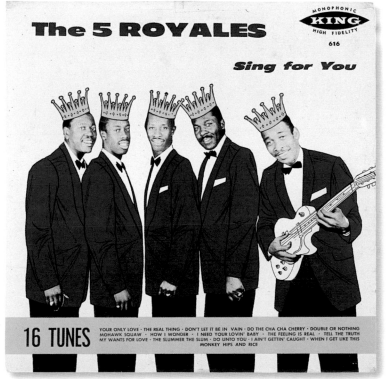

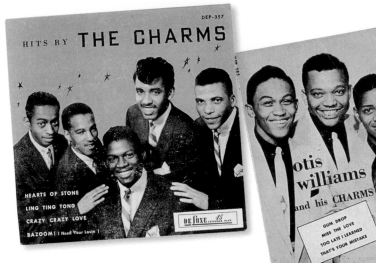

ABOVE LEFT & BELOW **Harman Bethea and Jocko: Masqueraders having a ball.**

ABOVE CENTER **The brilliant Charms.**

ABOVE RIGHT **Otis Williams and his "mob" once recorded "Ling Ting Tong," a song originally recorded by the Five Keys.**

When Gary "U.S." Bonds took a Caribbean jaunt on his album *Twist Up Calypso* for LeGrande Records, the singer, best known for his hit *Quarter to Three*, did not wear the tied-off shirt and tattered trousers of a true Calypso singer, possibly because it was viewed as demeaning. Instead, Bonds wore modified gigolo attire with a short-waisted iridescent bolero jacket. To add that indispensable island flavor? A conga drum and a bamboo shade. The album included the ersatz-calypso ditties *Dear Lady Twist* and *Twist, Twist Sonora*, neither of which had anything to do with the West Indies, unless you count the fake accent Bonds affected for the sessions.

Perhaps the most bizarre of all musical masqueraders was Harman Bethea, who wore a Lone Ranger-styled disguise when fronting his group the

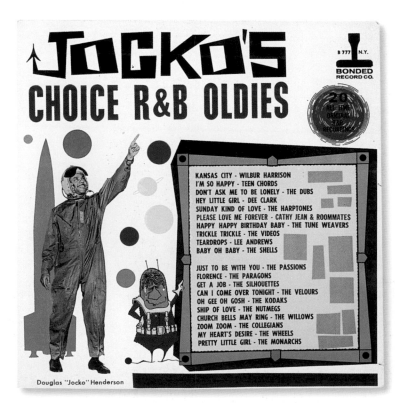

Agents on such obscure songs as *Life Is a Cafeteria*. Bethea's syntax was consistently wrong. Instead of "the Masked Man," Bethea proudly referred to himself as "the Mask Man," obviously relating personally to his choice of costume. Perhaps best known for

the cautionary hit *One Eye Open*, Bethea's album of the same name depicts a scene from his only other hit, *My Wife, My Dog, My Cat*. The cover features a crude rendering of his pets combined with a photo ostensibly of his wife and, of course, the artist

ABOVE For their publicity shot, the Five Keys sport courtly cravats with a Regency feel. Oddly, they began their careers as the Sentimental Four and ended up, at least in this photo, as a sextet.

LEFT U.S. intervention.

himself in a mixed-media pastiche every bit as puzzling as his Mask Man's true identity.

"Our Gang"

The pursuit of a group persona spawned a garish spectrum of "uniforms" ranging from the sublime to the ridiculous. From the 1950s to the present, the urge to buy a matching set of everything has proven well-nigh irresistible to the members of musical ensembles. In fact, in its effect of sublimating an individual's identity to the group effort, joining an R&B or soul ensemble was not unlike signing on for a hitch in the armed services.

Otis Williams & the Charms' version of the Jewels' *Hearts Made of Stone* was their primary claim to fame, but on the cover of their DeLuxe extended-play release, they seemed to be trying out for the role of enforcers for the Cosa Nostra, complete with dark shirts and white ties.

Remember the Cadets of *Stranded in the Jungle* fame? They adopted an alter ego, the Jacks, to perform their ballads. With exactly the same lineup as the Cadets, the Jacks scored a Top 5 hit with *Why Don't You Write Me*. For the cover of their *Jumpin' with the Jacks* album, their only long player, the guys dressed most conservatively with matching dark suits and ties and tasteful pocket squares. Their brilliant white shoes were the only link to the unrestrained flair of the Cadets.

Philadelphia's five beauties, the Deltairs, evinced a flair for Greek drama in a publicity shot promoting their 1957 hit on Ivy Records, *Lullaby of the Bells*. The group posed in clinging wraparound gowns that seemed to have been borrowed from Mount Olympus's wardrobe mistress.

The Dubs and the Shells had a fashion face-off on the tarmac when they shared the cover of their

ABOVE Sometimes, a group's attire was dictated by their repertoire: the message was, indeed, the medium. In a publicity shot for the Delroys' 1956 hit "Bermuda Shorts," the Queens, New York quartet appeared dressed in the titular knee-length britches and matching argyle socks.

BELOW Sharp dressed men: the Dubs, the Shells and the Jumpin' Jacks.

PAGE 105 Hold the phone, it's the Orions.

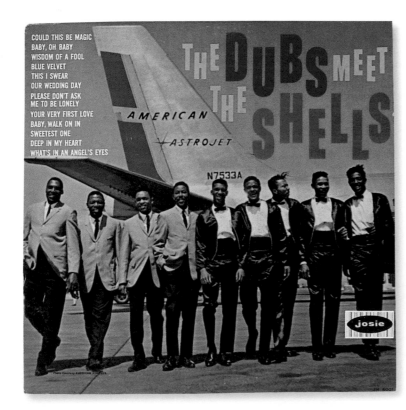

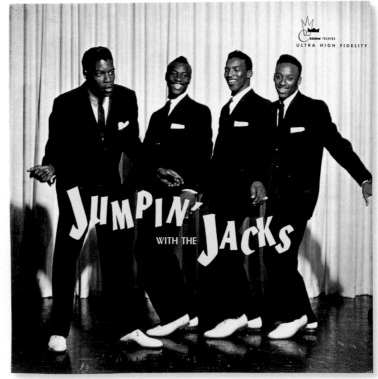

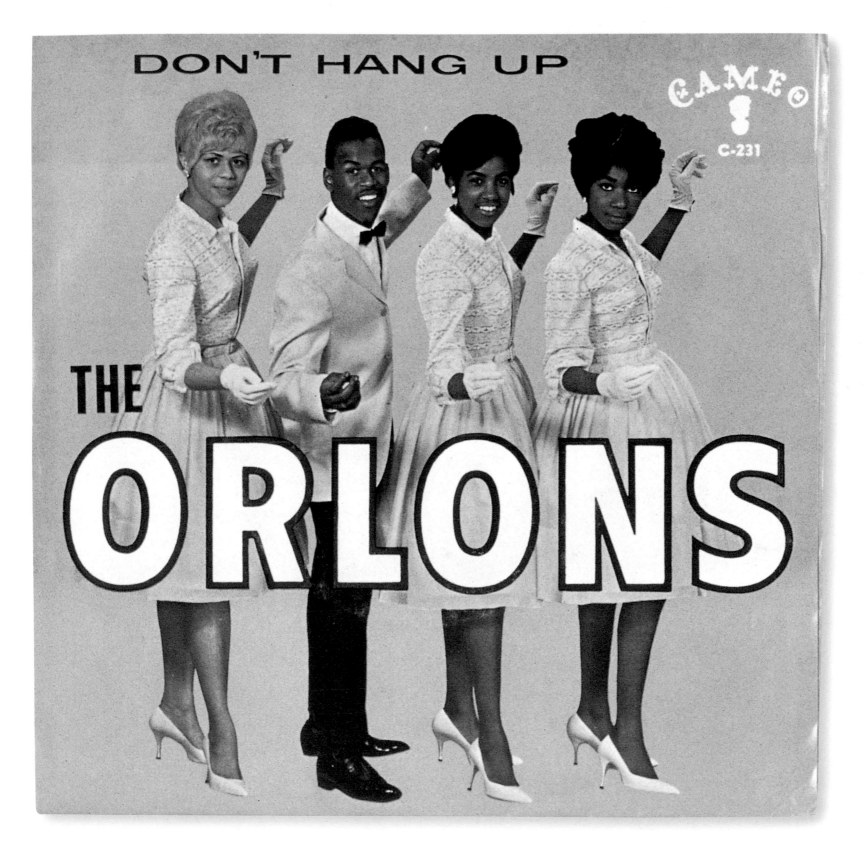

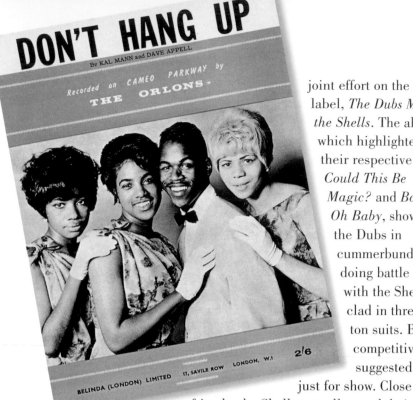

joint effort on the Josie label, *The Dubs Meet the Shells*. The album, which highlighted their respective hits *Could This Be Magic?* and *Baby Oh Baby*, shows the Dubs in cummerbunds doing battle with the Shells clad in three-button suits. But any competitiveness suggested was just for show. Close friends, the Shells actually owed their start to the Dubs, who invited the Shells to piggyback onto the session that yielded the Dubs' hit *Baby Oh Baby*.

The Miracles had the challenge of achieving a uniform look for a lineup that was not completely homogeneous. They had two anomalies to deal with, the first being Claudette, the wife of Miracles' front man Smokey Robinson and the only female in an all-male lineup. The second was how to include guitarist Marv Tarpin, who, although not an official member of the Miracles, appeared at all their live dates, performing the duel functions of acting as their on-site musical director and keeping the house band in line.

The group was inconsistent in their treatment of these elements. On the cover of their *Fabulous Miracles* album, the group's upper torsos, including Claudette's, are resplendent in gold lamé. Marv, with Les Paul Gibson guitar in hand and at the center of the setup, wears a dark jacket with lamè trousers, neatly reversing the rest of the group's look and bringing a symmetrical perfection to the shot. The 1962 picture sleeve for their hit *I'll Try Something New*, on the other hand, shows Marv sporting the same double-breasted getups as the Miracles, and Mrs. Robinson standing out by making no effort to blend in.

The Orlons' adoption of a synthetic fabric name was a sly dig at

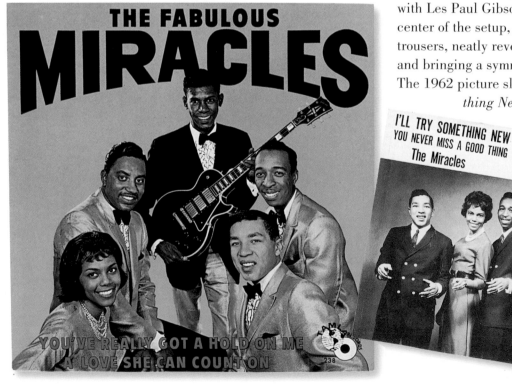

ABOVE LEFT & BELOW **The Orlons and The Miracles: co-ed cool.**

ABOVE RIGHT **The Deltairs: a soul sorority.**

their musical predecessors at Overbrook High, the Cashmeres (later the Dovells). For the cover of their Cameo LP, *Don't Hang Up*, they opted for crisp crinoline. The group featured a trio of comely Philadelphia warblers—Rosetta Hightower, who would later become a fixture in the UK music scene; Marlena Davis; and Shirley Brickley—joined by baritone Steve Caldwell. They are best known for the cautionary *Don't Hang Up*, a Top 5 hit on R&B and pop charts in 1962, and for the dance-enhancing *Wah Watusi* and ode to their Philly roots, *South Street*.

Let Me In, implored the Sensations, another Philly group, on their 1961 hit of the same name. It was an irresistible plea when delivered by Yvonne Mills, Alphonso Howell, Richard Curtain, and Sam Armstrong, dressed in matching faux-leopard-skin attire, just as they appeared on the cover of their Argo album (featuring another Sensations charter, *Music, Music, Music*, a cover of the Teresa Brewer perennial). Lead singer Yvonne completed the

exotic motif with a fetching Sheena–esque, off-the-shoulder number.

The Five Stairsteps, a family affair from Chicago, took the concept of matching outfits to garish extremes on the cover of their self-titled, mid-1960s album on Curtis Mayfield's Windy C Records label. Clarence, James, Kenneth, Dennis, and Alohe Burke appeared in black cabretta-leather car coats and crimson trousers. The group—often cited as a template for the Jackson Five, who were growing up in nearby Gary, Indiana—had the affect of upscale Blackstone Rangers, the dominant Chicago street gang of the time. Billed as "America's First Family of Soul," the Five Stairsteps racked up a string of mid-chart hits produced by Curtis Mayfield. In 1967, they were joined by two-year-old baby brother, Cubie.

The Philadelphia "Look"?

The 1970s ushered in an era of feathers and furs, velvet and velour, as groups strove for the reflexive over-

LEFT **The Sensations: opening fashion's door.**

RIGHT **The Five Stairsteps: style escalation.**

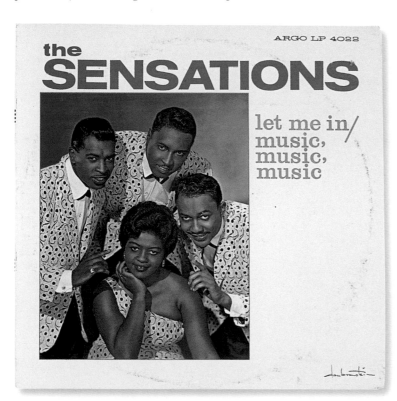

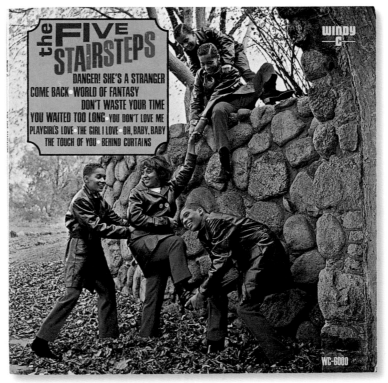

statement in keeping with that glitzy decade. At the cusp were three stalwarts of the distinctive Philadelphia Sound, the Ambassadors. On the cover of their Arctic Records release, *Soul Summit*, the Ambassadors may not have looked like members of any diplomatic corps we know, but there's no question that their double-breasted evening wear with Chesterfield collars, red contrasting Edwardian lapels, and ruffled shirts looked smashing against the imposing front of the Philadelphia Museum of Art. Their image occupied only a brief moment in time, however, as the Ambassadors vanished from the charts soon after their one and only hit, *I Really Love You*.

The Intrigues, also from Philadelphia, had a chart run only nominally longer than the Ambassadors'. On the cover of their Yew Records album named for their one Top 10 hit, *In a Moment*, their outfits were indeed an *intriguing* blend of a foppishly styled shirt and a parti-colored, batik pants-and-vest ensemble.

Singer/producer/manager Richard Barrett saw his composition *Maybe*—which had years earlier established the Chantels as a vocal force to be reckoned with—resurrected by the lovely Three Degrees. But, while the Chantels were personifications of the demure and chaste, the Three Degrees were sexy and suggestive, as evidenced by the sultry spoken intro to their version of *Maybe*. On their 1970 Roulette album, the trio sported an alluring décolletage-and-navel-bearing smock and hip-hugger combo that contributed to their blatant erotic appeal. The ladies followed up *Maybe* with the monster hit, *When Will I See You Again?* and the acronym-rich *TSOP by MFSB (the Sound of Philadelphia by Mother Father Sister Brother)*.

Double-wide and Hyper-flared

The heavy disco look endemic to the fabulous 1970s was front and center with Chicago's Notations, who found the style so nice, they used it twice . . . on the

Ambassadors and the Intrigues: members of the 1970s style council.

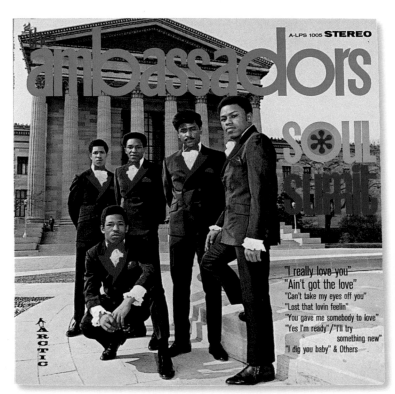

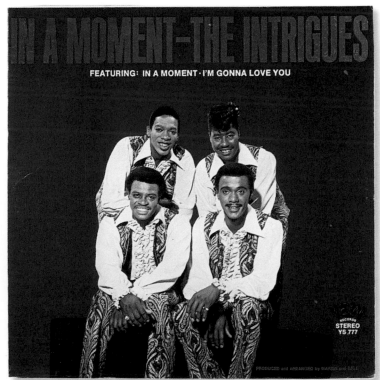

HEART & SOUL

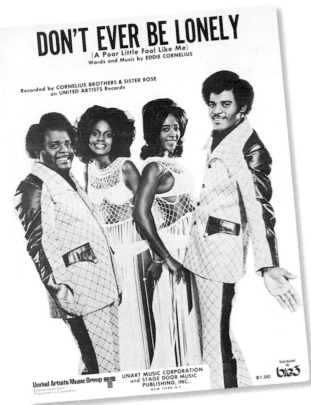

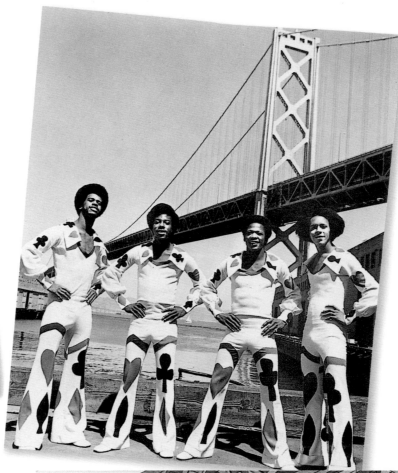

same album cover. The group, decked out in powder-blue, triple-knit, poly-velour suits with double-wide lapels and hyper-flared pants, are seen kicking back in a rattan, shag, and palm-frond paradise, while behind them the ghostly image of their stage selves seems to be serenading their earthly personae. They recorded their hit *It Only Hurts for a Little While* for Gemigo Record.

It was the 1970s triumphant when San Francisco's Master Plan posed in front of the East Bay Bridge. Although the short-lived group never saw the upside of the charts, it was not from a lack of style. Fashion was definitely their "strong suit," as evidenced by their skintight uniforms, festooned with spades, clubs, hearts, and diamonds.

But even the most dedicated 1970s Beau Brummels would have to go a very long way indeed to achieve the excess of the Cornelius Bros. & Sister Rose. They appeared on the sheet music for *Don't Ever Be Lonely* unabashedly adorned in a bizarre multimedia melange of mattress quilting, with fringed suede-ette paneling and pocket flaps, midriff

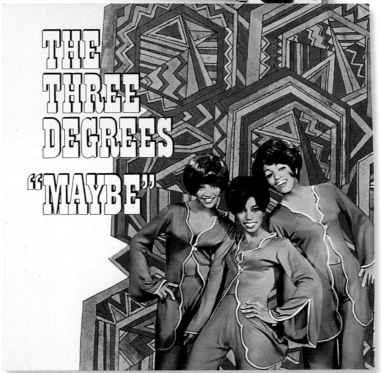

ABOVE LEFT **Cornelius Bros. & Sister Rose: a family fashion flair.**

ABOVE RIGHT **Bridgework by the Master Plan.**

BELOW **The Three Degrees.**

chains, and spangled halters. The South Florida quartet was made up of brothers Edward and Carter and, of course, sister Rose Cornelius. A second sister, Billie Jo, joined the lineup after the group caught fire. *Don't Ever Be Lonely* was the 1972 hit follow-up to their twin smashes, *Treat Her Like a Lady* and *Too Late to Turn Back Now*.

⸻ ◼ ⸻

Album-cover art and record-sleeve design are the artist/record company's powerful visual statements to the consumer. As with virtually every form of advertising, subtlety and nuance are abandoned in favor of a strong, immediate, and, it is hoped, lasting impression. By definition, the images have more to do with marketing than art. However, just as popular music frequently transcends its commercial origins, the creative talents behind these often-stunning designs could and did produce artistic works, particularly when measured by their ability to evoke these amazing artists and their enduring music. ♫

The Notations: powder-blue persuasion.

Chapter 7
GOIN' UPTOWN

Bill Robinson steppin' out.

GOIN' UPTOWN

And as I walk through this world,
nothing can stop me, because I am the Duke of Earl . . .

— Gene Chandler, *Duke of Earl*

Duke's hues: classic Ellingtonia.

RCA VICTOR SHOWPIECE

BLACK and BEIGE

BROWN

a DUKE ELLINGTON tone parallel
to the American Negro

as played by the composer and his Famous Orchestra at his Carnegie Hall concerts

Black style has often transcended the aesthetics of the down and dirty, the down home, or funk for funk's sake. To be sure, black music is founded on an earthy, emotional, and expressive impulse that is usually most at home on the "wrong" side of the tracks. But, as often as not, black music, and the musicians who created it, developed a degree of sophistication in terms of musical technique and presentation that evolved in tandem to its raw and unvarnished counterparts. For every Lightnin' Hopkins, there's a Paul Robeson; for every Midnighters, there's an Inkspots; for every Little Richard, there's a Duke Ellington.

Jazz Gentry

Ellington is a sterling point of departure for any exploration of the class acts of black style. Simply put, the legendary bandleader epitomizes all the best of the uptown, top-hat-and-tails, champagne cocktail, and cigarette-holder sensibility that infuses much of black music. Witness, for example, his

collection of 78-RPM recordings, *Black, Brown and Beige*. The album cover's very hues convey tasteful understatement. Recorded in the fortress of highbrow, Carnegie Hall, the music purports to represent nothing less than the whole range of African American history, and the scholarly, quasi-classical sheen did nothing to detract from Ellington's haute monde reputation. Neither, for that matter, did his recording in 1931 of *Mood Indigo*, also known as *Dreamy Blues*. Ellington had recorded it earlier with different ensembles, including the Harlem Footwarmers on Okeh and the Jungle Band on Brunswick, but the most familiar version was with the Cotton Club Orchestra on Victor.

Ellington's smooth, elegant style charmed the fairer sex, and he had a number of courtly come-on lines that rarely failed to strike an amorous spark: "My, but you make that dress look lovely"; "I can tell that you're an angel. I can see the reflection from your halo shining on the ceiling"; or the surefire,

"Whose little girl are you?" Fastidious to the point of obsessive-compulsive behavior, Ellington adopted all manner of fanciful taboos and superstitions by which he ordered his life. For example, he would never give a pair of shoes for a present or eat peanuts in the dressing room. And he forbade his band either to wear the color yellow or to button a shirt all the way down the front. If one of his own regal cloaks was missing a button, he would retire the entire garment rather than have one sewn on.

Ellington's patrician bearing was mirrored, modified and, in some cases, subverted by contemporaries and musical progeny alike. Cab Calloway presented a skewered version of the man about town in white tie and tux, but with heavily pomaded hair falling into his wild eyes.

Bill Robinson would never be caught out on the town without his top hat and white gloves. Even while appearing with Shirley Temple and portraying a butler, he dressed to the nines. Bill and Shirley are shown in their most stylish incarnations on the sheet-music companion to the third edition of the Cotton Club's theatrical presentation, *The Cotton Club Parade*. The revue included the songs

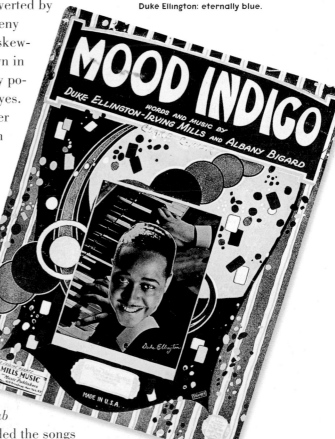

Duke Ellington: eternally blue.

Harlem Bolero, Savage Rhythm, and *She's Tall, She's Tan, She's Terrific.*

Count Basie affected a jaunty nautical demeanor with a yachtsman cap, skinny tie and lapels in the 1960s when he became a Vegas adjunct to the Rat Pack at the Sands. Fats Waller's trademark chapeau was a dapper derby cocked at a rakish angle. His *Ain't Misbehavin'* was expressed most eloquently by Louis Armstrong, who introduced his version as part of *Connie's Hot Chocolates*, a revue that began at Connie's Inn, the Cotton Club's principal Harlem competitor.

As did Basie and Ellington, Ella Fitzgerald transcended the whims of contemporary fad and fashion and dominated the jazz vocal field with her consummate artistry for more than half a century. As much a solo vocal pioneer as Ella proved to be over that time, she was equally adept at creating memorable music in concert with other musical greats in any number of idioms. Among her more notable collaborations was that with Decca label mates, the Inkspots, on a series of hits in the mid-1940s that included *Into Each Life Some Rain Must Fall, I'm Beginning to See the Light, Cow-Cow Boogie,* and *I'm Making Believe* from the film *Sweet and Low-Down.*

Other historic pairings juxtaposed Ella with the two Louis: Armstrong and Jordan. With Jordan she recorded the evocatively titled saga *Stone Cold Dead in the Market (He Had It Coming)* and *Baby It's Cold Outside* (later, a substantial hit for

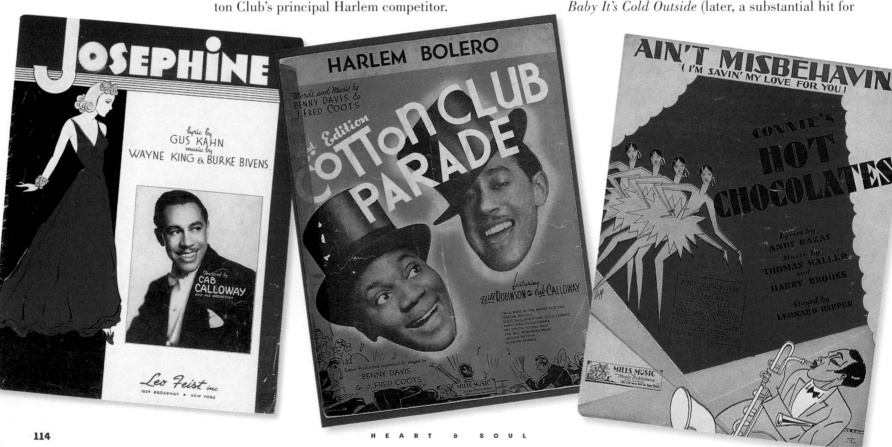

The always-animated Cab Calloway.

another power couple, Ray Charles and Betty Carter). Teaming with Armstrong, she recorded, among other tracks, *The Frim Fram Sauce* and *You Won't Be Satisfied Until You Break My Heart*. She also did sessions with her one-time boss, drummer/band-leader Chick Webb, whose orchestra she herself directed for a short time following his death in 1939. All these and more were included on a mid-1950s Decca concept compilation album, *Ella and Her Fellas*, which also paired the chanteuse with the Mills Brothers, Eddie Heywood, the Delta Rhythm Boys, and Sy Oliver. Not flashy in her looks or attire, Ella neverthe-

less upheld a stylistic standard that was both tasteful and refined, an unerring reflection of her artistry.

Pianist Earl "Fatha" Hines, affectionately dubbed "Jug Brother" by Fats, had a sense of style that extended even to his band's boudoir. He provided them with bathrobes and pajamas, and urged each player to sport a flower in his robe's lapel, because, as he told co-hort Art Blakely, "you never know when the press is coming." Hines founded a posh Chicago nitery in 1945 called the El Grotto. For a time, it was the premier Chicago watering hole until its owner went broke and joined Louis Armstrong's

ABOVE LEFT **"Fatha" figure Earl Hines.**

ABOVE RIGHT & PAGE 117 BELOW **Ella's winning combinations.**

BELOW RIGHT **Jazz giants Satch and Nat.**

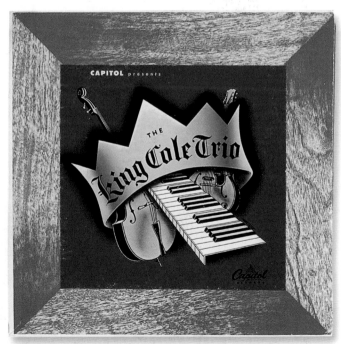

HEART & SOUL

All-Stars in 1948 to help make ends meet.

The great Nat King Cole was an early disciple of Fatha Hines and another eternal jazz/pop icon with a refined flair. The son of an Alabama Baptist minister, Cole eclipsed his mentor not on the keyboard—where he showed early promise along the lines of Art Tatum and Oscar Peterson—but as a silky smooth vocalist whose effect on an audience was nothing short of mesmerizing. The Nat King Cole Trio was formed in 1939, somewhat by accident. Cole had intended his group to be a quartet, but when the drummer failed to show at their gig at the Swanee Inn on La Brea Avenue in Los Angeles, he made the best of the short count and never looked back. His cohort at that time was bassist Wesley Price, later replaced by Johnny Miller and Oscar Moore, author of a highly regarded guitar instruction book.

The Nat King Cole Trio dressed like they sounded: understated, with suits that were neither Zoot nor cute, but impeccably tailored. Cole and his crew set the tone with a cocktail sophistication and cosmopolitan flair that reverberates to this day. In 1948, Cole began recording under his own name, and his first proprietary hit was the hauntingly evocative *Nature Boy*. It went to number one on the pop charts with a melody based on an old Yiddish folk tune *Schweig Mein Hartz*. Before his death in 1965, he had hosted his own TV series, seen his songs used in scores of films, and had hits that appeared at the top of the charts with clockwork regularity—the *Christmas Song*, *Get Your Kicks on Route 66*, *Mona Lisa*, *It's Only a Paper Moon*, and *Rambling Rose*—all enduring classics.

Earl's Court: Chicago's El Grotto.

Sepia Tones

Pianist Charles Brown was also the visual and musical picture of elegance. After departing Johnny Moore's Three Blazers in 1949, Brown developed a distinctive brand of mellow mood

music dubbed "cocktail blues." Everything about the music of this Texas native was low-key, urbane, and elegant, but he cut a dashing figure. In spite of his refined musical and performance styles, Brown was a flamboyant personality. He would arrive at his dates in a powder-blue Cadillac Fleetwood, sporting a mink cape and matching tie, often with a jewel-encrusted beret over his toupee, and accompanied by his pet Doberman and his full-blooded Cherokee grandfather. Brown's ten-inch LP,

Oscar Moore: solo and with royalty.

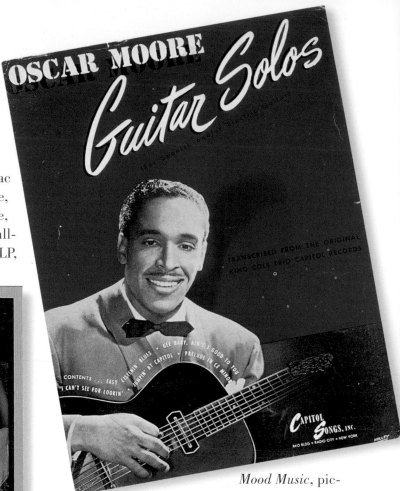

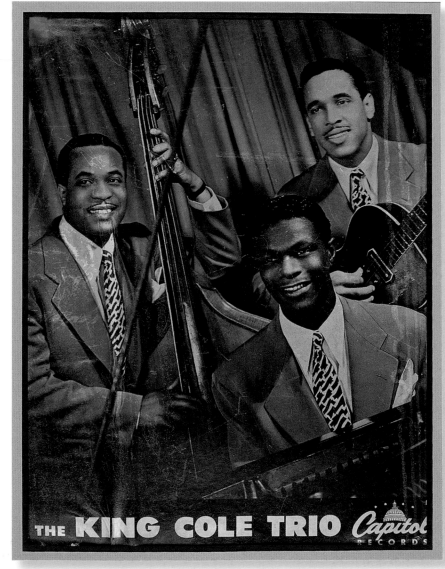

Mood Music, pictured the suave performer in a sepia-drenched motif, underscoring the color's long association with the classiest aspects of American black music.

Saxophonist Paul Williams likewise came across as a debonair sophisticate when pictured in deep, sepia-toned shadows on the cover of his Savoy ten-inch LP. Williams, pegged as the perky "Hucklebuck," worked with the likes of James Brown, Lloyd Price, and Ruth Brown, and led Atlantic's in-house studio band during the 1950s.

Earl Bostic received the same sepia-toned treatment on the cover of *Earl Bostic and His Alto Sax*, issued in England on King's U.K. licensee, Parlophone. Bostic attended Xavier University in New Orleans and wrote a number of smooth and supple jazz and R&B standards. One of these, *Let Me Off Uptown*, made no secret of the location of his favorite haunt.

Like Ellington, Jimmie Lunceford was taken with the black-and-tan concept, going so far as to record a hit entitled *Black and Tan Fantasy* in 1935. A seminal swing bandleader, Lunceford insisted that his musicians follow his example and dress to the nines. He was a stickler for perfection, and although he was a saxophone player of some ability, he would set the instrument down to turn his full attention to conducting his orchestra.

One of the key elements of the Lunceford sound was Sy Oliver, vocalist, trumpeter, and arranger, whose charts for *Organ Grinder Swing* and *T'ain't What You Do (It's the Way That You Do It)* are considered exemplars of swing-era genius. But Lunceford and Oliver are perhaps best remembered for another pivotal swing ground-

breaker: *For Dancers Only. Rhythm Is Our Business*, declared Lunceford in the title of his first number one hit in 1935, and so it would be until his untimely and mysterious death in 1947. Legend has it that he was murdered by a racist restaurant owner who poisoned Lunceford after the bandleader demanded service for his orchestra.

Jonah Jones, a veteran of the Lunceford band, was trumpeter who had a comedic flair to match his dapper appearance. He formed a music and comedy act with Stuff Smith, a violinist whose career included collaborations with everyone from Jellyroll

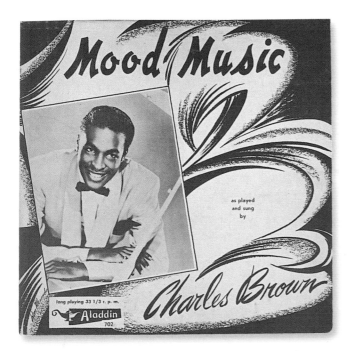

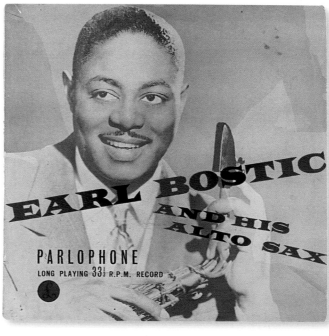

Lunceford, Brown and Bostic:
rhythm's suave sophisticates.

Morton, Fats Waller, and Dizzy Gillespie to Nat King Cole and Ella Fitzgerald. As a straight-up but still flamboyantly mirthful musician, Jones played with an equal number of musical legends, among them, Fletcher Henderson, Cab Calloway, and Earl Hines. His many accomplishments include his resurrection of the 1914 number one hit *Ballin' the Jack*, first recorded by the Prince's Orchestra, the Columbia Records house band of the time.

Although Kansas City bandleader Andy Kirk, who was married to his piano player Mary Lou Williams, was the picture of decorous dandyism, he was known to cut loose with fellow sax maniacs Lester Young, Dick Wilson, Coleman Hawkins, and Jimmie Lunceford at a Harlem after-hours haunt called the Victoria Bar & Grill. There they spent many nights of legendary carousing, jamming, and frittering away of fortunes. Kirk was one of the few baritone (bass) sax men in the business, but for the most part he eschewed his basso-profundo instrument to focus on bandleading à la Jimmie Lunceford. Kirk's string of mid-1930s hits included his theme song, the maudlin *Until the Real Thing Comes Along*, and *I Won't Tell a Soul (I Love You)*.

Trumpeter and bandleader Erskine Hawkins put his sophisticated style straight to music in 1939 with his biggest hit, *Tuxedo Junction*, covered shortly afterwards by Glenn Miller. Both were released by Bluebird Records. Dubbed "the Twentieth-Century Gabriel" for his distinctive horn work, Hawkins was an Alabama native with a flair for the high end of the register. After relocating to New York, he became a staple with swing dancers at the Savoy Ballroom. His string of pop and R&B hits included 1948's *Gabriel's Heater* and *Corn Bread*, *Tippin' In*, and the corollary,

ABOVE LEFT **Jonah Jones brought the "Jack" back.**

ABOVE RIGHT **Andy Kirk: bassman with band.**

BELOW RIGHT **Cecil Gant: khaki cool.**

Sneakin' Out. Hawkins's mastery of his instrument resulted in a seemingly effortless style of play that once resulted in an admonishment from the inimitable Satchmo himself. Impressed by Hawkins's facility, Armstrong cautioned him, "you're making it look too easy."

Cecil Gant, the "GI Sing-Sation," had a sense of style that leaned heavily on his standard-issue GI uniform. In virtually all his publicity shots and album-cover poses he wore sharply pressed dress khakis direct from the quartermaster. Gant was a protorocker who got his big break in Los Angeles in 1944 when he appeared there at a war-bonds rally. He so stirred the crowd that he was signed to a record deal and billed on the label as "Private Cecil Gant." Gant's pounding piano style had been honed in roadhouses in the Deep South before the war, and he used it to propel a number of R&B hits, including *I Wonder*, *Cecil's Boogie*, *Grass Is Getting Greener*, and *I'm a Good Man, But a Poor Man.*

Fifties Cool

Cool iconography of the 1950s elegantly expressed the postwar minimalist aesthetic. Zoot suits and top hat and tails gave way to skinny ties and highballs, as well as a studied understatement that epitomized the era and was summed up by the resonant sound of the vibraphone. Among the more notable of the period's vibraphonists was Milt Jackson, nicknamed "Bags" for the luggage under his eyes. Before he founded that pinnacle of jaded jazz detachment, the Modern Jazz Quartet, Jackson was a solo performer known for his tolling-bell sound and mix of cool jazz and dusky blues.

What the Modern Jazz Quartet symbolized in the jazz realm, Sam Cooke personified in pop. A dangerously handsome man with a voice to match, he was, unquestionably, one of the most important bridges between black music and the lucrative realms of mainstream pop. Cooke, a veteran of the gospel circuit, took on an ultrasmooth stage persona

calculated to drive the ladies well past the limits of decorum. He successfully took his act from R&B hot spots like the Apollo straight into the heart of white show business with SRO stands at venues like the Copacabana.

In many ways Cooke's career had a strange yet explicable schizophrenia that dogged his whole professional life. As a gospel singer, he

Erskine Hawkins

EXCLUSIVE RCA VICTOR RECORDING ARTIST

SAVOY MG 12080

JACKSON'S-VILLE

Featuring

MILT JACKSON-VIBES
LUCKY THOMPSON-TENOR
HANK JONES-PIANO
WENDELL MARSHALL-BASS
KENNY CLARKE-DRUMS

ABOVE "In" and "out" with Erskine Hawkins.

BELOW Milt Jackson: Bag's good vibes.

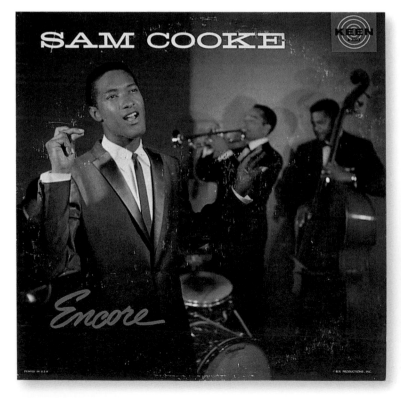

originally recorded secular material under the pseudonym Dale Cooke to avoid alienating his church following. As a pop star of major proportions, Cooke tailored his act to the color of the crowd. For instance, the Copacabana dates featured Cooke rendering show tunes, while a posthumously discovered recording of a set played at a Miami inner city nightspot, *Live at the Harlem Square Club*, highlights a much more immediate and charged performer. His impressive string of hits tells the tale: his first mainstream single, 1957's *You Send Me*, reached number one in both pop and R&B categories and was followed by a succession of double-barreled chart burners that included *Everybody Likes to Cha Cha Cha*, *Wonderful World*, *Chain Gang*, and *Having a Party*. Before his untimely and sordid death in 1964 at age 29, Cooke

Chuck Jackson, Sam Cooke and Clyde McPhatter: R&B beau brummels.

had achieved a match of black style with white sensibilities that would rarely be equaled in the annals of American music.

On the pure R&B side, Clyde McPhatter created the pattern that countless earnest and intense 1950s vocalists would use to fashion their careers. Sweet tempered and shy, McPhatter was born in Durham, North Carolina, and first came to fame as a member of Billy Ward's Dominoes. He left in 1953 to form his own ensemble, the Drifters, and, after his discharge from the Army in 1955, reeled off a catalog of effortless, engaging classics starting with *Love Has Joined Us Together*, a duet with Ruth Brown (with whom he had a brief fling), *Treasure of Love*, *Just to Hold My Hand*, *Lover's Question*, and more. Dapper to the point of

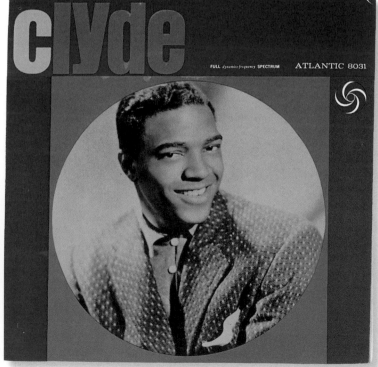

distraction, McPhatter exuded an aura of elegance that found its way into a vastly influential body of work.

Vocalist Chuck Jackson counted as one of his prime musical influences McPhatter's replacement in the Dominoes, the great Jackie Wilson. Jackson was himself a graduate of a latter-day version of the Del-Vikings. Equally at home in a tux, tailored suit, or V-neck alpaca sweater, Jackson had a commanding baritone used to great effect on 1960s hits such as *I Don't Want to Cry* and *Any Day Now*. His fashion flair was noted by Ruth "Miss Rhythm" Brown, who recounts that Jackson was variously known as "the Peacock" for his preened look or as the less-than-flattering "Thimble Ass" for his slight proportions.

Nicknames and trademarks often defined an artist's public persona. The album cover for the *Cool Sounds of Albert Collins*, with its towering highball, worked in a visual pun that played off Collins's name, as well as his nickname, "the Ice-Picker." The Texas-bred guitarist and blues growler exploited the cool angle for all it was worth. With his spare, icy, and unadorned guitar-picking style, Collins created a whole blues sub-genre with cuts like *Frosty*, *Frostbite*, *Thaw Out*, *Icy Blues*, and *Snow Cone*, as well as albums entitled *Ice Pickin'*, *Frostbite*, *Frozen Alive!* and *Cold Snap*.

Another down-home denizen with a taste for tuxedos is bluesman B.B. King. Currently a one-man ambassador for the blues, the Indianola, Mississippi native today owns his own nightclubs and has landed more accolades than any dozen of his contemporaries combined. Best known for his crossover hit *The Thrill Is Gone*, King has made himself acceptable to a wide audience, in part, by his assiduous attention to an upscale image that includes a trademark tux on stage. His astute manager,

LEFT **Even James Brown, whose primal approach was, if anything, antithetical to the whole concept of cool reserve, got into the act on occasion when he shifted himself into a mellow mode. Witness such anomalous hits by the singer as "Prisoner of Love," cut by the Ink Spots, Perry Como, and archetypal crooner Russ Columbo, and "Bewildered," a song made famous by the mild-mannered likes of Tommy Dorsey in 1938.**

BELOW **Albert Collins: frosty blues.**

The Cool Sound of ALBERT COLLINS

FROSTY
HOT 'n COLD
FROST BITE
TREMBLE
THAW-OUT
DYIN' FLU
DON'T LOSE YOUR COOL
BACKSTROKE
KOOL AIDE
SHIVER 'n SHAKE
ICY BLUE
SNO-CONE II

PRINTED IN U.S.A.

MONAURAL

TCF 8002

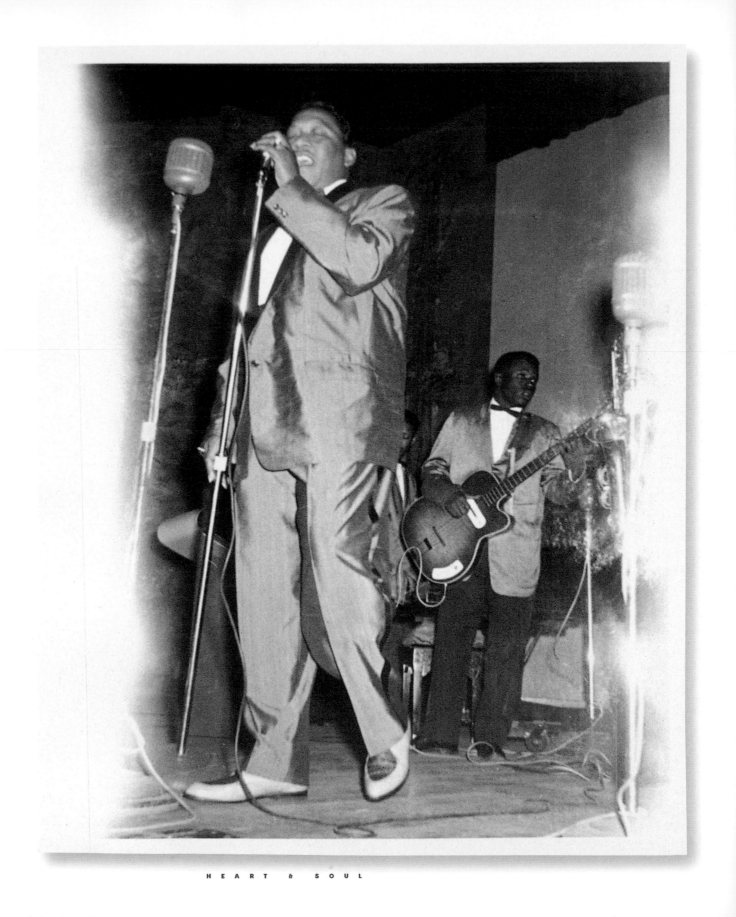

Sid Seidenberg, formerly an accountant for Chuck Willis, established the policy of bestowing B.B. King monogrammed cufflinks to any and all who assisted his client's rise to the top of the blues heap. As at home on the stage of the Regal Theater in Chicago as he is in posh niteries worldwide, King, with his seamless blend of blues and jazz idioms and his classy demeanor, lends glitz and glamour to the blues that he learned firsthand from such uptown practitioners as Count Basie and Duke Ellington.

Bobby "Blue" Bland's place in the blues hierarchy has been assured since his trademark "squall" issued forth on his first recordings for Modern at the dawn of the 1950s. Following his discharge from the Army in 1954, he moved to the Houston-based Duke label, where his career crystallized with a string of R&B masterpieces from *Farther up the Road* and *I Pity the Fool* to *Turn On Your Lovelight* and *Chains of Love*. Bland's glottal gargle was lifted directly from Aretha Franklin's father, the Reverend C.L.

Franklin. For all his rough and raw vocal projections, Bland fronted a band that delivered some of the smoothest and most modulated arrangements in or out of the genre. Bland, "the Lion of the Blues," was himself as regal in appearance as his band was musically mellow. His album covers tell the tale, showing Bland beautifully manicured in the sportsman style, his large frame cloaked in exotic trappings and dripping with conspicuous, but tasteful jewelry. Although not conventionally handsome, Bland had a certain undeniable magnetism that had a profound effect on his female fans.

Like Bland, Joe Hinton recorded for Duke Records through its Back Beat subsidiary. Originally from the Memphis area, he championed a sharkskin aesthetic that served him well in the mid-1960s. His biggest claim to fame came in 1964 with his interpretation of Willie Nelson's composition *Funny*. He was so self-assured that he inserted his own name in the lyric, intoning that "Joe Hinton's back in town."

Bobby Bland and B.B. King: the Lion squalls and calls, while the King wails.

Not for long, however; he died four years later, leaving a legacy of one of the more distinctive styles in black music.

The torch of soft, sincere, and sentimental vocal groups was passed from the Mills Brothers and the Ink Spots to the Los Angeles-based Platters. One of the group's greatest hits was their 1956 version of *My Prayer*, originally cut by the Ink Spots in 1939 and, concurrently, a huge Glenn Miller hit. The group was a bonanza for Mercury Records, which really entered the record-biz big leagues on

ABOVE Joe Hinton: back in town.

BELOW Deep soul practitioner Sam Baker died leaving barely a trace of his short-lived career. Sadly, he is most notable in the annals of black style not for his heartfelt music, but for his frilly Edwardian cuffs prominently displayed on the cover of his album *Sometimes You Have to Cry*.

the strength of their many hits, starting in 1955 with *Only You (and You Alone)*. The song was originally written by the Platters' manager, Buck Ram, for the Three Sons, whose terminally square approach can be summed up in their biggest hit, *Peg O' My Heart*.

The Platters, on the other hand, elevated schmaltz to a new and emotionally charged level, with their bathos-drenched performances validating whatever material they tackled. And they tackled plenty, almost all of it showcasing the mellifluous tenor of lead singer Tony Williams, initially backed by Herb Reed, David Lynch, and Alex Hodge, but later joined by Zola Taylor, who softened the group's sound even more. Their hits included *(You've Got) that Magic Touch*, *Twilight Time*, the *Great Pretender*, and *Smoke Gets in Your Eyes* (a hit in 1934 for Paul Whiteman).

Before they splintered into a dozen different groups that all claimed some corner of the Platters' legend, the quintet blazed the trail for countless black vocal outfits to follow . . . and made musical history in the process. Their sound was all-but-perfect, not only musically, but in terms of sheer excellence in elocution along the lines of Nat King Cole and Chuck Berry. White audiences were comfortable with their perfectly rendered diction, so different from the growls, moans, and gutteral incantations of R&B and blues shouters. As a result, the Platters were widely embraced by audiences of all races, rendering the obligatory covers by white groups moot.

The Tymes were one of the few groups who

VS 7004

Sam Baker

SOMETIMES YOU HAVE TO CRY

SOMEONE (BIGGER THAN YOU & ME)
THAT'S ALL I WANT FROM YOU
SAFE IN THE ARMS OF LOVE
YOU CAN'T SEE THE BLOOD
LET ME COME ON HOME
JUST A GLANCE AWAY
STRANGE SENSATION
I CAN'T BREAK AWAY
I BELIEVE IN YOU
IT'S ALL OVER
I LOVE YOU

VIVID

HEART & SOUL

actually did cover the Platters. This Philadelphia group recorded a version of *To Each His Own*—a song also in the Ink Spots' repertoire. More important, the Tymes' own calling card, *So Much In Love*, is one of the most evocative oldies of all time. On the 1963 album cover of the same name, the nattily dressed quintet appears in a summer-love motif that seems to borrow heavily from Harlequin's pulp-romance books. The frothy pop/soul confection also contains a rendering of Johnny Mathis's *Wonderful! Wonderful!* And it is.

A purveyor of cool sound and style in a very different vein was Jerry Butler, "the Iceman." A seminal member of the Impressions, along with

Curtis Mayfield, his role in the group was so pivotal that initially their record labels read "Jerry Butler and the Impressions," or "the Impressions Featuring Jerry Butler." However the name appeared on the marquee, the group benefited from Butler's polished and resonant baritone only from 1958 to 1960. The group's first hit with him was 1958's *For Your Precious Love* written by Butler despite the fact that the bulk of the group's repertoire was penned by the prolific Mayfield, who also composed *He Will Break Your Heart*, Butler's 1960 breakthrough solo chart topper.

In the late 1960s, Butler's career came under the production guidance of Philadelphia's Kenny

The Platters could not be covered — except by the Tymes.

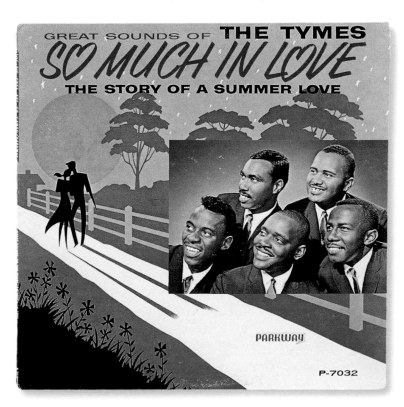

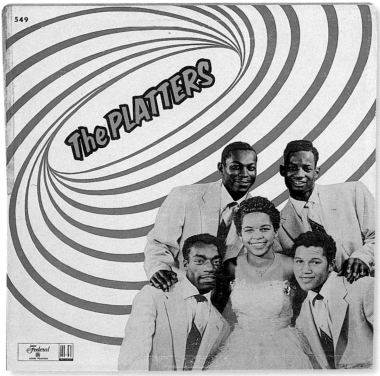

Gamble & Leon Huff, who worked with him on such hits as *Never Give You Up* and *Only the Strong Survive*. The team made the most of Butler's nickname, releasing albums entitled the *Iceman Cometh* and *Ice on Ice*, à la Albert Collins. On the cover of his first solo album in 1959, Butler presented a noble bearing underscored by the collection's title: *Jerry Butler, Esq.* Butler still serves the people, although rarely in song. He is an elected commissioner of Chicago's Cook County.

Sixties' Royals

Gene Chandler was another Chicagoan who invented for himself an aristocratic persona of quite fanciful proportions. So fascinated was he by peerage that he assumed the identity of the title character from his first and best-known hit, 1962's epochal *Duke of Earl*, a number one hit on both pop and R&B charts. A Chandler original, *Duke of Earl* tells the tale of a lonely nobleman, with the Duke offering up his realms to the hoped-for Duchess of Earl. The plea struck a chord, and remains a staple of the doo-wop/soul idiom.

None of which stopped Chandler from playing his self-appointed role to the hilt, appearing on stage with a cape, top hat, cane, frock coat, and the all-important monocle. On his debut album, in fact, his regal alter ego took over completely. Chandler's own name wasn't mentioned on the cover at all, but was replaced by his assumed title. The Duke of Earl was no pretender to the soul throne, however, as he went on to have a fairly notable career recording such hits as *Rainbow '65* and *Groovy Situation*, and producing others that included Mel & Tim's *Backfield in Motion* and Simtec and Wylie's *Gotta Get over the Hump*.

Another member of R&B royalty in both name and achievement was Ben E. King. King actually had two careers: one as the lead singer of the Five Crowns/Drifters during the key years from 1958 to 1960, when he was the primary vocalist on *This Magic Moment*, *Dance with Me*, *Save the Last Dance for Me*, and other Drifters delights, and his second career, as a solo artist, which was no less auspicious. King cut *Spanish Harlem*, *Don't Play That Song*, and his own composition, *Stand By Me*, which made the charts twice, first in 1961 and later on the strength

Jerry Butler: stylishly stepping out of the Impressions.

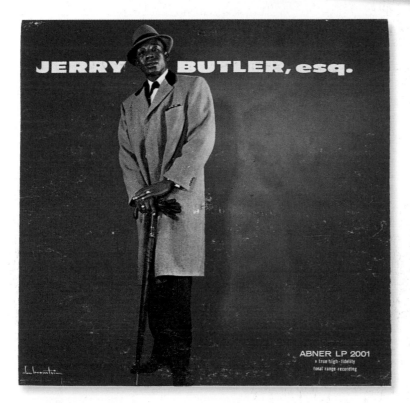

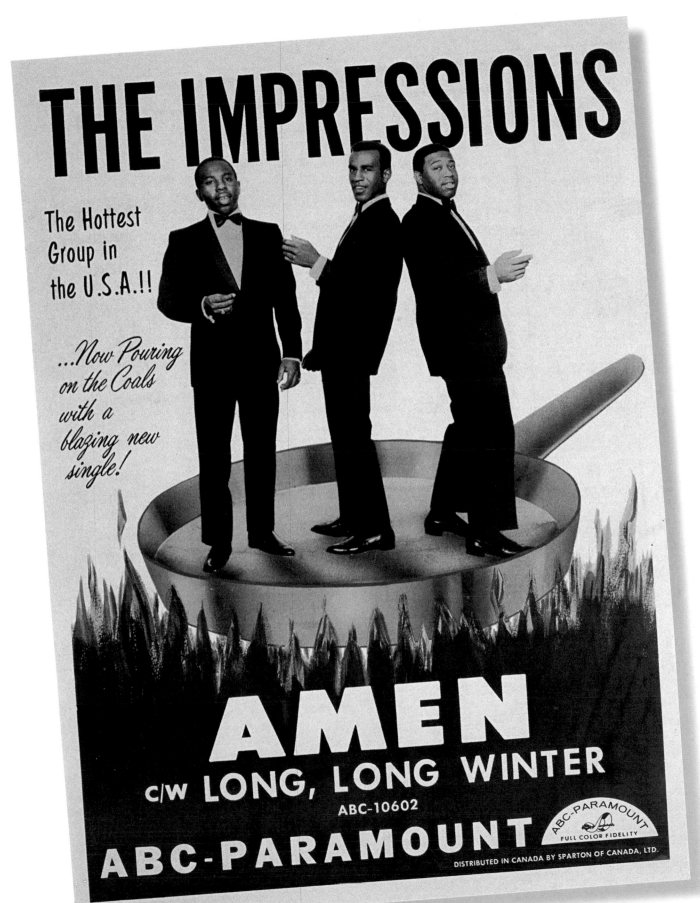

The Impressions in an incongruous trade ad for a scene in Sidney Poitier's film vehicle "Lillies of the Field."

of the nostalgic 1986 film of the same title.

Motown Charm School

From the beginning, Detroit's Motown Records had an artist-development regimen that turned out poised and polished entertainers who would do the company proud. The so-called Motown Charm School covered everything from proper posture and attire to correct diction, gracious manners, and, of course, seamlessly choreographed stage acts, many conceived by the legendary Cholly Atkins.

Among the many who benefited from Motown's fine-tuning of its talent were the Temptations, who had one of the most fluid and engaging acts of any on the roster. Never appearing in anything less than full custom-tailored evening wear, the group's lineup delivered twirls, spins, synchronized hand claps, and dance steps that were dazzling in their intricacy and elegance. It is inadequate to describe the Temps as simply a vocal group. To be sure, the singing of David Ruffin, Eddie Kendricks, Paul Williams, Melvin Franklin, and Otis Williams supported an astonishing hit-making career from the mid-1960s well into the 1970s, with *My Girl*, *Get Ready*, *Ain't Too Proud to Beg*, *Just My Imagination*, and *I Wish It Would Rain* . . . the stuff of legends. But from the moment they hit the boards, the Temptations had even more to offer than great music. Here and for all time was the quintessential entertainment package.

The Spinners spun off their act from the patented Temptations song-and-dance extravaganza. Although many of their best-known early 1970s hits

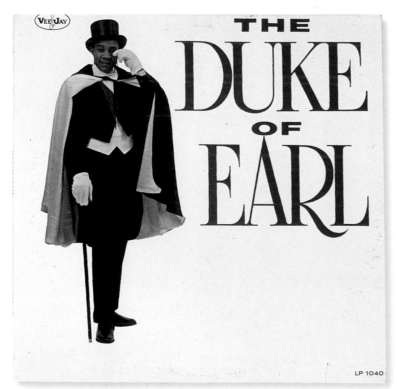

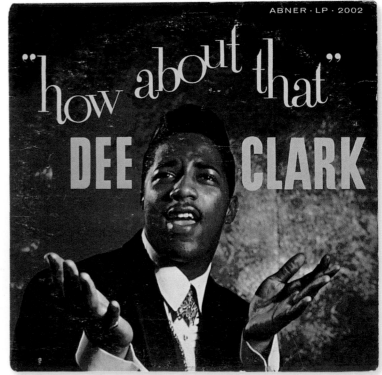

ABOVE **Ben E. King: Standing by, over and over.**

BELOW LEFT **Gene Chandler: Chi-town nobility.**

BELOW RIGHT **With the exception of the deeply soulful "Raindrops," Dee Clark was best known for his bubbly, pop R&B fabrications, including "Hey Little Girl, Just Keep It Up," and "Nobody But You." His early tenure in a failed Chicago vocal group called the Kool Gents pretty much sums up Clark's appeal.**

were conceived with producer and songwriter Thom Bell in Philadelphia, their years at Motown qualified them as Charm School alumni, and it was under this label that they scored their earliest chart successes, *I'll Always Love You* (1965), *Truly Yours* (1966), and *It's a Shame*, produced by Stevie Wonder in 1970. They were joined by Philippe Wynne, in 1971, and commenced a five-year string of hits, including the majestic *One of a Kind Love Affair* (1973).

Also on the Motown roster at one time were Gladys Knight & the Pips. Not since Claudette Robinson left the Miracles had Motown experienced solid success with a group of mixed gender, a success based in part on the suave backup harmonies and high-styled dance routines of the Pips. Knight herself exuded a wholesome yet sensuous charm, the combination of which was aptly summed up in the title of the group's 1968 album *Silk 'n' Soul*. Gladys and the Pips, composed of her brother Bubba Knight and cousins Edward Patton and William Guest, came to Motown after achieving significant success in the early 1960s on Vee-Jay with *Every Beat of My Heart* and on Fury with *Letter Full of Tears*, but they are best known for their pop/soul staples, *Friendship Train*, *Neither One of Us (Wants to Be the First to Say Goodbye)*, and *I Heard It through the Grapevine*, a chart topper later for both Marvin Gaye (though his version had been recorded earlier) and Credence Clearwater Revival.

Marvin Gaye may have eschewed the Motown "factory" approach later in his career with such statements of self-awareness as the visionary album *What's Going On?* and the openly erotic *Sexual Healing*, but he was the very picture of suave, schooled style during his earliest days at the label, with *Stubborn Kind of Fellow*, *Pride and Joy*, and *You're a Wonderful*

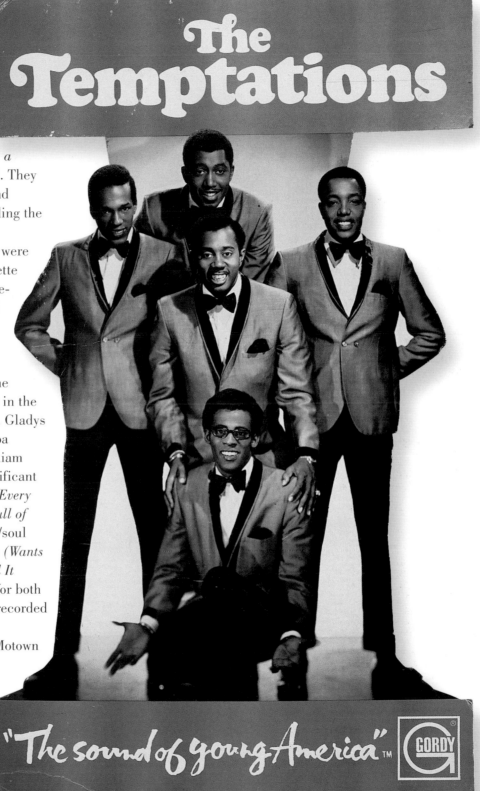

Motown Charm School's Phi Beta Kappas: the Temptations.

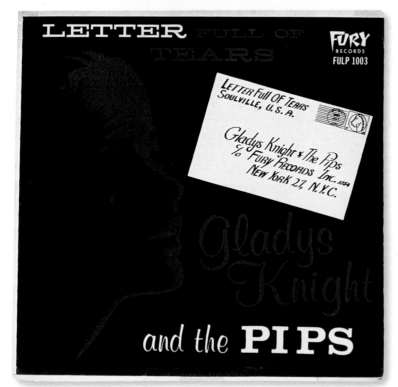

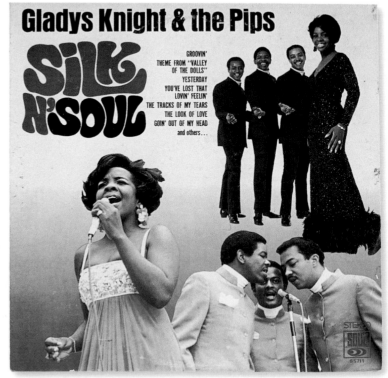

One. The Motown moguls recognized that Gaye was irresistible to women and packaged him as a duet partner with Mary Wells, Kim Weston, Tammy Terrell, and Diana Ross. It's easy to see what the ladies found so entrancing. On the cover of his 1961 debut album, *The Soulful Moods of Marvin Gaye*, the singer stares off with bedroom eyes into some romantic reverie all his own.

Velour and Bellbottoms

During the 1970s, many of the traditions of smooth style established during the previous half century were carried on in high fashion, albeit with a velour and bellbottom subtext. The Continental IV, an era also-ran, featured a variety of good-life accoutrements on the cover of Dream World, their one and only album. These included a Lincoln Continental Mark IV, a fetching woman, and the band's wild outfits.

The Manhattans exuded cosmopolitan savvy even in their choice of name. The group, however, was not from New York City, although the members could see its gleaming spires from their Jersey City digs across the Hudson. Their musical point of reference was characterized as "progressive doo-wop" by founding member Winfred Lovett, but their stage apparel might better be described as "Regency dandyism," replete with matching orange tuxedos and white gloves. Best known for their vintage ballads, the Manhattans later racked up a number of important 1970s hits, including *There's No Me without You* and *Kiss and Say Goodbye*, a number one pop charter.

Philadelphia's Delfonics were in some ways a throwback to an earlier musical era. Their straight-ahead, doo-wop vocals were updated by the Philadelphia producing and writing team of Thom Bell and William Hart. Hart, with his fabulous falsetto, was the group's lead singer. In their hands, a bit of doggerel along the lines of *La-La Means I Love You* became a standard in its own time and is *still*

CLOCKWISE PAGE 132 ABOVE LEFT
The Spinners spun more gold after leaving Berry Gordy's stable.
ABOVE RIGHT **Marvin at his moodiest.**
BELOW RIGHT **A Motown momento.**
BELOW LEFT **Gladys and her guys: their first long-player.**

THIS PAGE **The Manhattans and The Delfonics: an unfettered flair for fashion.**

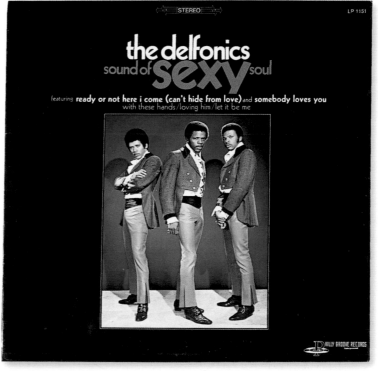

Continental IV: living the
good life.

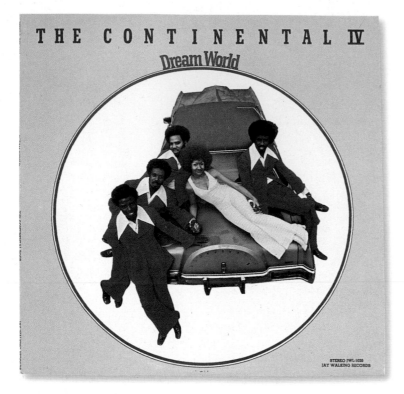

heard over and over on most oldies stations. The trio,
however, was anything but out-of-date when it came
to outrageous 1970s fashion. On the cover of their
Sound of Sexy Soul album in 1969, they cast them-
selves as befrocked lotharios in tight toreador pants,
with cummerbunds and waistcoats.

———————————■———————————

 The sophistication embodied by polished black
entertainers contrasted starkly with the daily lives of
those who idolized their favorite singing stars. Yet,
for all their uptown airs, these artists maintained a
vital link to their roots and were an example to the
black community of what talent, determination, and
a bit of luck could accomplish. ◉

Chapter 8
DiDN'T i BLOW YOUR MiND THiS TiME

The afrodelic Barkays.

DIDN'T I BLOW YOUR MIND THIS TIME

I want to thank you for lettin' me be myself again . . . — Sly Stone, *Thank You (Falettinme Be Mice Elf Agin)*

With the dawning of the 1960s much-vaunted Age of Aquarius, a colorful stylistic revolution was set in motion that had little historical precedence in American culture. Previously, the bestowing of musical and visual values between blacks and whites had been primarily one way: black innovation was followed by white emulation. Little Richard begat Elvis, Duke Ellington begat Stan Kenton, Muddy Waters begat the Rolling Stones, and so it went.

The Psychedelic Revolution turned the question of musical parentage on its ear. Originally there were few black participants in the acid-drenched music, dress, and free-form lifestyle of the counterculture. It was only with the arrival of towering rock-guitar innovator and counterculture hero, Jimi Hendrix, that the concept of the turned-on Negro gained credence. But as time went on, the extreme style of the Flower Children found a foothold in black culture, especially among performers whose penchant for the outrageous had always been an article of faith. The transfer of influence, however, was by no means total. Appropriation of white hippie dress by blacks was followed by imitation of black style by white squares, followed by further borrowing from the counterculture by blacks, followed by, well,

you get the picture. By the early 1970s, the whole Western world seemed to be one vast expanse of paisley, velveteen, and Afrodelic sheen, all mounted on ankle-twisting platform shoes. It was, indeed, a revolt into, or maybe even a revolt away from, style.

The bell-bottom, leather-and-lace, headband, and mile-wide lapel aesthetic belied the fact that the music itself still remained very much an original black expression. Notwithstanding that the freely freaking Jimi Hendrix played behind the Isleys and Little Richard, most black groups in the 1960s and 1970s could hardly be considered acid-rock pioneers. Doo-wop, soul, R&B, blues, and jazz continued to be the fundamental elements of black musical expression during that era. To be sure, the Temptations recorded *Psychedelic Shack*; the Supremes chimed in with *Love Child* and the *Happening*; and the musical lexicon was noisy with wah-wah, fuzz-tone, echo chambers, and assorted mind-bending aural effects. But the essence of black

music remained, by and large, untouched until the advent of the disco era.

The Isley Brothers were one group that occupied a flamboyant niche in the 1960s, although they put down their roots in the 1950s. They appropriated a hippie-esque style and ethos that lent them relevance through their second and third decades of continuous hit making. Draped in the finest of the then-stylish "Moroccan roll" threads and skins made famous by Brian Jones of the Rolling Stones, the Isleys made a bid for Aquarian acceptance on the cover of their 1966 album, *It's Your Thing*, featuring the hit of the same name—a song that summed up the laissez-faire fatalism of the counterculture. The group took their flower power mandate a step further with an energetic cover of the vapid Stephen Stills song, *Love the One You're With*.

Another veteran who was able to respond successfully to the happening 1960s scene was New Orleans producer and bandleader Paul Gayton. He

LEFT **Little Janice: bell-bottom blues.**

RIGHT **The Isley's Aquarian chords.**

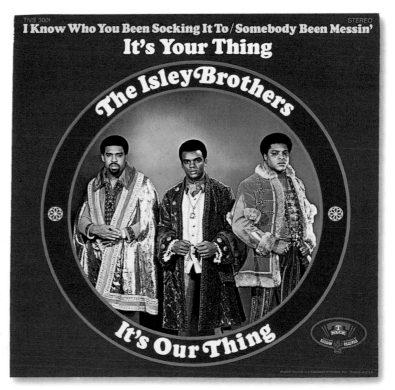

signed an obscure teenage singer-songwriter from Texas named Little Janice to his own Pzazz label, which later also released albums by Louis Jordan. Janice Tyrone's late 1960s offering, *Today's Youth, Tomorrow the World*, featured the earnest youngster literally "sitting on top of the world," anxious to spread her message of peace, love, and universal personhood across the globe.

The Family Stone

Still, there were black performers who burst onto the 1960s music scene without having to adapt their earlier style to the new milieu. In direct line of descent from Jimi Hendrix and James Brown, and directly on top of the San Francisco Youthquake, was Sylvester Stewart, aka Sly Stone. Jumping into the Bay Area music scene in the 1960s, and as a producer for Tom Donahue's Autumn Records, he cut both pop and soul sides for artists ranging from the Beau Brummels to Bobby Freeman. He held down disc-jockey air shifts at two radio stations at the same time he formed the

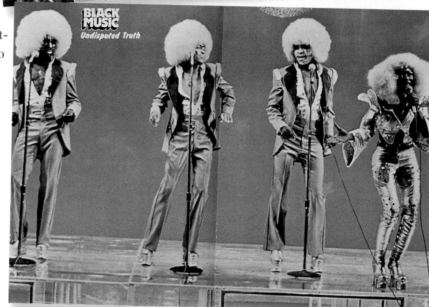

Stoners in early 1966. Sly's penchant for mixing and matching vintage gospel, soul, and R&B with the way-out sounds he heard emanating from the Fillmore and Avalon ballrooms jelled with the formation in 1967 of Sly & the Family Stone, a mixed-race, mixed-gender ensemble that included his brother and sister and low-register vocalist and bassist Larry Graham. The group really made a "stand" at Woodstock, where they electrified the predominantly white audience and thrust black music into the vanguard once again. Sly and company had a look that was equivalently trailblazing. They substituted the mandatory uniform of most soul outfits for thrift store and gypsy finery that adhered to Hendrix's admonition to let your "freak flag fly." Sly's flag was among the most freely flapping of all, but he was ultimately eclipsed by his own myth. After a remarkable run of number one soul and pop hits that

included *Everyday People*, *Thank You (Falettinme Be Mice Elf Agin)*, and *Family Affair*, he dropped off the charts, a victim of his own hubris and unrestrained substance abuse.

Motown Takes a Trip

After its long run of successes in the 1960s, Motown flexed the full might of its marketing muscle on behalf of Joe and Katherine Jackson's brood of adorable afro-headed kids. The Jackson Five's first album, 1970's *Diana Ross Presents the Jackson Five*, provided a convenient bridge between Motown's glory days and a new generation. They were a galvanizing live attraction and, as early as 1968, were opening bills at Chicago's Regal Theater for the Miracles, the Delfonics, and the Temptations. Flounced, frilled, and fringed to within an inch of their lives, the J5 featured a pint-sized Michael who would go on to carve an outsized place in both music and tabloid history. In adapting many of James Brown's stage moves, Little Richard's androgyny, and Jackie Wilson's vocal dynamism, Michael came to embody all the considerable commercial appeal of soul music. Crossing racial and generational divides with a sound and style that made him one of his era's most significant stars, he impacted on everything from music to fashion to the emerging art form of video.

Another group on which Motown placed high hopes was the Undisputed Truth, put together by the label's staff producer, Norman Whitfield, who had enjoyed great success with his pseudopsychedelic productions for the Temptations. The group's wah-wah-infused sound was matched by their incredible on-stage appearance, spotlighting huge bleached-white afros for that dazzling interplanetary look. The Truth's most notable hit was the cautionary *Smiling Faces (Sometimes)*. In an interesting footnote, they recorded an early version of the Whitfield-penned *Papa Was a Rolling Stone*, which later became a huge smash for the Temptations. The group changed

lineups three times before they called it quits; the final variation featured vocalist Taka Boom, sister of Chaka Khan of Rufus renown.

Soul Connections

Memphis's Al Green was a link between the classic soul of the 1960s and the brand new 1970s "thang." A disciple of Sam Cooke and heavily steeped in church tradition, Green's ethereal voice and the trenchant studio production of collaborator Willie Mitchell kept the R&B light burning throughout that often soul-deprived decade. His chart toppers included *Let's Stay Together*, *I'm Still In Love with You*, and *You Ought to Be with Me*. A criminally handsome man, Green had a dazzling smile and supple sensuousness that shone through a wardrobe that went from "plaid all over" to the outer limits of fashion fantasy. Although he later became a full-fledged minister of the gospel, Green never quite abandoned his street-corner flair.

Billy Butler, brother of Impressions founding member Jerry Butler, launched his career at the height of the 1960s groovefest. Although his brand of soul had a straightforward, traditional quality, the art directors at Okeh Records festooned the cover of his 1966 *Right Track* solo LP that featured the hit title song with Fillmore-style typography. Butler formed his first group, the Enchanters, while still in high school and, encouraged by his brother, went on to

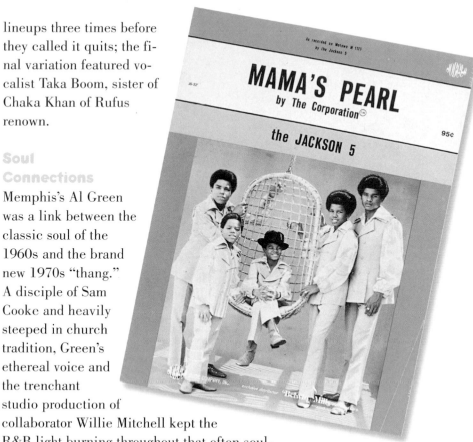

The Jackson 5: Gary's greatest gift.

make something of a name for himself, especially in his native Chicago. Before he faded from the scene, Butler fronted a group with the appropriately cosmic moniker Infinity.

For a time Butler operated out of his brother's tunesmith workshop, a farm club funded by Chappell Music for aspiring songwriters in Chicago. Also involved in the workshop were Marvin Yancey and Chuck Jackson (no relation to Chuck *Any Day Now* Jackson but a half-brother of Jesse *Keep Hope Alive* Jackson). The pair formed a group with some backing talent and dubbed it the Independents. They rose briefly to number one on R&B charts in 1973 with *Leaving Me* but subsequently disbanded, leaving behind scant evidence of their existence aside from a handful of singles and a publicity shot that looks like nothing if not a high school prom portrait, complete with enor-

mous sateen cravats. Marvin Yancey eventually wed Natalie Cole (daughter of the legendary Nat King Cole), and the team of Yancey and Jackson produced four gold and two platinum albums for her in the mid-1970s.

The Stylistics were formed in Philadelphia in 1968. The quintet clung close to the essential traditions of soul and R&B with the addition of the patented Philly studio gloss. Tending more toward class than flash, the group nevertheless gained a firm foothold on the 1970s charts with hits that included *Betcha By Golly, Wow, I'm Stone In Love with You*, and *Breakup to Make-Up*.

From the depths of Dayton, Ohio, came an aggregate known for their theatrical player regalia. In fact, they called themselves the Ohio Players. Although the group originally got together in the 1950s as an instrumental ensemble backing the Falcons and others, the Ohio Players embraced funk with a vengeance. They took the Afro mandate to alarming extremes, and devised a series of risqué album covers featuring naked women, whips, honey pots, livestock, and other highly suggestive props. The group reinvigorated the uniform concept, but this time with a fanciful flourish that obviated any notion of conformity. The septet took their lewd and lubricious visual component into the studio, cranking out a string of mid-1970s R&B hits that included *Funky Worm, Skin Tight, Sweet Sticky Thing, Love Roller Coaster*, and *Fire*. Persistent, but specious, music-biz scuttlebutt has it that *Fire* was the first "snuff record," with an unsuspecting woman murdered during its recording.

The Chi-Lites were one of the most successful vocal groups to emerge from Chicago, following the lead of the Impressions a decade earlier. On the cover of their debut album, *Give It Away*, the group suggests what might be considered a mushroom-induced reverie captured in coordinated pea-green tunics through a mind-bending fish eye lens. The group's music, on the other hand, was anything but jarring.

ABOVE **Al Green: plaid all over.**

BELOW **Billy Butler — Jerry's little brother, right on track.**

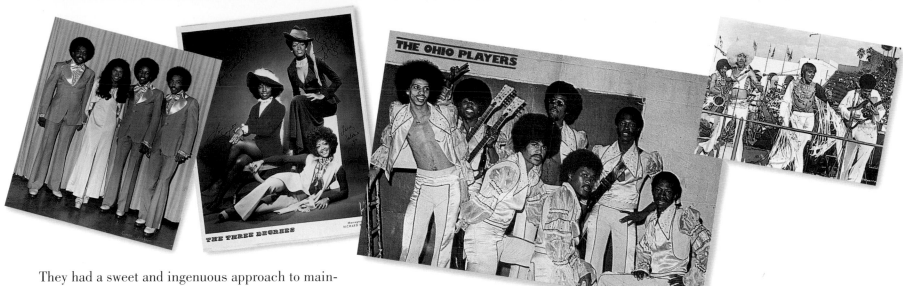

They had a sweet and ingenuous approach to mainstream soul and owed a heavy debt to the pathos and passion of doo-wop.

Behind the vocal strength of former taxi driver, Eugene Record, the Chi-Lites racked up an impressive run of 1970s hits, including the heavily parenthetical *(For God's Sake) Give More Power to the People*, *Are You My Woman? (Tell Me So)*; *I Like Your Lovin' (Do You Like Mine)*; their Vietnam-era *There Will Never Be Any Peace (Until God Is Seated at the Conference Table)*; and their greatest, *Have You Seen Her?* and *Oh, Girl*.

Though not from Cook County, San Francisco's Natural Four were "naturalized" Chicagoans thanks to their affiliation with Curtis Mayfield's Curtom Records. Their biggest hit for the label, *Can This Be Real?* was written by Leroy Hudson, himself a Curtom roster regular. On the sheet music for *Can This*

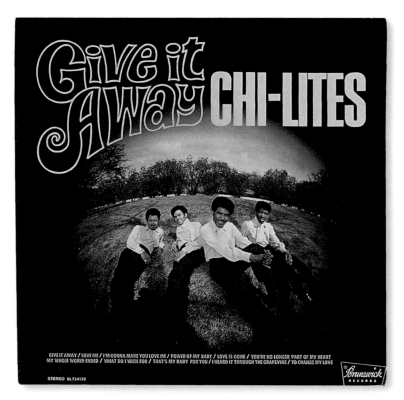

ABOVE LEFT The Independents, featuring the "other" Chuck Jackson.

LEFT CENTER Two of the Three Degrees, who hailed from Philadelphia, appeared in a period publicity shot sporting flouncy, beribboned hats. While there is no explanation for this glaring millinery mismatch, the remaining Degree is compensated with a de rigueur thigh-length vest for that all-important "player" look.

RIGHT CENTER The Ohio Players: funk with a vengeance.

FAR RIGHT The Barkays.

BELOW LEFT Chi-Lites: Eugene Record on the record.

BELOW RIGHT The Stylistics: Philly falsetto.

Be Real? the Natural Four favor the versatile "Superfly" look, down to the floppy hat and fur-collared overcoat.

The Bar-Kays had two distinct incarnations, resulting from one of soul music's most wrenching tragedies. They were passengers on the same ill-fated flight that took the life of soul great Otis Redding. The group perished, except for two members who had not flown that night, James Alexander and Ben Cauley. The pair reformed the Bar-Kays with a new lineup and continued to record hits more than three decades after that tragic event. Prior to the accident, the group had broken through with _Soul Finger_, a left-handed ode to James Bond. The resurrected version of the Bar-Kays created a sensation with their appearance at the Los Angeles Watts Stax Soul Festival. Their performance was notable as much for a plethora of fringe, flapping pant legs, and jumbo-sized Afros as for the music, but the Kays didn't stint on the latter either. During the course of the 1970s and into the 1980s, they remained current with such dance-enhancing delights as _Son of Shaft_; _Shake Your Rump to the Funk_; _Boogie Body Land_; _Move Your Boogie Body_; _Sex-O-Matic_; and, from the 1984 film _Breakin'_, _Freak Show on the Dance Floor_.

Bootzilla

Whether it was Hendrix, Sly, or any other psychedelic soul ranger, no one, nowhere, at no time, in no way could measure up to the sheer wigged-out extravagance of Parliament/Funkadelic, aka the P-Funk Thang, a free-wheeling, high-flying aggregate based in Detroit and built around the musical and aesthetic genius of George Clinton. Because the fundament was funk and the basis of funk is bass, the key player in this maniacal mélange was one William "Bootsy" Collins of Cincinnati, Ohio. In 1969, at age eighteen, Bootsy joined James Brown's band for three years, after which he formed his own mind-blowing outfit, Bootsy's Rubber Band. As a front man in his own right, Boosty yielded to no one in his display of cosmic, logic-defying costumery. In his own mind he was a cartoon character, part Hanna Barbera creation, part Astro Boy, and he dressed the part to the hilt with his custom-made star bass guitar, star sunglasses, fringed fringe, and Mylar hip boots. A potent force on the R&B charts, Bootsy's Rubber Band reached number one in 1978 with the eponymous monster epic _Bootzilla_. Other distinctive Bootsy flights of fancy included _Psychoticbumpschool_, the _Pinocchio Theory_, and _Mug Push_. ♪

ABOVE **Bootzilla.**

BELOW **The Natural Four's "fly" look.**

Chapter 9
SOUL FOR SALE

Buddy Johnson.

SOUL FOR SALE

Women be wise
Don't advertise
What your man can do . . . — Sippie Wallace, *Women Be Wise*

Theater lobby cards from the Golden
Age of Black Cinema.

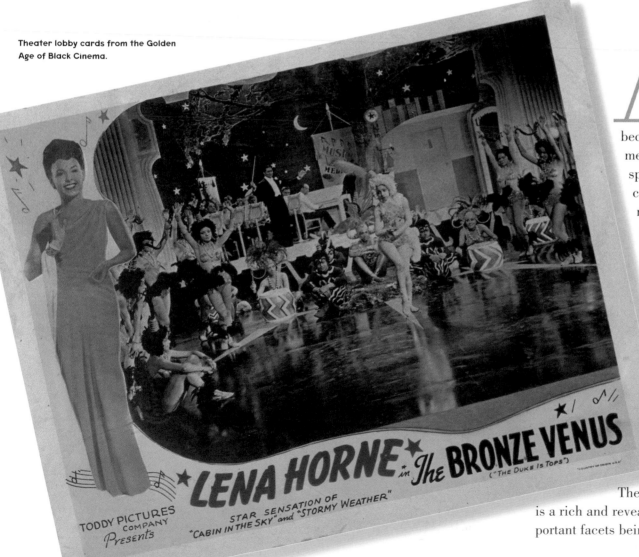

TODDY PICTURES
COMPANY
Presents

LENA HORNE in The BRONZE VENUS
("THE DUKE IS TOPS")
STAR SENSATION OF
"CABIN IN THE SKY" and "STORMY WEATHER"

As black personalities became recognized for their achievements, primarily in entertainment and sports, they developed their own celebrity cachet and, with it, commercial clout that marketers seized on to sell their wares. The target market was, of course, the black population, but, inevitably, the appeal of black artists and their music, at times crossed over to the white market.

Film Noir

For the most part, marketing executives were eager to recruit black music stars as product spokespersons, recognizing their proven allure on the silver screen. The history of black American cinema is a rich and revealing saga, with one of its most important facets being the box office draw of singers

and musicians who had already made an impact on entertainment seekers of all races. Black actors were confined either to subservient or stereotyped roles in Hollywood, or to all-Negro productions for all-Negro audiences, but black musical performers eventually found themselves reaching over the racial divide by virtue of the sheer magnetism of their on-screen presence.

Among the most appealing was Lena Horne, who appeared in a number of early all-black films, including *Cabin in the Sky* and *Stormy Weather*. In the 1940 production *Bronze Venus*, which was also released as *The Duke is Tops*, Horne played a singer in a broad melodrama that also featured the Cats and the Fiddle, a legendary group that included ace-guitar "cat" Tiny Grimes in the lineup. The film was produced by black-cinema trailblazer Ted Toddy, who put his films together with budgets considered minuscule even for the time.

The paltry resources and often improvisational nature of black film production could be seen in the lobby-card art of an obscure all-black movie entitled *Ebony Parade*, a compilation of "soundies" featuring cinema noir great Mantan Moreland (the star of an earlier Toddy presentation, *Mantan Dresses Up*) and the ubiquitous Cab Calloway. A theater poster for the film featured a taped-on photograph of the Jubilaires, mislabeled as the Mills Brothers. The sedate Mills siblings would never have appeared in hepster hunting mufti that included jackets emblazoned with giant dollar signs.

Like Mantan Moreland, Cab Calloway had multiple roles in cinema and also contributed many of his songs to the movies. Among those that were used in films are *You're the Cure for What Ails Me* and *Keep That Hi-Di-Hi in Your Soul* from the *Singing Kid*; *Peckin'* from *New Faces of 1937*; *Mama I Wanna Make Rhythm* from *Manhattan Merry-Go-Round*; the title songs *Every Day's a Holiday* and *Blues in the Night*; and *Let's Take the Long Way Home* from *Here Comes the Waves*. Calloway revisited the hi-de-hi, hi-de-ho theme when he starred in a pair of two reelers in 1939 and 1947, both entitled *Hi-De-Ho*. The latter 1947 film included Chesterfield-cigarette spokesperson Ida James singing *Don't Falter at the Alter*.

Harlem naturally served as an ideal locale for lively musical fantasies. Titles from the 1930s era

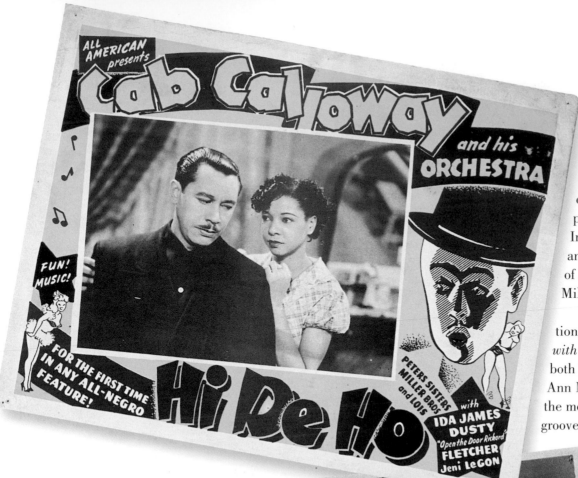

DUKE ELLINGTON AND HIS "SWING BAND OF THE YEAR"

ranged from *Harlem on the Prairie* to *Harlem after Midnight*, the latter produced by the black film pioneer Oscar Micheux. Another classic Harlem-themed production was *Paradise in Harlem* (1939), which boasted "the greatest colored cast ever assembled in one picture," a gangster-peopled plot, and a plethora of great music. In it Mamie Smith performed *Harlem Blues* and Edna Mae Harris delivering her version of *Harlem Serenade* backed by Lucky Millinder's band.

The war years brought cinematic integration of a kind, as seen in the 1943 effort *Reveille with Beverly*, which highlighted performances by both black and white swing stars. Starring dancer Ann Miller as a leggy excuse for a disc jockey, the movie's format called for the music in the grooves to come to life in short vignettes by, among others, Duke Ellington, Count Basie, the Mills Brothers, Frank Sinatra, Ella Mae Morse, and Dixieland maestro Bob Crosby. Of particular note was the Ellington band's performance of *Take the A Train*, written especially for the film by Billy Strayhorn. The radio-to-reel connection continued in 1949 with *Make Believe Ballroom*, taken from the popular radio broadcast of the same name and featuring performances by Gene Krupa and the Nat King Cole Trio, to name a few.

The rise of R&B and the advent of rock 'n' roll found their cinematic expression in a variety of cheerfully exploitative vehicles. Two such pastiches were *Rhythm and Blues Revue* and *Rock 'n Roll Revue*, both taken from performances kinescoped for the short-lived TV series, *Harlem*

146

Variety Revue, in 1954. With disc jockey Willie Bryant, the self-declared "Mayor of Harlem," as master of ceremonies, the two features were released in quick succession by Studio Films in "kaleidoscopic wonder color." However, the brains behind the films seemed unclear about which musical genre was which. For *Rock 'n Roll Revue*, the mixed bag of artists included Dinah Washington, Duke Ellington, the Clovers, crooner Larry Darnell, and comic Nipsy Russell. Stars showcased in *Rhythm & Blues Revue* were, among others, Amos Milburn, Faye Adams, Sarah Vaughan, Count Basie, and "colored" singing cowboy Herb Jefferies. Striding the divide between R&B and rock 'n' roll, and appearing in both kaleidoscopic epics, were Ruth Brown, Nat King Cole, Lionel Hampton, Big Joe Turner, the Deep River Boys, and, of course, Mantan Moreland.

The lasting fame of the artists mentioned above sharply contrasts with the nearly complete obscurity of the stars of *Rockin' the Blues*, a 1955 extravaganza. Savoy recording artists the Wanderers and King's Hurricanes were heard by a sorrowful few. Lest audiences walk away totally mystified, however, the movie also featured the

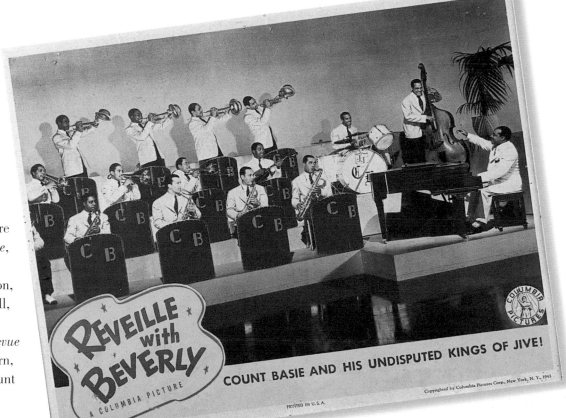

COUNT BASIE AND HIS UNDISPUTED KINGS OF JIVE!

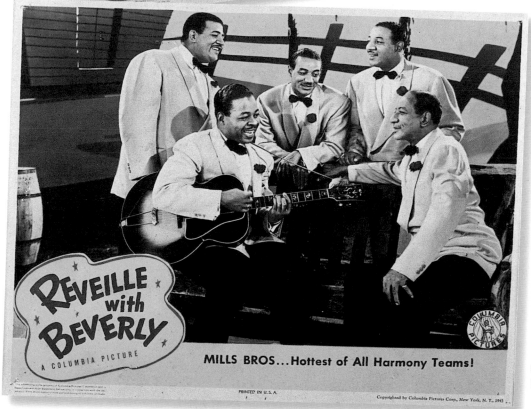

MILLS BROS...Hottest of All Harmony Teams!

Music in the movies: weak plots, strong sounds.

Groovin' with gangsters in 1939.

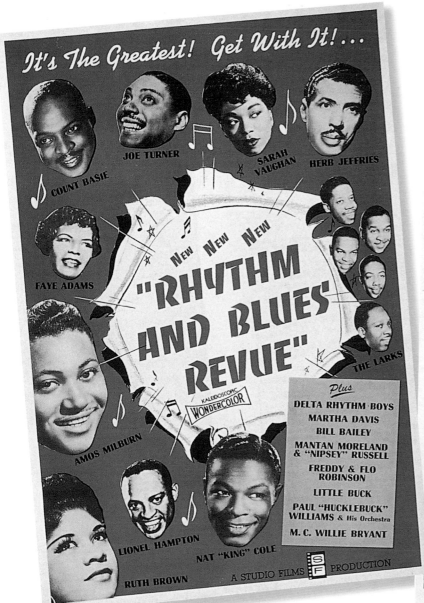

reassuring presence of Mantan Moreland, without whom it seemed impossible to make a black feature film in those days. The sole exception to the cast's also-ran status was the group the Harptones featuring Willie Winfield. Although known for their exquisite balladeering, they performed only out-of-character up-tempo material in front of the *Rockin' the Blues* camera.

The lineup was considerably more stellar for 1957's *Mister Rock and Roll*, a film whose feeble effort at a plot revolved around rock 'n' roll's preeminent promoter, Alan Freed. The story, however skimpy, did not detract from a great lineup of seminal rock 'n' rollers, including Little Richard, the Flamingos, the Moonglows, Frankie Lymon & the Teenagers, Chuck Berry, Clyde McPhatter, and Brook Benton. The kitchen-sink aesthetic also prevailed, however, with the inclusion of such

anomalies as country-crooner Ferlin Huskey, rock 'n' roll convert Lionel Hampton, and pugilist Rocky Graciano. Notable by his absence was Mantan Moreland.

Music in the movies continued to garner appreciative audiences, as evidenced by the return-to-roots documentary *Soul to Soul* in 1971. The rise of black nationalism and Afrocentric culture paved the way for this concert film shot in Lagos, Nigeria. It starred American soul greats Wilson Pickett, the Staple Singers, and Ike and Tina Turner, who contributed the theme song of reconnection between the Motherland and her long-lost children.

Selling the Blues

As the popularity of black musicians and singers became evident by their box office draw, advertising executives began to consider black performers as spokespersons who would appeal to the black consumers. The alcoholic

THIS PAGE Rock 'n' roll and rhythm & blues: staples of the silver screen.

PAGE 151 BELOW LEFT Soul To Soul: the Wicked One takes in back to Africa.

beverage industry has never been shy about approaching potential customers in the most direct way: "Man, the sock is terrific!" exclaimed jazz vibraphonist Lionel Hampton in a print ad for Bulldog Beer, perhaps reflecting the inebriated subtext of his best known hit, *Flying Home*, which featured a tenor solo by Illinois Jacquet. Jacquet himself got into the "spirit," along with bandleaders Buddy Johnson (known for his hits *Since I Fell for You* and *Did You See Jackie Robinson Hit That Ball?*) and Cab Calloway, appearing in a series of spreads for the Schenley brand of distilled liquors. Cab was himself a virtual one-man marketing campaign, appearing in films and cartoons and having his own chapter in a swing-era comic-book bio appropriately subtitled *Dean of American Jive.*

Tobacco, too, was a business that leaned heavily on celebrity endorsements before its advertising was all but banished. The legendary Louis Armstrong once shilled for the Camel brand, an association somewhat puzzling when you consider the sandpaper rasp of

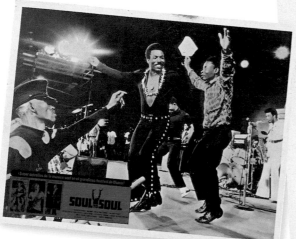

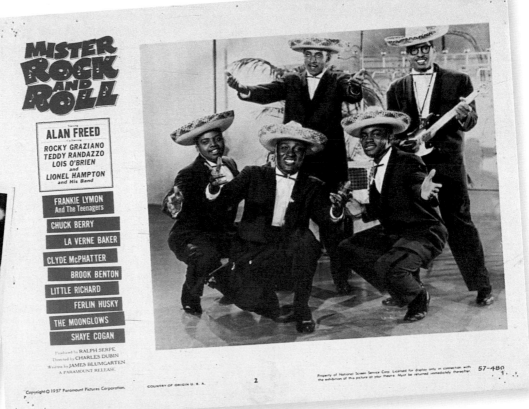

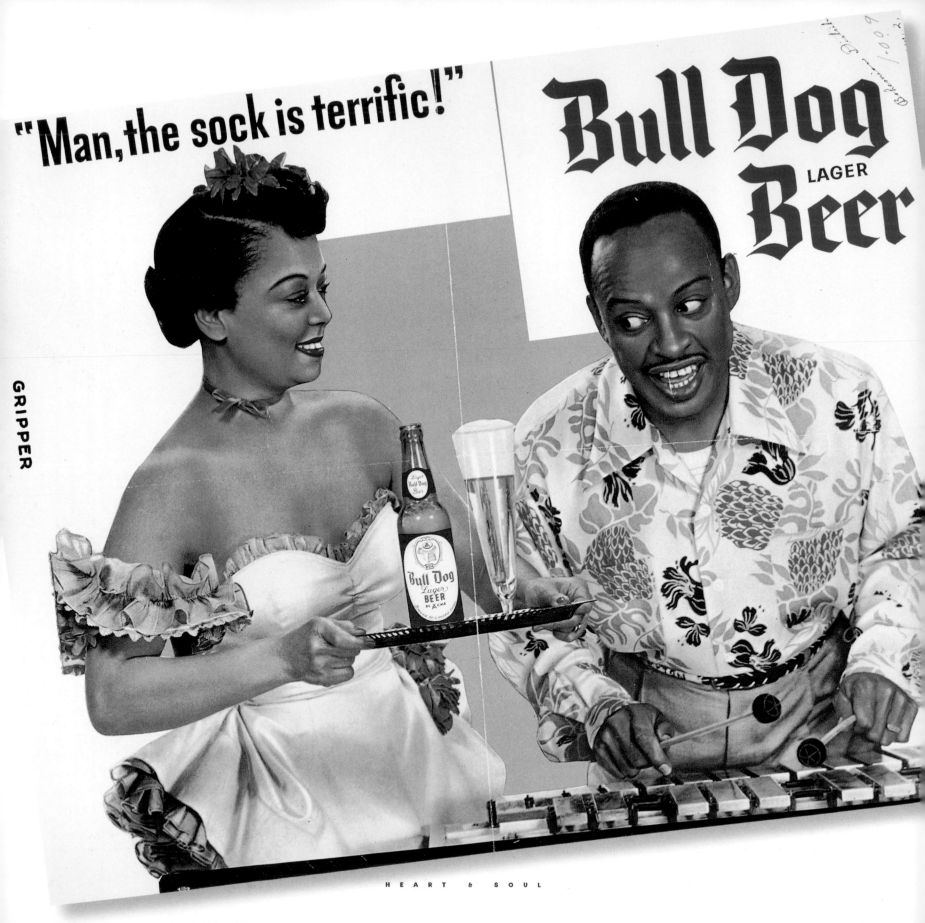

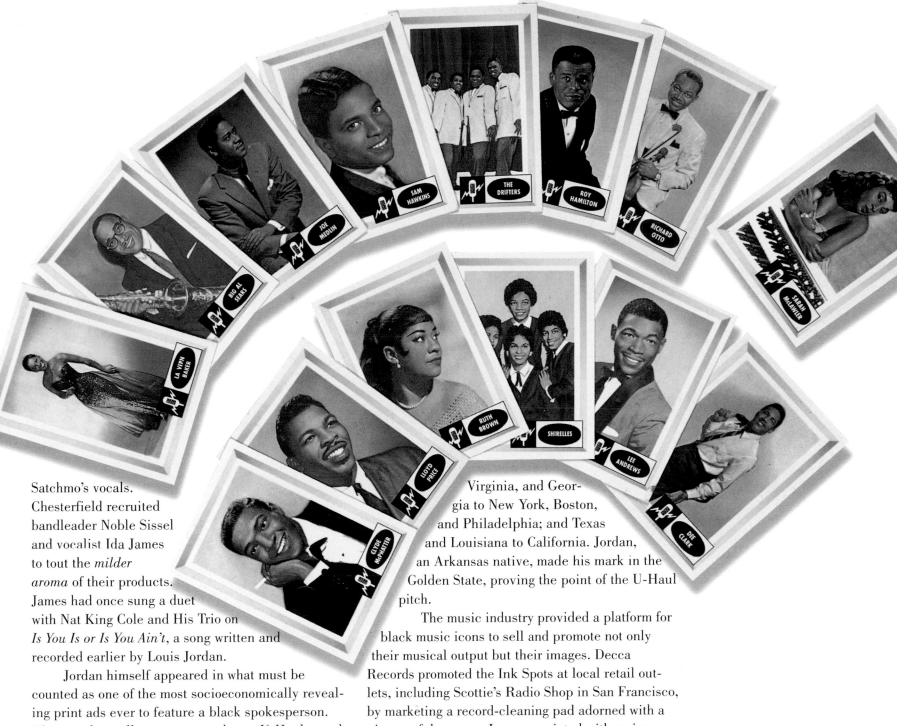

Satchmo's vocals. Chesterfield recruited bandleader Noble Sissel and vocalist Ida James to tout the *milder aroma* of their products. James had once sung a duet with Nat King Cole and His Trio on *Is You Is or Is You Ain't*, a song written and recorded earlier by Louis Jordan.

Jordan himself appeared in what must be counted as one of the most socioeconomically revealing print ads ever to feature a black spokesperson. "A man who really moves around uses U-Haul rental trailers," avowed the bandleader, calling attention to the postwar Black Diaspora that saw whole populations from the Deep South migrate across the nation—Mississippi to Chicago; the Carolinas, Virginia, and Georgia to New York, Boston, and Philadelphia; and Texas and Louisiana to California. Jordan, an Arkansas native, made his mark in the Golden State, proving the point of the U-Haul pitch.

The music industry provided a platform for black music icons to sell and promote not only their musical output but their images. Decca Records promoted the Ink Spots at local retail outlets, including Scottie's Radio Shop in San Francisco, by marketing a record-cleaning pad adorned with a picture of the group. Long associated with major league baseball, Topps trading cards branched into rock 'n' roll in the 1950s, setting the scene for Little Richard, Screamin' Jay Hawkins, LaVern Baker, and other hit makers of the day to be packaged with that

PAGE 152 **Hamp, about to hoist one.**

ABOVE **Cards of the Stars: rock 'n' roll and R&B trading cards of the 1950s.**

pink slab of gum, just like Elston Howard, Roy Campanella, and Willie Mays. Not to be outdone, an entire line of trading cards devoted to musical artists under the Spins & Needles moniker highlighted images of Lloyd Price, Ruth Brown, Clyde McPhatter, and others.

Fats Waller's girlfriend, singer and pianist Una Mae Carlisle, had hits in the 1930s and 1940s that included *Walking by the River*, *Hangover Blues*, and *Don't Try Your Jive On Me*. She certainly was not jiving when she urged her female fans to try Snow White pomade and "delight your man tonight." Years later, "the Divine One," Sarah Vaughan, extolled the relaxing properties of Perma Straight. Hair-care products have long been a staple of black enterprise; the largest black-owned company in America today is Johnson Products, whose line of grooming aids sponsored *Soul Train*—the preeminent black television music showcase that was a part of the U.S. cultural landscape for a quarter century.

James Brown in no uncertain terms epitomized black capitalism. He owned radio stations and a production company, and leveraged himself into the public

consciousness at every available opportunity. In 1969, *Look* magazine trumpeted him in a cover shot, alongside presidential hopeful Ed Muskie, as possibly America's most important black man. Brown himself seemed cognizant of his larger-than-life status, at one time challenging S & H Green Stamps with his own brand of Black & Brown trading stamps. He once declared himself a candidate for "World Ambassador,"

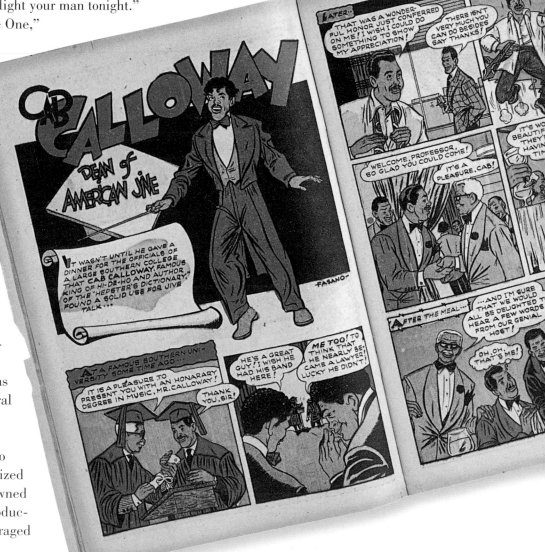

Cab's comic: Hi-De-Ho in four colors.

an office which, to the best of anyone's knowledge, is neither elective nor appointive nor extant. But, to be sure, he did attain the post of Soul Brother Number One, by general acclamation.

Visual "Records"

An intriguing sidelight in black music marketing was the evolution of concert posters, specifically those created by Globe Ticket in Baltimore. Advertising local R&B package shows, they became vivid visual records of the music of their respective eras. A 1965 offset job for a revue at Chattanooga's Memorial Auditorium featured a staggering lineup of predominantly Chicago-based acts, including the Impressions, Gene Chandler, Jerry Butler, Major Lance, Gladys Knight & the Pips, the Ikettes, Barbara Mason, and a host of others. The Globe format invariably included a head shot of the artists, along with the name of their latest single, resulting in an historic timeline in three colors. Music trade ads likewise provided a slice of time, while underscoring a long-standing industry maxim: "You're only as good as your last hit." In the case of Philadelphia's Intruders, the hit was

Cowboys to Girls on (Kenny) Gamble Records, and the trade spread capitalized on the obvious with a pair of cowboy boots and spurs as its generic visual elements.

Black music stars, entertainers, and sports figures have gradually become recognized as powerful spokespersons who can reach both black *and* white shoppers. Celebrities like Bill Cosby and Michael Jordan have become forever identified in the public consciousness with specific brand-name products.

The saga of style in black music has resonated through society in a way that few other artistic

ABOVE **Keeping it clean with the Ink Spots.**

BELOW LEFT **Straight and sassy with Miss Sarah.**

CENTER **Una Mae sells smooth hair.**

RIGHT **Louis Jordan: Adventure and moving.**

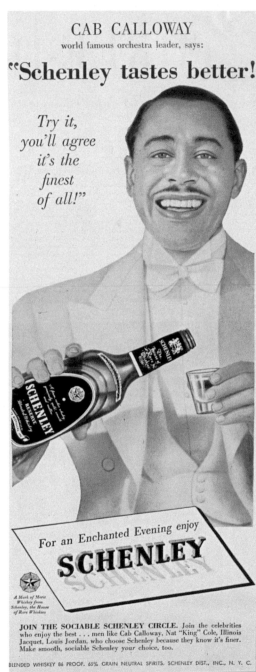

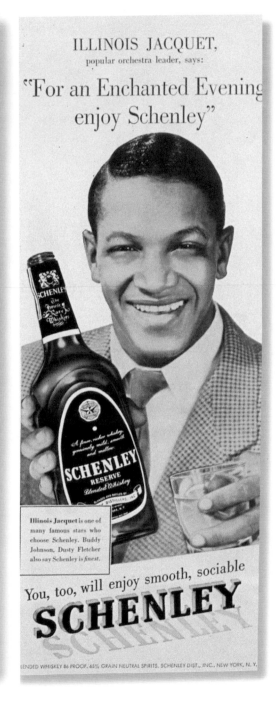

Buddy, Cab and Illinois: selling Schenley.

and cultural expressions can boast. Aspects of the way we dress, the way we talk, the emotional connection we have come to expect from those who entertain us . . . all this is the enduring legacy of the pioneers of black style. And it's an influence that continues. There is hardly a dance floor in America, or, for that matter, the world, where black-inspired steps are not earnestly emulated. The same may be

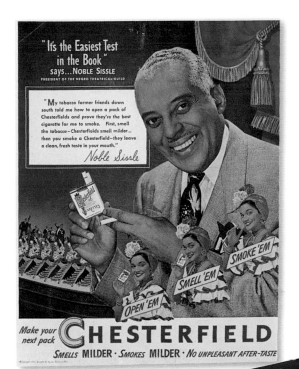

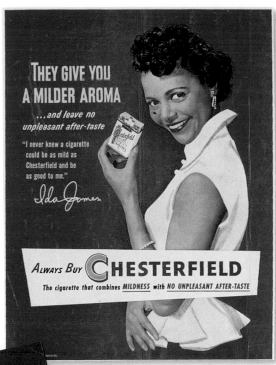

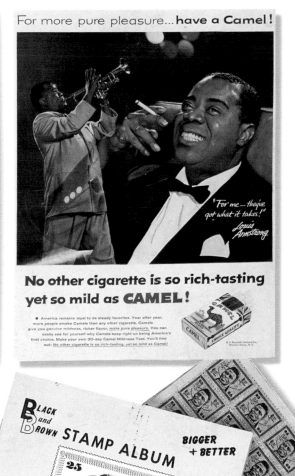

said for the cutting edge of fashion, in which inner city street styles have been appropriated on Paris runways. Trace any of these strains back to their point of origin, and you'll find a link with the energy, inspiration, and innovation that personify this quintessentially American artistic expression.

In the fifty years covered in this book, a remarkable number of explosive talents emerged and left their mark on our collective consciousness. Cab Calloway's sly and slinky way with a song, Little Richard's towering pompadour and pounding piano, the radiant grace of Lena Horne, the sweat-drenched charisma of James Brown, the alternately tough and

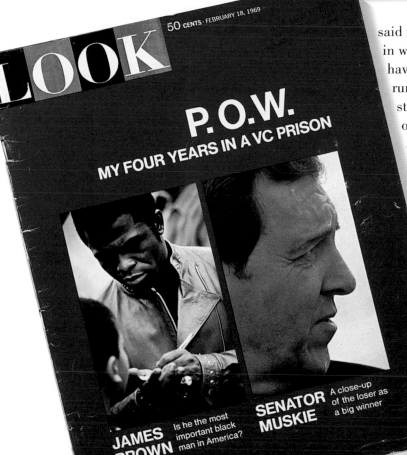

Emerging markets getting attention.

157

tender sentiments of Aretha Franklin, and the flash and panache of Michael Jackson have all permeated our culture. These, and many other artists who put us in touch with their souls and ours, have created a legacy that continues to have liberating effects on all of us. 🎵

ABOVE The Intruders lasso a hit with "Cowboys To Girls."

BELOW RIGHT James Brown: light of the world.

SELECTED BIBLIOGRAPHY

Bogle, Donald. *Brown Sugar*, New York, NY: Da Capo Press, 1980.

Broughton, Viv. *Black Gospel*, Dorset, UK: Blandford Press, 1985.

Case, Brian & Britt, Stan. *The Harmony Illustrated Encyclopedia Of Jazz*, New York, NY: Harmony Books, 1986.

Clifford, Mike (ed.). *The Illustrated Encyclopedia Of Black Music*, New York, NY: Harmony Books, 1982.

Clifton, John. *Who's Who In Jazz*, Philadelphia, PA: Chilton Book Company, 1978.

Crow, Bill. *Jazz Anecdotes*, New York, NY: Oxford University Press, 1990.

Driggs, Frank & Lewine, Harris. *Black Beauty, White Heat: A Pictorial History Of Classic Jazz*, New York, NY: Da Capo Press, 1995.

Gregory, Hugh. *Soul Music A-Z*, New York, NY: Da Capo Press, 1995.

Guralnick, Peter. *Sweet Soul Music*, New York, NY: Harper & Row, 1986.

Hadlock, Richard. *Jazz Masters Of The Twenties*, New York, NY: Collier Books, 1965.

Hildebrand, Lee. *Stars Of Soul And Rhythm & Blues*, New York, NY: Billboard Books, 1994.

Kern-Foxworth, Marilyn. *Aunt Jemima, Uncle Ben And Rastus*, Westport, CT: Praeger Publishers, 1994.

Murray, Albert. *Stomping The Blues*, New York, NY: Da Capo Press, 1976.

Null, Gary. *Black Hollywood*, New York, NY: Citadel Press, 1990.

Pruter, Robert. *Chicago Soul*, Chicago, IL: The University of Illinois Press, 1992.

Santelli, Robert. *The Big Book Of Blues*, New York, NY: Penguin, 1993.

Warner, Jay. *The Billboard Book Of American Singing Groups*, New York, NY: Billboard Books, 1992.

Whitburn, Joel. *Pop Memories 1890–1954*, Menomonee Falls, WI: Records Research, Inc., 1986.

Whitburn, Joel. *Top Pop Singles 1955–1986*, Menomonee Falls, WI: Records Research, Inc., 1987.

Whitburn, Joel. *Top Pop Albums 1955–1992*, Menomonee Falls, WI: Records Research, Inc., 1993.

Whitburn, Joel. *Top R&B Singles 1942–1988*, Menomonee Falls, WI: Records Research, Inc., 1988.

White, Adam & Bronson, Fred. *The Billboard Book Of Number One Rhythm & Blues Hits*, New York, NY: Billboard Books, 1993.

Wynn, Ron (ed.). *All Music Guide To Jazz*, San Francisco, CA: Miller Freeman Books, 1994.

PHOTO CREDITS

TABLE OF CONTENTS: MUDDY WATERS Courtesy of the Estate of McKinley Morganfield **PREFACE PAGE 12:** THE CRYSTALS "Twist Uptown," Phil Spector Records, Inc. 1962, Copyright © Phil Spector Records, Inc. **PAGE 14:** SOUL STIRRERS Specialty Records, Courtesy of Fantasy Records **PAGE 15 (TOP):** SISTER ROSETTA THARPE Universal Music Group **PAGE 15 (BOTTOM):** SISTER ROSETTA THARPE Courtesy of Savoy Records c/o Malaco Records. Used by permission. **PAGE 16:** THE ZION TRAVELERS Courtesy of Ace Records Ltd., THE DIXIE HUMMINGBIRDS Universal Music Group, THE DELTA RHYTHM BOYS Universal Music Group, THE GOSPEL HARMONETTES Courtesy of Savoy Records c/o Malaco Records. Used by permission. **PAGE 17:** THE SWAN SILVERTONES King Records **PAGE 19:** HIGHTOWER BROTHERS Reprinted by permission of General Bobby Farrell, Vandor Music Group, NATIONAL INDEPENDENT GOSPEL SINGERS Courtesy of Sony Music, THE FAMOUS WARD SINGERS Courtesy of Savoy Records c/o Malaco Records. Used by permission. **PAGE 20:** THE MEDITATION SINGERS Universal Music Group, DEE DEE SHARP, "Songs of Faith," Cameo (ABKCO) 1962, Copyright © ABKCO Records. **PAGE 21:** THE STAPLES SINGERS Reprinted by permission of Pops Staples, THE DRINKARD SISTERS Used courtesy of the RCA Records Label, a unit of BMG Entertainment **PAGE 22:** Okeh Record Label, MAMIE SMITH and CLARA SMITH Courtesy of Sony Music **PAGE 23:** FATS WALLER, "Latch On" Reprinted by permission of Mr. Harry Fox, Jr. **PAGE 24:** COUNT BASIE Universal Music Group **PAGE 25:** COUNT BASIE Poster Courtesy of Sony Music **PAGE 28:** THE MILLS BROTHERS Universal Music Group, "Java Jive" Used by permission: Warner Bros. Publications, U.S., Inc., Miami, FL **PAGE 29:** BILLY WARD AND HIS DOMINOES King Records, THE ORIOLES Reproduced by permission of Rhino Records, Inc. **PAGE 30:** BILLY WARD AND HIS DOMINOES King Records, HOWLING WOLF Universal Music Group **PAGE 31:** JIMMY RUSHING King Records **PAGE 33:** ROY BROWN, WYNONIE HARRIS King Records **PAGE 34:** ROY BROWN/WYNONIE HARRIS King Records, AMOS MILBURN Universal Music Group **PAGE 35:** IVORY JOE HUNTER King Records **PAGE 36:** EDDIE "CLEANHEAD" VINSON King Records **PAGE 37:** "T" BONE BLUES Used by permission EMI UK, BILL DOGGETT King Records **PAGE 38:** EARL BOSTIC, THE MIDNIGHTERS King Records **PAGE 39:** LITTLE WILLIE JOHN, TINY BRADSHAW, EARL BOSTIC, LITTLE ESTHER King Records **PAGE 40:** MUDDY WATERS Courtesy of the Estate of McKinley Morganfield, LIGHTNIN' HOPKINS ("Death Bells" matchbook) Mel Bay Publications, Inc. **PAGE 43:** THE DEL-VIKINGS Universal Music Group, LITTLE RICHARD/PAT BOONE Courtesy of Sony Music **PAGE 44:** THE TEENAGERS, FRANKIE LYMON Reproduced by permission of Rhino Entertainment Company **PAGE 45:** LITTLE STEVIE WONDER Album cover licensed courtesy of Motown Record Company, L.P. **PAGE 46:** DIXIE CUPS: Used by permission, courtesy of SUN Entertainment Corporation **PAGE 47:** THE CHANTELS Reproduced by permission of Rhino Records, Inc. **PAGE 48:** THE MARVELETTES Album cover licensed courtesy of Motown Record Company, L.P. **PAGE 50:** SAM AND DAVE Courtesy of Stax Records, Fantasy, Inc. **PAGE 54:** JACKIE WILSON Courtesy of Sony Music **PAGE 55:** BILLY WARD AND HIS DOMINOES King Records **PAGE 56:** SOLOMON BURKE Universal Music Group **PAGE 57:** O.V. WRIGHT Universal Music Group **PAGE 58:** CHUCK JACKSON Courtesy of Sony Music **PAGE 59:** MAJOR LANCE Courtesy of Sony Music, EDWIN STARR Album cover licensed courtesy of Motown Record Company, L.P. **PAGE 60:** THE TEMPTATIONS Album cover licensed courtesy of Motown Record Company, L.P. **PAGE 61:** FOUR TOPS Album cover licensed courtesy of Motown Record Company, L.P. **PAGE 62:** JR. WALKER AND THE ALL STARS: Album cover licensed courtesy of Motown Record Company, L.P. **PAGE 64:** BILLIE HOLIDAY Courtesy of Sony Music **PAGE 66:** EARTHA KITT Used courtesy of the RCA Records Label, a unit of BMG Entertainment **PAGE 67:** CARLA THOMAS Courtesy of Stax Records, Fantasy, Inc., BIG MAYBELLE Courtesy of Savoy Jazz-Denon Records/Denon Active Media, a division of Denon Corp., USA **PAGE 68:** MARY WELLS "Two Lovers" Album cover licensed courtesy of Motown Record Company, L.P. **PAGE 69:** ETTA JAMES Universal Music Group **PAGE 70:** MAXINE BROWN Courtesy of Sony Music, MARVA WHITNEY King Records **PAGE 72:** BARBARA MASON Blockbuster Music (BMI) **PAGE 73:** MUDDY WATERS Courtesy of the Estate of McKinley Morganfield **PAGE 75:** CAB CALLOWAY Courtesy of Sony Music **PAGE 78:** JOHNNY "GUITAR" WATSON **PAGE 79:** ILLINOIS JACQUET Universal Music Group, YOUNG/COLMAN Courtesy of Savoy Jazz-Denon Records/Denon Active Media, a division of Denon Corp. USA, LESTER YOUNG Universal Music Group **PAGE 81:** BIG JAY MCNEELY King Records **PAGE 82:** LOUIS JORDAN on Decca Universal Music Group **PAGE 83:** THE MIDNIGHTERS King Records, CADETS Universal Music Group, THE ISLEY BROTHERS Used courtesy of the RCA Records Label, a unit of BMG Entertainment **PAGE 84:** CAPITOLS Trio Music Co., Inc. and Alley Music Corp. All rights reserved. Used by permission, INEZ AND CHARLIE FOXX Universal Music Group, BOBBY FREEMAN Reproduced by

permission of Rhino Records, Inc., THE CONTOURS Album cover licensed courtesy of Motown Record Co., L.P. **PAGE 85:** LITTLE RICHARD Used courtesy of the RCA Record Labels, a unit of BMG Entertainment **PAGE 86:** NOLAN STRONG, NATHANIEL MAYER Mr. Sheldon Brown/Fortune Records/Trianon Publications, used by permission. **PAGE 88:** DUKE and ARISTOCRAT RECORD LABELS Universal Music Group **PAGE 89:** BUSTER BROWN/DR. HORSE Bobby Robinson, the owner of Fire and Fury Record Companies and world renowned producer, J.B. LENORE/BIG MAMA THORNTON Universal Music Group, TAMPA RED AND CHICAGO FIVE Used courtesy of the RCA Records Label, a unit of BMG Entertainment, JUNIOR PARKER Courtesy of Sun Entertainment Group **PAGE 90:** JERRY MCCAIN Reprinted by permission of General Bobby Farrell, Vandor Music Group, THE FIVE KEYS Universal Music Group, THE MIRACLES Album covers licensed courtesy of Motown Record Co., L.P., DREAMLOVERS Reproduced by permission of Rhino Records, Inc. **PAGE 92:** ILLINOIS JACQUET EMI Records, UK **PAGE 94:** LIONEL HAMPTON Used courtesy of the RCA Record Labels, a unit of BMG Entertainment, LESTER YOUNG Courtesy of Savoy Jazz-Denon Records/Denon Active Media, a division of Denon Corp. USA, SONNY TERRY and BROWNIE MCGHEE EMI Records, UK **PAGE 95:** JAMES BROWN Polygram Holding Inc., LONNIE JOHNSON King Records **PAGE 96:** HONEY AND THE BEES EMI Records UK, TOMMY TUCKER Universal Music Group, AL GREEN Reproduction of the cover artwork from the Bell/Hotline 1968 release "Back Up Train" by Al Green **PAGE 97:** DIZZY GILLESPIE Polygram Holding Inc., THE PENGUINS Courtesy of Ace Records Ltd. **PAGE 98:** THE MIRACLES Album cover licensed courtesy of Motown Record Co., L.P., THE FIVE KEYS Universal Music Group **PAGE 99:** THE CADILLACS Reproduced by permission of Rhino Records, Inc., LITTLE JUNIOR PARKER Universal Music Group **PAGE 100:** SCREAMIN' JAY HAWKINS Courtesy of Sony Music, LYNN HOPE King Records **PAGE 101:** LITTLE ANTHONY AND THE IMPERIALS Reproduced by permission of Rhino Records, Inc., THE 5 ROYALES King Records **PAGE 104:** THE DUBS/THE SHELLS Reproduced by permission of Rhino Records, Inc., THE JACKS Universal Music Group **PAGE 105:** THE ORLONS The Orlons, "Don't Hang Up," Cameo (ABKCO) 1962 Copyright © ABCKO Records **PAGE 106:** THE ORLONS Used by permission: Warner Bros. Publications, U.S., Inc., THE MIRACLES Album covers licensed courtesy of Motown Record Co., L.P. **PAGE 107:** THE SENSATIONS Universal Music Group **PAGE 109:** CORNELIUS BROTHERS "Don't Ever Be Lonely (A Poor Little Fool Like Me)" Writer: E. Cornelius, Production/Sound: Bob Archibald, Stage Door Pub. (BMI), THE THREE DEGREES Reproduced by permission of Rhino Records, Inc. **PAGE 112:** DUKE ELLINGTON Used courtesy of the RCA Records Label, a unit of BMG Entertainment **PAGE 113:** DUKE ELLINGTON Used courtesy of the RCA Record Label, a unit of BMG Entertainment, "Mood Indigo" Used by permission: Warner Bros. Publications, U.S., Inc. **PAGE 114:** COUNT BASIE EMI Records, UK **PAGE 115:** CAB CALLOWAY Courtesy of Sony Music **PAGE 116:** "That's The Way It Is" EMI, UK, LOUIS ARMSTRONG Universal Music Group **PAGE 117:** ELLA AND HER FELLAS Universal Music Group **PAGE 119:** JIMMIE LUNCEFORD Universal Music Group, EARL BOSTIC King Records, CHARLES BROWN Universal Music Group **PAGE 121:** ERSKINE HAWKINS Used courtesy of the RCA Record Labels, a unit of BMG Entertainment, MILT JACKSON Courtesy of Savoy Jazz-Denon Records/Denon Active Media, a division of Denon Corp. USA **PAGE 122:** CHUCK JACKSON Courtesy of Sony Music, SAM COOKE "Encore," Keen (ABKCO), 1958, Copyright © ABKCO Records **PAGE 125:** B.B.KING and BOBBY BLAND Universal Music Group **PAGE 126:** JOE HINTON Courtesy of Sony Music **PAGE 127:** THE PLATTERS King Records, THE TYMES "So Much in Love," Cameo (ABKCO), 1963 Copyright © ABKCO Records **PAGE 128:** JERRY BUTLER Courtesy of Vee-Jay Ltd. Partnership **PAGE 130:** GENE CHANDLER and DEE CLARK Courtesy of Vee-Jay Ltd. Partnership **PAGE 132:** THE ORIGINAL SPINNERS/MARVIN GAYE/GLADYS KNIGHT AND THE PIPS, "Silk N' Soul" Album covers licensed courtesy of Motown Record Co., L.P., GLADYS KNIGHT AND THE PIPS "Letter Full of Tears" Bobby Robinson, owner of Fire and Fury Record Companies and world renowned producer **PAGE 133:** THE DELFONICS Reproduction of the cover artwork from the Philly Grove 1968 release "The Sound of Sexy Soul" by The Delfonics **PAGE 138:** SLY STONE and UNDISPUTED TRUTH: Copyright: Blues & Soul Magazine, Ltd. **PAGE 139:** THE JACKSON FIVE: Licensed courtesy of Motown Records Co, L.P. **PAGE 140:** BILLY BUTLER Courtesy of Sony Music **PAGE 141** THE OHIO PLAYERS Copyright: Blues & Soul Magazine, Ltd. **PAGE 142:** BOOTSY COLLINS Copyright: Blues & Soul Magazine, Ltd. **PAGE 143:** CAB CALLOWAY Courtesy of Mr. Marvin Shadman, Barton Brands, Ltd. **PAGE 146–147:** REVEILLE WITH BEVERLY Courtesy of Columbia Pictures **PAGE 151:** MISTER ROCK AND ROLL Reprinted by permission of Paramount **PAGE 155:** THE INK SPOTS Universal Music Group **PAGE 156:** SCHENLEY WHISKEY ADS Courtesy of Mr. Marvin Shadman, Barton Brands, Ltd., **PAGE 160:** LOUIS ARMSTRONG Courtesy of Sony Music **COVER PHOTO ON DUST JACKET:** LITTLE RICHARD: Used by permission of Bob Douglas, photographer **NOTE:** All images in this book courtesy The Rico Tee Collection, P.O. Box 22372 San Francisco, CA 94122